The

WATERCOLOR
BIBLE

Joe Garcia

NORTH LIGHT BOOKS
CINCINNATI, OHIO
www.artistsnetwork.com

The Watercolor Bible. Copyright © 2006 by Joe Garcia. Printed in Singapore. All rights reserved. No part of this book may be reproduced in any form or by any electronic or mechanical means including information storage and retrieval systems without permission in writing from the publisher, except by a reviewer who may quote brief passages in a review. Published by North Light Books, an imprint of F+W Publications, Inc., 4700 East Galbraith Road, Cincinnati, Ohio, 45236. (800) 289-0963. First Edition.

fw
F+W PUBLICATIONS, INC.

Other fine North Light Books are available from your local bookstore, art supply store or direct from the publisher.

10 09 08 07 06 5 4 3 2 1

DISTRIBUTED IN CANADA BY FRASER DIRECT
100 Armstrong Avenue
Georgetown, ON, Canada L7G 5S4
Tel: (905) 877-4411

DISTRIBUTED IN THE U.K. AND EUROPE BY DAVID & CHARLES
Brunel House, Newton Abbot, Devon, TQ12 4PU, England
Tel: (+44) 1626 323200, Fax: (+44) 1626 323319
Email: mail@davidandcharles.co.uk

DISTRIBUTED IN AUSTRALIA BY CAPRICORN LINK
P.O. Box 704, S. Windsor NSW, 2756 Australia
Tel: (02) 4577-3555

Library of Congress Cataloging in Publication Data
Garcia, Joe.
The watercolor bible / Joe Garcia.
 p. cm.
Includes index.
ISBN 1-58180-648-5 (hc. : alk. paper)
1. Watercolor painting--Technique. I. Title.
ND2420.G37 2005
751.42'2--dc22 2005015874

Edited by Christina Xenos
Designed by Wendy Dunning
Production art by Joni Deluca and Barb Matulionis
Production coordinated by Mark Griffin

METRIC CONVERSION CHART

TO CONVERT	TO	MULTIPLY BY
Inches	Centimeters	2.54
Centimeters	Inches	0.4
Feet	Centimeters	30.5
Centimeters	Feet	0.03
Yards	Meters	0.9
Meters	Yards	1.1

About the Author

Native Californian Joe Garcia lives and works near Julian, California, where the forest of oaks and pines shelter an abundance of birds, deer and other wildlife. It is an area of varied landscapes and a perfect setting for an artist who specializes in painting those subjects.

Joe earned a BFA degree with an advertising/illustration emphasis from the Art Center College of Design in Los Angeles. Since 1983 Joe has painted full-time, leaving the commercial work behind. He published his first book, *Mastering the Watercolor Wash* with North Light books in 2002.

Acknowledgments

This book was like having triplets! A lot of hard work, four-letter words and a great team effort.

Writing this book comes with many hours of research. I would like to give special thanks to Judy Sonderby who opened her extensive art library to me. I just have to remember that those wonderful research books I borrowed do not belong to me. I would like to thank Don Zaphy. His time, effort and knowledge are greatly appreciated.

A thank you must be given to my students, friends and clients who support my obsessive tendencies about painting. They keep me on my toes. Nothing is worse than complacency in an artist.

I give special thanks to Christina Xenos, my editor at North Light Books. She is very understanding and patient. She must have been a psychologist in another life. Thank you Jamie Markle for asking me to do this book.

Finally, thanks without any hesitation to my wonderful wife, Anne. She translated, edited and typed all my handwritten copy. Her patience and support have made this book special. Thank you, Anne, but I don't understand why you said, "You better never do this again."

Dedication

This book is dedicated to Anne for all her support and patience and to our granddaughter Gia, already a budding artist at two and a half!

TABLE *of* CONTENTS

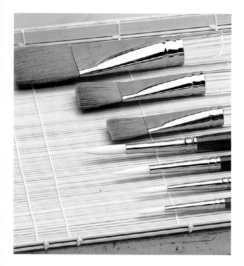

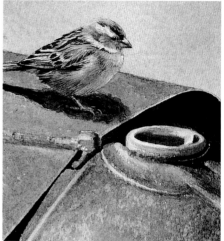

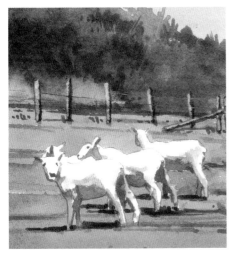

3

A Quick and Easy Guide to Composition

4

Drawing Techniques

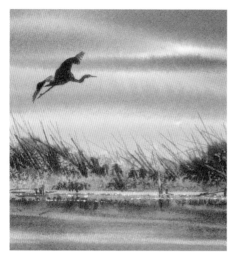

5

Paint Properties and Techniques

80

6

Color

122

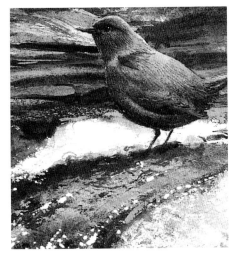

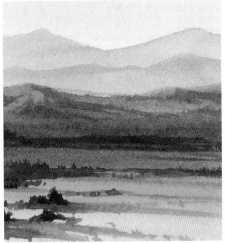

7

Special Effects

176

8

Popular Subjects

194

INDEX

300

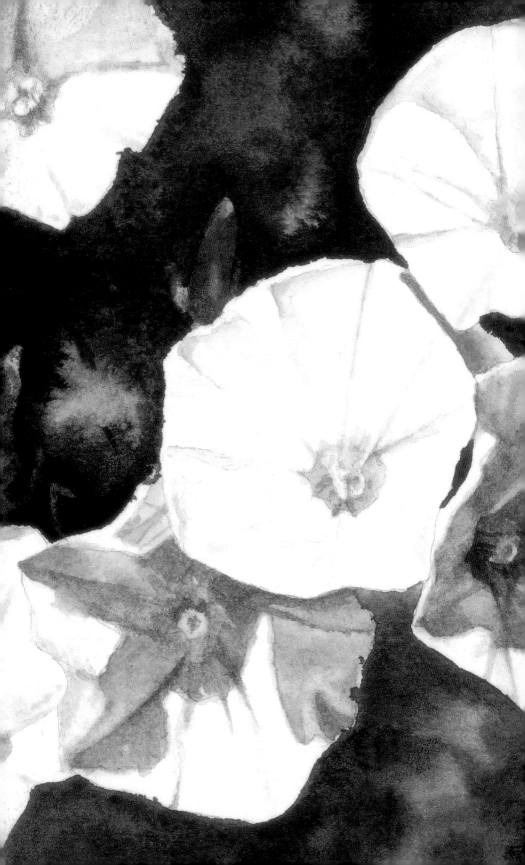

Materials and Supplies

A wide variety of high quality materials for the water-colorist is offered at all good art stores. You will most likely be overwhelmed by the many shelves of paint, brushes, mediums and paper to be had. Because select-ing the proper tools can have a profound effect on the result of your painting skills, be selective in what you purchase. Buy only what you need—and what you need is not necessarily the most expensive equipment. Some of the most valuable tools are things you can find around your studio or home. Salt, sand-paper, mat board and paraffin are only a few examples.

Synthetic brushes are excellent and do not break the bank, as kolinsky sable might. However, do not skimp or try to save pennies on the quality of paint or paper. Student-grade paint and paper will only slow your artistic career. Start with a few professional grade colors and do smaller sized paintings to con-serve paint and paper. You can finish almost any painting with a 1-inch (25mm) flat and nos. 4 and 8 round brushes. Ask other artists what brands of brushes they like. Three to six tubes of paint, a couple of sheets of 22" × 30" (56cm × 76cm) quality paper and you are ready to start. If you are don't know what colors to choose, go with the primaries—red, yellow and blue.

FIRST DIP
Watercolor on 300-lb. (640gsm) cold-pressed paper
24" x 32" (61cm x 81cm)

WATERCOLOR PAINTS

Watercolors come in tubes, cakes or pans, pencils or liquids. They vary in price and quality, and there are many brands available. Stick to the professional quality paints, which offer consistency of color, lightfastness and a general degree of excellence.

Transparent paints (as opposed to opaque paints such as gouache) consist of pigment mixed with gum arabic, glycerin and a wetting agent. When you thin the paint with water, the glycerin and water allow the pigment to adhere to the surface of the paper. The wetting agent allows the paint to flow evenly as it is diluted.

Pan, or cake, paints come in half and full pans, individually or in kits. Kits are compact, travel well, and are useful for doing small paintings; however, it is difficult to mix enough paint for large, even washes. Cakes are small and you will use your favorite colors quickly, so have extras available.

KNOW YOUR HUES

Paint names followed by *Hue* (Hooker's Green Hue) tend to be of a lower quality. They are made with an imitation product of the actual pigment.

Tube Paints
are sold as small (5ml), medium (14–16 ml) and, occasionally, in large (37ml) sizes.

Small Traveling Palette

The secrets to controlling paint are timing and learning to use the correct amount of water. A basic rule of watercolors is that the wettest area always flows into an area that is less wet. This moisture may come from paint, damp or wet paper, or even your moist brush. Use this fundamental law to create or eliminate textures, such as bleeds or blooms, lift color or create wet-into-wet washes.

Paper Influence

Paper type (page 18) also influences paint behavior. Hot-pressed paper does not readily allow the pigment to soak in. Hot-pressed illustration board, watercolor paper or Yupo—a "plastic" paper—all work basically the same way. These surfaces are hard and slick and do not allow the pigments to be readily absorbed. Cold-pressed and rough papers allow water and paint to absorb and their texture works well for paint granulation (when coarse pigments, such as raw umber, settle into the little depressions in the paper).

Mediums

Mediums influence paint behavior. Wetting agents such as ox-gall or glycerin extend the time a wash stays wet. Ox-gall helps the pigment adhere to the surface of the paper. It also increases

the pigment's transparency, so use it sparingly. Alcohol creates textures, but you can also add it to your water to shorten drying time. Gum arabic is another agent that you can add to your watercolors to slow the drying time.

CONTROL THE PAINT

Add water back into a damp wash. The wettest area tries to reach an equilibrium with a less wet area. Try this technique with paint.

Drop, splatter or place paint on a damp surface. Control depends on the amount of water on the surface.

For this wet-into-wet wash, the paper is tilted and the paint runs in the desired direction. The type of surface and amount of pigment and moisture on the paper influence this technique.

PALETTE

Palettes come in a variety of shapes and sizes. A white dish, butcher's tray or cookie sheet will suffice, but a traditional covered palette is best. A good palette has large separate wells or reservoirs to store each color and a large mixing area with no divisions. The deep wells are important because they allow you to have a lot of pigment available. They also keep colors from being contaminated by adjacent colors and help you see and arrange your colors in a logical order. The open mixing area allows you to mix enough color to get rich, saturated washes. For years I used a butcher's tray because of the large mixing area. Now I use the John Pike palette because of its heavy construction. It also travels well.

Mixing Colors on a Palette

Make sure to always mix enough paint to avoid running out in the middle of your painting. A palette that has a large flat area is helpful for this.

PICK YOUR PALETTE

A palette influences how you paint. A good palette is one that starts you on a logical journey through your painting.

Divided mixing areas restrict mixing large pools of paint.

Large paint wells fit large brushes and are good for mixing large washes.

Flat well construction helps keep dirty color away from the pigment in the well.

Slated or round wells allow contaminated color to flow up to and around the pigment already there.

Incomplete Mixing

Pull two or three colors from the palette wells and allow them to partly mix on the palette. Drag your brush through these colors and apply to your paper. The parent colors retain some of their identity while also mixing on the paper surface. Some of the parent colors remain visible, resulting in washes that are interesting and spontaneous.

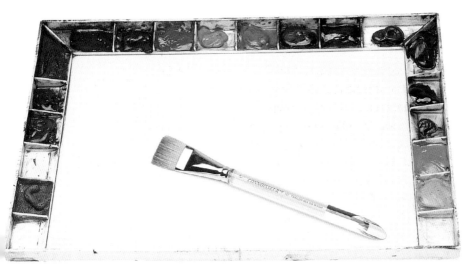

John Pike Palette

Placing Colors

My warm colors are on the left, blues and greens across the top and my earth tones and yellows are on the right. I do not fill all the wells, but use the open wells for an occasional new color. Once you have decided on the arrangement of your pigments, keep it that way for every palette you make up. Eventually, you will not have to search for your colors; you will know exactly where they are and are therefore less likely to dip into the wrong well.

PALETTE TRICK

A new plastic palette may resist paint. Use steel wool or very fine sandpaper to buff the mixing area.

BRUSHES

The success of what or how you paint depends on the brushes you use. Use what you can afford and works for you. My brushes consist of a couple of kolinsky sables (1-inch [25mm] flat, no. 10 round) and a variety of synthetic brushes. Sizes range from a no. 10 round to a no. 2 round. The flats are ½-inch (12mm), 1-inch (25mm) and 2-inch (51mm) synthetics. I generally return to the same old favorites.

Pick brushes for the job they do. Flat brushes hold a lot of paint or water and are the workhorse for wet-into-wet washes. Use large flats them for wet-into-wet washes or small flats for fine detail work. They are good for creating texture or, if a bit worn and blunted, to lift out areas. Rounds hold a lot of fluid because of their shape.

Each area of your painting will require a specific brush. Always start with the largest brush possible. Switch to smaller brushes for detail as the

painting progresses. Your painting style and technique will develop and be enhanced according to how you use your brushes.

Synthetic Brushes
Synthetic brushes are affordable and less intimidating than natural fiber brushes. They wear out faster, but the low cost helps make up for that. I like the springy, resilient quality of a good synthetic brush and use them almost

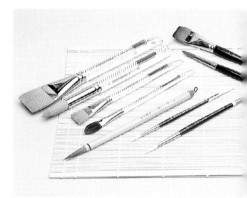

Flat and Round Brushes

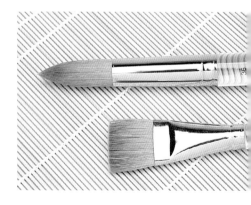

Brush Quality
Brushes should have good shape and construction—no shedding or bent hairs. If the handle is wood, it should be lacquered. The ferrule should be seamless.

exclusively. I tend to be a rough painter and do not mind buying brushes a little more often.

Natural Brushes

Natural fiber brushes are made of anything from kolinsky sable to goat hair. Sable brushes retain water best and have a springy point. The natural fiber brushes are expensive but have long life, great water retention and spring.

Transporting Brushes
Proper transportation of your brushes is important. Do not just lay them in your box or carrier. The brushes will bounce around and the tips and edges will get damaged. Use a brush holder that separates brushes individually. Place them separately on a bamboo place mat as you roll it up. Use a strong rubber band to keep it rolled.

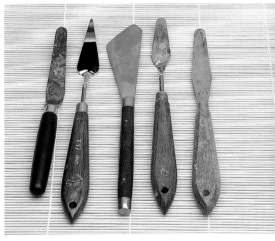

Palette Knives
With a little practice, the palette knife can be an important addition to your painting kit. Look for one that is flexible and easy to hold so you can apply pressure in varying degrees. Use it like a squeegee to remove paint or like a knife-edge to draw a fine line or apply paint. Practice makes perfect, but remember: This is one tool that will damage the surface of the paper, so be careful.

BRUSH CARE

- Do not leave brushes tip down in a water container. This breaks the ends of the fibers and also bends and twists them out of shape.

- Wash your brush with mild bar or liquid soap to remove paint that would dry and break hair or fibers of the brush. Doing so also keeps unwanted pigment from building up in the belly of the brush.

- Form your rounds to a point and your flats to a square before you store them to dry.

- To enhance the longevity of your brushes, use an old round for mixing paint on your palette.

17

PAPER

Paper comes in blocks, sheets or pads; numerous brands of high quality papers are available. Try many brands of paper and to find one you like.

Paper comes in three textures: hot-pressed (very smooth), cold-pressed (lightly textured) and rough (heavily textured). Cold-pressed paper is a good surface with which to start.

Paper comes in various weights. The weight or thickness is based on a ream, or five hundred sheets of paper. A standard sheet of watercolor paper is 22" × 30" (56cm × 76cm). As an example, five hundred sheets of cold-pressed paper weighs 140 lbs. (300gsm). I use 140- or 300-lb. (300gsm or 640gsm) Arches cold-pressed paper most often. The surface handles my rough way of painting.

Other Surfaces

Your surface affects the style or technique of your paintings. A soft paper may not work well if you like to scrub, lift, scratch or texture your paintings. Surfaces can vary from Yupo (a "plastic" paper) to illustration board. Select paper paper that is 100 percent cotton fiber, with the exception of Yupo. All high quality papers are acid-free. Illustration board comes in various weights and surface textures.

TYPES OF PAPER

Paper sheets are handmade, mouldmade or machine-made.

- Handmade papers are expensive, but have a high degree of excellence.

- Mouldmade papers are durable and generally of good quality.

- Machine-made papers are the least desirable. Their defined surface texture looks mechanical and is often used in student-grade pads.

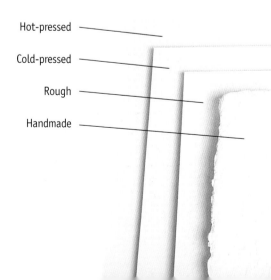

Hot-pressed

Cold-pressed

Rough

Handmade

Stretching Paper

Paper stretching is the process of soaking the paper, attaching it to a board, then letting it dry completely. The paper expands as it is soaked and as it dries, it shrinks to a nice, flat surface. This shrinkage helps keep the paper from buckling as you paint. Use paper tape or staples to adhere the wet paper to the board. Tape works best for lightweight paper up to 140 lbs. (300gsm). You will have better success with staples on the heavier papers. Placing the staples close together keeps the paper from pulling up from the board. A heavy, stiff board that will not bend or warp is essential.

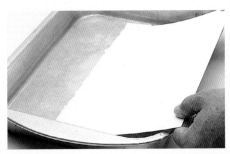

1 | Soak the Paper Thoroughly
Soak 7–10 minutes for 140-lb. (300gsm) paper, 30–45 minutes for 300-lb. (640gsm) paper.

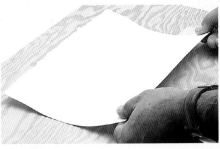

2 | Drain and Place
Drain off excess water and place on mounting board. Use a sponge to flatten and wipe off excess water.

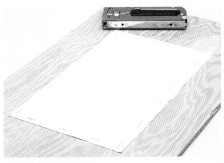

3 | Secure the Paper
Stapling the paper is the easiest way to mount the paper. A heavy-duty electric stapler is helpful. Place staples approximately ½" (12mm) from the edge of the paper. Heavier paper requires more staples.

SUBSTITUTE TAPE FOR STAPLES

If you don't want to mount your stretched paper with staples, precut four lengths of gummed paper tape.

1. Lightly dry the edge of the paper with paper towels.

2. Moisten the tape. (Be careful not to overmoisten the tape, as it will be less likely to adhere to the paper.)

3. Overlap your paper with the damp tape by about ½" (12mm).

4. Burnish down the edges of the tape.

5. Allow the paper to dry completely. The paper will shrink and leave a tight flat surface.

OTHER SUPPLIES

Your tools and materials, such as pencils, paper and sponges, must be in easy reach to facilitate your painting.

Artist's Table
An artist's table is like a mechanic's workbench. It is covered with tools.

Pencils
Pencils come in a wide range of hardness, from 9B (very soft) to 9H (very hard). If you are sketching a drawing that you will paint, a soft pencil may smudge too easily. A hard lead pencil, on the other hand, will score or leave an indentation on the surface of the paper, showing up later in your painting as an unwanted dark line. I use a 2H or 3H pencil, which makes a line that's easy to see as I paint. I like to use softer pencils to draw in a sketchbook. They give variety to the linework.

Sponges
Sponges offer a great opportunity to play with texture. A natural sponge is great for creating trees or rocks. Load it with paint and gently press it to the surface of the paper. Use a variety of sponges, each with a different texture. A synthetic sponge is good for applying washes or picking up paint, but its uniform surface lacks interesting textures.

Masking Fluid
Masking fluid creates a water-resistant barrier between the paint and the paper. It is a liquid that is applied to the paper with a brush, stick, sponge, etc. It is similar to rubber cement but is made specifically for watercolors. If you use a brush, load it with liquid soap before dipping it into the masking fluid so it won't penetrate the belly of the brush. Don't allow the masking agent to dry because it will ruin the brush.

Gouache
Gouache is technically an opaque watercolor, but you can thin it with water and make it transparent. You can use it on a number of different surfaces, such as primed canvas, illustration board or watercolor paper. A toned or colored paper is ideal to use because of the opacity of gouache.

Camera, Lenses and Film
The camera is an important tool that allows the artist to record ideas or references that might otherwise be lost. Cameras may be as simple as a "point and shoot" or as high-tech as a digital. The standard 35mm SLR is sufficient. It uses slide or print film and most have interchangeable lenses. A zoom lens can help you crop and compose a photo for a future painting.

General Materials

Every artist has equipment or materials that will help him make his painting unique. Make sure these tools of the trade are readily available: drawing boards of various sizes, masking tape of various widths (some to create textures and some simply to tape down your paintings), a craft knife, paper towels and a water bucket. Sandpaper or emery cloth, paraffin and spray bottles all come in handy as well. The list continues. You need tools or equipment that enhances or complements your painting technique. Observe what other artists use. You may find another treasure to add to your box of tricks.

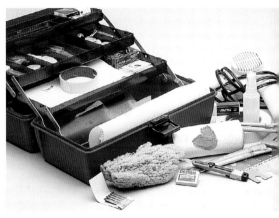

Odds and Ends
Materials helpful to have on hand while painting.

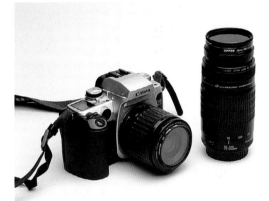

35mm Camera, 35–80mm and 75–300mm Zoom Lenses.

GO DIGITAL

Digital cameras are becoming more affordable, and offer some advantages over the 35mm. Some are small with high resolution and have interchangeable lenses. They allow you to see the image immediately. You can store and catalogue the picture in your computer or print it without the delay of processing.

Collecting and Recording Ideas

You can find ideas for paintings by looking through art books and magazines, talking with artist friends or simply observing your surroundings.

Friends are a valuable source for ideas. They talk about places or subjects they have seen that could make interesting paintings, so take note. Looking and studying images painted by other artists is a way to understand how they solved color, composition or value problems. A trip to the museum to view the old masters, Impressionists or contemporary art will no doubt introduce new ideas into your work.

Recording ideas can involve sketchbooks, field paintings or a camera. Be prepared: How often have you said, "I wish I brought the camera," or, "If only I had my sketchbook." A sketch, a few scribbled words or a photo helps preserve an idea that you might later paint. Ideally, you will combine the various methods. A field painting or sketch allows you to paint some of the detail, and commit the overall area to paper. Add a few words and take a photo to complement your sketch and you have the perfect start to a larger painting.

END OF THE ROAD
Watercolor on 300-lb. (640gsm) cold-pressed paper
22" × 10½" (56cm × 27cm)

INSPIRATION

Inspiration comes from many sources. It may come from the instructor or mentor who gives you the motivation to succeed, a visit to a museum or art show displaying work that astounds you, or scenery that leaves you breathless. As an artist, I think inspiration is the motivation to create or communicate an idea or emotion.

I was teaching a workshop on the headlands of Mendocino, an incredibly picturesque coastal community in northern California. It was late in the afternoon and a thunderstorm hovered over the Pacific. The clouds were dark, the lightning was flashing and the sun was setting. What more could an artist ask for? Inspiration was poised on every paintbrush. Suddenly, a bolt of lightning flashed above our heads and a clap of thunder shook our palettes. At that moment, inspiration turned into motivation! We rushed to our vehicles, leaving aluminum chairs and umbrellas to the approaching storm. Inspiration left an impression in our minds and on our film that particular day.

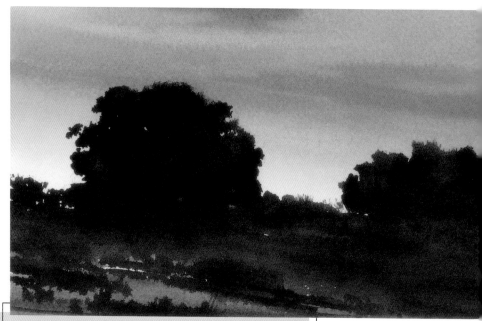

LAST LIGHT OF DAY
Watercolor on 140-lb. (300gsm) cold-pressed paper
4" × 6⅝" (10cm × 17cm)

MAKE A PLAN

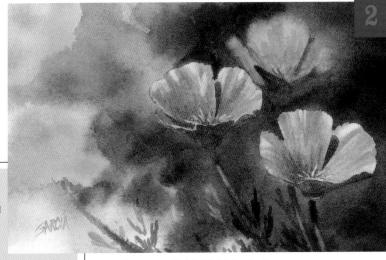

TOUCH OF GOLD
Watercolor on 300-lb.
(640gsm) cold-pressed
paper
4½" × 7½"
(11cm × 19cm)

Loose to Tight, Light to Dark

A good plan is the foundation to your success. Your objective may be to paint a very spontaneous interpretation of the subject, but the successful completion of the painting is based on a series of steps. These steps make up a plan or formula that varies from artist to artist.

What follows is my general approach to painting watercolors. It works for me because it is flexible and gives me a direction in which to start.

1. Take a few minutes to really study your subject. Where are the shadows? What are the big planes and masses? Do you understand the color and value? Is the perspective tricky? When you're ready, visualize how you're going to do the painting.
2. Pick the center of interest, or focal point. Set the composition with a very quick pencil sketch. If you like the idea, do a more comprehensive drawing.
3. Decide how to start the painting. Which techniques will you use and where? Should you progress loose to tight, light to dark, use a wet-into-wet or a dry-brush technique?
4. Decide how to convey the subject's feeling or emotion with color and value. Should you use a full or limited palette? Should the painting be high key or low key?

Each of these steps can change as you see fit, with the emphasis placed as needed. Create a plan. If you understand how to start the painting, the battle is partly won. Each painting you do adds to your knowledge and confidence.

THE CREATIVE PROCESS

For every artist the creative process is a little different. I find the creative process starts by continually looking for interesting painting subjects. I try to keep an open mind and analyze the situations around me. I try to get a "feel" for what I see. Does the idea have a mood? Can I look at it differently than other artists? Can I change the perspective to make an idea more interesting? Some subjects can go beyond inspiration and should be explored. Planning how I will paint the idea is the last step in the creative process.

Start with a quick line or value study, using pen, pencil, marker or paint. This sketch helps you decide the composition and the location of the center of interest.

You may add color to your sketch to help decide the technique to use. Will the subject be a vignette or painted edge to edge? Adding color also helps you decide if the painting should be high key (light colors) or low key (dark colors). This is a good time to turn your small study upside down to see the images as shapes and values.

The drawing should reflect the technique you plan to use in the painting. A loose, free drawing will not impede a wet-into-wet style. A carefully drawn subject reflects a controlled technique. Whatever style you choose, be creative by changing the reference. Use your imagination as much as possible.

Let Inspiration Strike
A very large pig was either curious or hungry as he stuck his snout through the fence. I never expected to do a painting of a farmyard pig in Italy. You never know where the creative process will lead you!

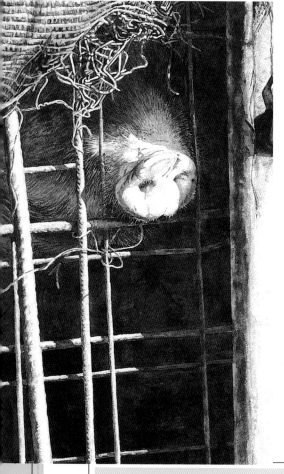

THIS LITTLE PIGGY STAYED HOME
Watercolor on 140-lb. (300gsm) cold-pressed paper
16" × 10½" (41cm × 27cm)

RECORDING INFORMATION

Methods of recording information vary from artist to artist. Time also dictates how much information you can record. Some artists need to make extensive visual and written notes, while others may need only a few lines to recall the necessary information. A camera is useful but has its limitations and may not always be handy.

If your time is limited, start with a quick compositional sketch. This will help you decide if your format will be vertical or horizontal. Draw your largest areas or planes. If you are using color, do not be too specific; you are just trying to capture the essence of the subject.

Try to emphasize or focus on the center of interest. If time allows, add information such as values and shadows. The important thing is to eliminate what is not necessary. If a camera is available, take a few photos from various angles.

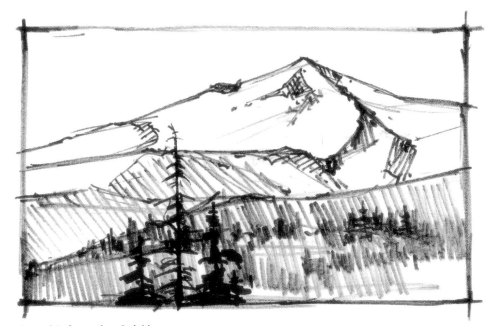

Record Information Quickly
I began recording information for this sketch by taking a couple of photographs. Time was limited so I did a very quick marker sketch. This helps catch the moment in my memory. I may or may not go beyond this point, but I will have this information in my files.

SKETCHING

Sketching is a way of recording information but with a little more flair. You can sketch to supplement painting information, as a travel journal or to improve your drawing skills. Sketch at every opportunity. Sketching sharpens your ability to record shapes, color and values. You will also develop eye-hand coordination, and, consequently, the ability to draw what you see more easily. Gradually you will develop a style or technique for sketching.

Try a variety of tools when sketching to find out what you like best. Use a pen, pencil, brush or marker. I like to use an almost dried-up felt-tip pen. You can get a variety of values and lines by applying different pressures to the paper. Brushing a little water onto some types of ink softens edges and lines and creates value changes. Pencils are always nice to use and come in various sizes and hardnesses. Try using a ballpoint pen with watercolor washes.

Sketchbooks, too, come in a wide range of sizes, textures and quality. I suggest buying only those made with quality paper.

TAKE YOUR SKETCHBOOK SERIOUSLY

It will help you in every aspect of your art. Keep and date your sketches and watch your improvement. Your sketches can be the foundation of your future paintings and they will add freshness to your studio work.

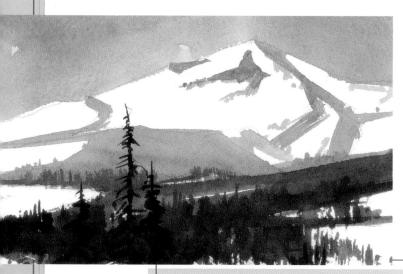

SNOW-CAPPED PEAK
Color sketch, 140-lb. (300gsm) cold-pressed paper
4" × 6¾" (10cm × 17cm)

WORKING FROM MEMORY

Work from your memory by exploring your imagination and experiences of the past. Try to imagine special images and how they would translate to watercolors. What made the memory special? Was it the color, place or event that made it memorable? The more familiar you are with an experience, the sharper the memory will be. The more emotion you have connected to a memory, the easier it will be for you to see. With practice you will become more observant.

APPROACHING YOUR PAINTING

Everything you do to improve your memory will improve your painting ability. Your imagination and memory will grow to complement each other. When you are ready to start painting, practice this approach:

- Paint loose to tight and light to dark.

- Paint large areas first and avoid using any detail. Try to capture the essence of the memory.

- Begin to define the large shapes with value and added detail.

- Keep the painting simple and arrange elements to your liking.

- Improvise what you cannot remember and paint the way you want it to look.

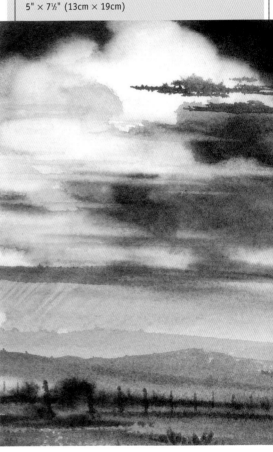

PASSING STORM—PAINTING FROM MEMORY
Watercolor on 300-lb. (640gsm) cold-pressed paper
5" × 7½" (13cm × 19cm)

Paint a Seascape from Memory
If you have spent a lot of time at the coast watching the waves and walking on the beach, you can probably remember a particular seascape pretty clearly. Try doing a painting of it from your memory. Study some photographic reference or think about a favorite scene. Visualize what you would like to paint. Then draw a quick thumbnail sketch to reinforce your memory and help plan your painting.

PHOTO REFERENCES

Using photographic references is an important part of the painting process. A photograph takes a three-dimensional subject, such as a landscape, and makes it two-dimensional. It is easier to paint a subject on a flat surface if the reference is flat because the changes of scale, perspective lines or distance values are easier to understand. When you turn the photo upside down to see shapes and values, you lose the sense of looking at a specific subject and interpret the negative and positive shapes more easily.

The camera allows you to capture images or situations when bad weather, a limited schedule or the complexity of the subject prevents you from painting it on location. A digital camera gives the advantage of seeing the image immediately. If the photo is not what you expected, you can delete it and take another shot.

Filing and Storing

Immediately file your prints or 35mm slides so you can easily find and use your reference. Don't waste valuable painting time by sifting through stacks of photographs. File subjects alphabetically, by location, season or any other suitable category. Plastic storage containers that fit 4" × 6" (10cm × 15cm) or 5" × 7" (13cm × 18cm) prints are great for filing. They are stackable and portable. Slides take less room to store

and, when kept in sleeves, are easily sorted and organized. Put them in a three-ring binder to transport them. Slides offer more accurate color than photographs, but a projector or light table is needed to view them.

Store Your Photos
Plastic storage box with 5" × 7" (13cm × 18cm) photographs

Camera Equipment
Digital cameras, interchangeable lenses and small Pentax

Create a Larger Image

Tape several 4" × 6" (10cm × 15cm) or 5" × 7" (13cm × 18cm) photographs together to create a larger image of a subject. This is helpful when you need a lot of close detail over a large area. Wide-angle lenses and panoramic cameras tend to distort images.

DON'T BE DEPENDENT

Although it might seem easy to become dependent on photographic reference, lose spontaneity and paint everything that is in the photo, the color or value in a photograph is not always accurate. The camera will expose for the light or dark values but not both. Highlights become washed out or shadows may fill in.

WORKING ON-SITE *and* IN THE STUDIO

Give yourself the option to paint on-site or in the studio. Watercolors are well suited for both situations.

On-Site Painting

The fast drying and portable characteristics of watercolors make them ideal for on-site painting. The spontaneity of this medium is well suited to nature's ever-changing conditions. On-site paintings can vary from thumbnail value sketches to large finished watercolors. Use on-site sketches as tools to complement your photographic reference or as fanciful, creative studies.

Studio Painting

Painting in the studio has the advantage of a controlled environment. No bugs, a constant light source and a bathroom that is readily available! You are limited to working from sketches and photographic reference, but you have all the time you need to do the drawing. The camera has helped develop the composition and focuses on the center of interest. Taking time in your studio to develop a good drawing can make the difference between a mediocre or successful painting.

DEVELOP YOUR CENTER OF INTEREST ON-SITE

Atmosphere and light are constantly changing when you're working outside. Finding and developing your center of interest is critical to the painting. Small on-site paintings will help you achieve a strong center of interest. Just follow these tips:

- Eliminate or move elements around.

- Don't show every detail.

- Set the shadows at the beginning of the painting. (As the light changes, keep the shadows the same.)

- Practice.

MUD FLATS AT BALLYCOTTON, IRELAND
Watercolor on 140-lb. (300gsm) cold-pressed paper
12" × 37½" (30cm × 95cm)

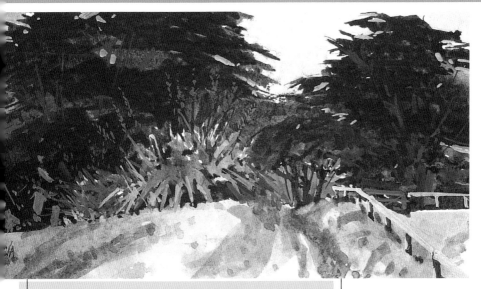

FLAX IN BLOOM, NEW ZEALAND (PAINTED ON LOCATION)
Watercolor sketchbook, 140-lb. (300gsm) cold-pressed paper
4" × 7½" (10cm × 19cm)

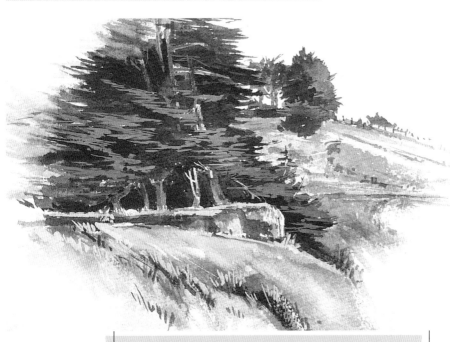

MENDOCINO HEADLANDS (PAINTED ON LOCATION)
Watercolor sketchbook, 80-lb. (168gsm) cold-pressed paper
8½" × 11" (22cm × 28cm)

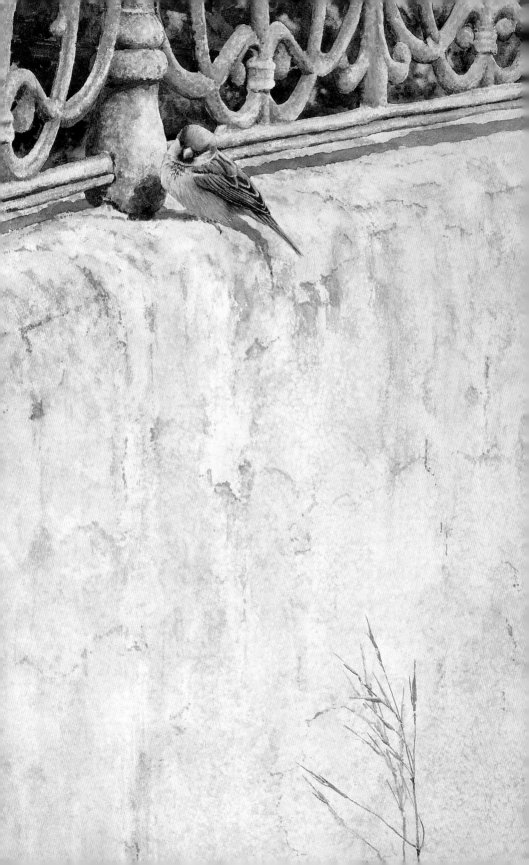

A Quick and Easy Guide to Compositions

The composition of a painting is what captures the viewer's attention. It is based on value, color, line, cropping, rhythm and balance, components that work together and take turns sharing the spotlight. Composition should consider all these components, but is based on two basic principles: the artist's knowledge of the rules of design and the use of intuition or instinct. The intuition aspect of composition is what makes each piece of art unique. Be willing to trust your instincts and intuition first.

Using your instinct adds flavor and creativity to your work. Move different parts of your painting around to emphasize or strengthen the composition until the painting feels right. The rules in composition are used to solve design problems, but rules can weaken or eliminate creativity. Think of them as the the foundation, but one that is not set in stone. When you are deciding on your composition, remember the saying, "rules are made to be broken." Trust your instincts!

ON SECOND THOUGHT
Watercolor on 300-lb. (640gsm) cold-pressed paper
23½" × 13" (60cm × 33cm)

ELEMENTS *of* DESIGN

A good composition keeps the viewer interested in the art by arranging all the parts of the image into a balanced, pleasing design. A poorly composed painting will cause the viewer to become bored or confused. Capture the imagination and attention of the viewer by using the elements of design.

Rhythm

This is the repetition of elements such as shape, color, value, line and pattern. It helps unify the different areas of the painting. However, there must be variety in the repetition or the image will become static and boring.

Balance

Good balance allows the viewer's eye to travel easily across the image. Create balance by giving the different elements equal emphasis. The variety of shapes and values, if well organized, will support the center of interest. The center of interest will be difficult to find if the balance is not correct.

Unity

Unity creates a visual relationship between the different elements in a painting. It brings all the elements together to form a cohesive balance. However, too much unity and similarity can result in an uninteresting design or composition. Then the eye will become bored and leave the painting—not the effect a good artist hopes to have. Ideally, the viewer focuses first on the center of interest and then naturally follows the composition through the painting.

Harmony

Harmony is the pleasing arrangement of all the individual parts of a painting. These parts could be theme, unity of elements or the use of color. Of these choices, color is most commonly used to create harmony. Colors must work together to create harmony. Artists use color harmony to create mood or an emotion. Analogous colors or those that are closely related on the wheel are especially good for this purpose. Snow scenes often use harmonious blues and sunsets consist of reds and oranges. Limiting color increases the likelihood of color harmony.

Eye Flow

Eye flow and composition depend on each other. If compositional elements fall short, eye flow is lost. The eye generally moves from left to right and top to bottom. The initial sketch or drawing provides a foundation to develop this movement, using elements such as mass, line, color and value. Visual pathways are formed and will lead the viewer in the desired direction. A road, path or river moving into the picture plane is the classic example.

BALANCE: The left and right side of the painting are balanced by value and the weight of the trees and foliage.

RHYTHM: The constant change of value and size of the trees carried across the painting creates rhythm in the composition.

UNITY: The overall use of color, value and eye flow unifies the painting.

HARMONY: Limited use of color creates harmony.

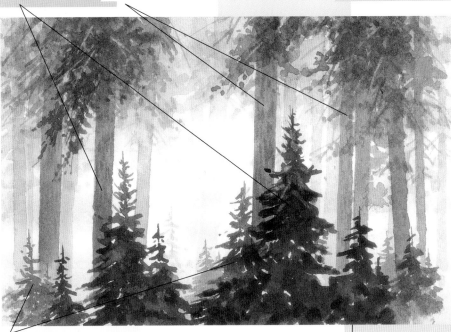

SYMMETRY VS. ASYMMETRY: Asymmetry is created by the change of scale, value and placement of the trees.

EYE FLOW: Eye flow is encouraged by the size and value of the foreground trees. The eye travels from left to right, moving up to the large trees. The dark foliage of the large trees travels across the painting, then downward. This could be considered an O composition, with elements of the steelyard composition included.

FOREST GLOW
Watercolor on 140-lb. (300gsm) cold-pressed paper
5" × 7½" (13cm × 19cm)

Symmetry vs. Asymmetry

To have a successful painting, symmetry and asymmetry must work together. A good composition or design will use both concepts. If your painting is too symmetrical, it will be stiff and boring and will lose its visual excitement.

Asymmetry refers to an imbalance of parts. It creates a tension that uses the imbalance to move the viewer through the painting. Used together, symmetry and asymmetry create a flow and rhythm throughout the painting.

VALUE *and* VALUE SCALES

Value is the term used for the relative lightness or darkness of an area. This range of value stretches from white to black. Within the range there is an infinite number of values, and to be successful, you should use a manageable number; between five and ten steps in value is a good range to use. Color also has value. Lemon yellow is light in value while French Ultramarine is dark in value. Therefore, the local color of the subject should be taken into consideration when painting. This could influence the composition of the painting. If you are working from a photograph and are not sure of the values, have a black and white copy made. In back and white, you will see the tonal values of the subject and not the color. This will help you compose, simplify and change values in your painting.

I like to use a gradated wash to create a value scale. It reflects how and what I like to paint. It is also easier to do! A value scale should go from the richest saturation of color to white, with a graduated transition from beginning to the end. Remember all colors have a full saturation value.

TO BUY OR TO MAKE?

Commercially made value scales can be purchased at most art stores, but making your own scale is a good and valuable lesson.

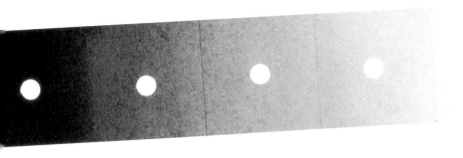

Create a Value Scale

Draw a 7½" × 1½"(19cm × 4cm) rectangle on your watercolor paper. Now create five 1½" (4cm) squares within this rectangle. Lay masking tape around the border of the rectangle and burnish it down. Use Lamp Black to create the scale; it is a nice flat black. Start the gradated wash (page 38) with a full saturation of black, using a 1" (25mm) flat brush. Now dilute this color by adding water to your brush. Do not rinse your brush. Only add water. With horizontal strokes, pull the color down. Keep diluting the color in your brush to the last square. The last square should be white. If you have used a lot of water in doing the gradated wash you can pick up the paper and tilt it back and forth to help smooth out any brushstrokes. Doing this and leaving the last square white will take practice. When the wash is dry, gently pull the tape away from the image. Redraw the 1½" (4cm) squares and, with a hole punch, put a hole in the center of each square. Put the scale up to your painting and look through the holes to see the color and value of your subject. Laminate the value scale and carry it with your art supplies. Make other value scales with different colors. It will help you see color, color temperature and value.

VARIATIONS

This scale works fundamentally the same as any value scale—allowing you to see light and dark values. Paint individual swatches of various values to produce a value scale. Cut squares from these values to create a five- or ten-step gradation. Glue the desired squares to a piece of paper and punch holes in the center of each square. Trim and laminate the value scale, and it is ready to use. From these, pick the three values. There must be a nice gradation from white to black. Cut 1" × 1" (2½cm × 2½cm) squares and permanently attach them to the 1" × 5" (2½cm × 13cm) rectangle. With a hole punch, place a hole in the center of each step or value. Use the hole to see a color's relative value on the gray scale.

SEE LOCAL COLOR AS VALUE

Local color is the actual color being viewed. A green tree or red apple is an example of local color. Hue refers to the general name and use of the color. Local color also has a specific value and light causes this value to change from area to area. An apple is red but it has a highlight, middle value and shadow. Each area may have a different value, but the local color is still red. In the outdoors, the time of day influences the local color and value of the subject. Early or late light is warmer. Midday sun is bluer and lighter.

Local color is also influenced by the colors or values that surround it. The focal point will be lost in the background if the local color is too close in value to the areas surrounding it. If you see a painting with lots of color, yet it looks flat, the artist did not control the values of the color. Use local color to guide the viewer's eye to the center of interest and direct it toward the area of highest contrast. When used correctly in a composition, local color makes a painting that is pleasing and dynamic to the viewer.

Local Color

Local color is the value and color of the subject being viewed. Shadows influence and change local color.

PONGA FOREST—BRIDAL VEIL FALLS, NEW ZEALAND
Watercolor on 140-lb. (300gsm) cold-pressed paper

FOCAL POINT

The center of interest, or focal point—the main or dominant subject in the painting—is the place where you want to direct the viewer's attention. It is important that only one point dominates the composition. If more than one dominates, the viewer will be confused or bored and will move on. Situate the focal point on any visual plane in the composition: the foreground, middle ground or background. When the focal point is in the background or middle ground, the artist asks the viewer to move into the picture plane. In a portrait, the center of interest (the person) is in the foreground and the eyes quite often become the focal point. Make the areas that surround the focal point less important by using weaker values, less detail, patterns or color. You can also use these elements in combination with each other.

Artistic License

Deciding on a focal point or center of interest often requires the use of artistic license. In a landscape you may need to move, eliminate or exaggerate what really exists. In a still life you may need to subdue the shapes, color and values to emphasize or establish the center of interest.

Rule of Thirds

Using the rule of thirds is a good way of establishing a focal point. You do this by dividing the picture plane into thirds with vertical and horizontal lines. These divisions establish four points of interest. This in conjunction with other elements of composition will direct the viewer to one of these points.

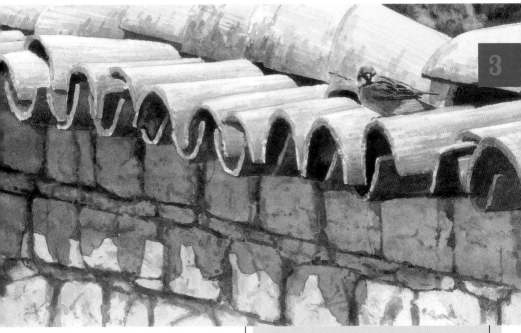

Break up Repetition

In this painting the bird is the focal point. It changes the repetition of shapes. I used this rule to place the bird in the focal point. It is often better to eyeball or guess at the focal point than being mathematically correct.

SPANISH TILE
Watercolor on 140-lb. (300gsm) cold-pressed paper
5" × 9" (13cm × 23cm)

RECOGNIZE CONTRAST

Contrast is the distance of a value range. The contrast can be from white to black or anywhere in between. Strong contrast is important because it allows you to see how the image is formed. The higher the contrast, the more basic the shape becomes. Learn to see the value patterns that describe shape. A strong light source creates a distinctive subject with strong shadow patterns. A soft light source is less dramatic, with diffused shadows, and creates a moodier effect. Contrast helps the viewer differentiate between the subjects and the background and directs the viewer's eye to the center of interest, because it is the point of highest contrast. To see a light area, surround it with dark value. To see a dark area, surround it with light value. This is the fundamental concept behind painting negative and positive shapes.

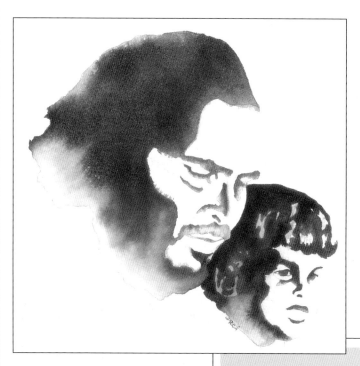

Strong Contrast Describes Shapes
I used contrast to eliminate unnecessary detail while painting the two faces. I created negative and positive shapes to describe the features of each person.

THE BOYS
Watercolor on 300-lb. (640gsm) rough watercolor paper
6" × 6" (15cm × 15cm)

DETERMINING MOOD

Mood in a painting conveys emotions to the viewer. A bright, vibrant painting may convey joy or excitement. Reds, oranges may make you feel warm, while blues and violets convey cold or coolness or sorrow. You can also create mood with spatial design: Large, empty areas in a painting may create a sense of ease or openness. Converging lines may make you feel closed in or confined.

Color and Value

Mood generally has a tonal range or value. These ranges are called low key, high key and middle key. A low key painting tends to be dark and conveys a heavy or somber feeling. A high key painting is the opposite, with bright and cheerful colors. Middle key paintings use a wider range of values and consequently have the most possibilities for paintings.

Analogous Colors

These are colors that are closely related on the color wheel. A snow scene might use a very limited color and value range. The general temperature of the colors is basically the same.

Glazing

Glazing a wash of color over the entire painting unifies the elements. Applying the wash first can create the same effect, setting the mood or atmosphere for the rest of the painting.

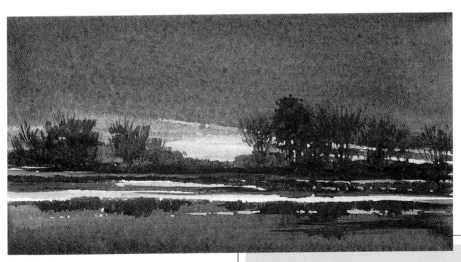

Set the Mood
Mood is the emotional side of painting. Dramatic colors and values help create the mood.

6:15 A.M. AND RISING
Watercolor on 140-lb. (300gsm) cold-pressed paper
4" × 7⅞" (10cm × 19cm)

SEEING SHAPES

When you see shapes, you are seeing line or mass. Line or mass describes the characteristics of a particular item. A contour line easily describes a shoe or vase. The mass or shape of shadows easily describes a face. A high contrast photo is a good example of this. By seeing shapes you can see the interaction of positive and negative forms. To make an image read successfully, the positive and negative areas must have balance and good design.

Practice Seeing Shapes

Look at an object and squint. By squinting, you eliminate unnecessary details and see your subject as light and dark masses. Use this technique while painting outdoors. When using a photograph, find your shapes by placing tracing paper over the image. Draw the contours of the shapes. Use a felt-tip pen to fill in the positive shapes. Do a second drawing and fill in the negative space. Repeat to fill in your shadows.

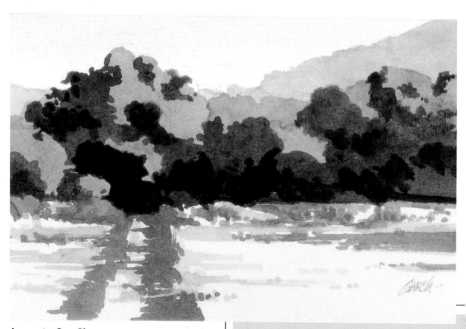

Learn to See Shapes
Eliminate all detail to see shapes. Create flat planes and look only at the value.

SEEING SHAPES
Watercolor on 140-lb. (300gsm) cold-pressed paper
5½" × 7½" (14cm × 19cm)

NEGATIVE SPACE

A painting is composed of negative and positive shapes. Thoroughly understanding the positive shapes determines how well you understand the negative space. Negative shapes are created by the space around and between the positive shapes. You can recognize negative space more easily when positive shapes are strong and visible. Use negative shapes to support, describe and define form. Think of them as the opposite of a silhouette. In this case, the background is a dark value. The contrast makes the positive shapes stand out. Use negative space to move the viewer's eye around the picture plane. In a composition, you want to create a pleasing balance between the negative and positive shapes. This balance creates eye flow with a sense of harmony and rhythm, and ultimately gives the composition unity.

Qualities of Negative Space
Negative space should have interesting shapes and support the center of interest.

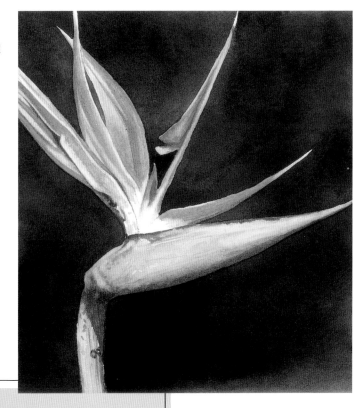

BIRD OF PARADISE
Watercolor on 140-lb. (300gsm) cold-pressed paper
6" × 5½" (15cm × 14cm)

DETERMINING FORMAT

Format sets the boundaries for the painting composition. It determines if a painting has a closed or open design. A closed format fully contains the subject matter. An open format allows the subject to leave or break the edge of the design. The three most often used formats are horizontal, vertical and square.

Horizontal Format

The horizontal format allows the viewer to move across the design. It conveys the sense of reading a book. The horizontal format is most often used for landscapes. Because of the proportions and sense of eye flow, landscapes work well with this format.

Vertical Format

The vertical format is often called the portrait format. It allows the eye to move up and down the picture plane, focusing on the detail of the head and eyes of the subject.

Try reversing the general use of these formats. Do some vertical landscapes and horizontal portraits. You can create some unusual and interesting designs.

Square Format

The square format is less frequently used because its shape gives the feeling of steadiness and balance. Balance creates an equal or static repetition of area and the working area becomes less visually interesting. The balance in a square also wants the viewer to find the focal point in the exact center of the format. To create a successful painting a square needs a strong center of interest to break the balance of equal sides and shapes. Try using a viewfinder or do a sketch to create a dynamic composition with this format.

ELIMINATE EXTRA INFORMATION

Use any of the following items to help eliminate unnecessary visual information and focus on the center of interest.

- A quick pencil sketch as you look through your camera's viewfinder helps you capture the essence of the design.

- Empty 35mm slide holder.

- Old matboard that has been cut at the corners. The mat can be held up and adjusted to create a vertical, horizontal or square window to look through.

- *View Catcher* is a commercially made format guide that works well.

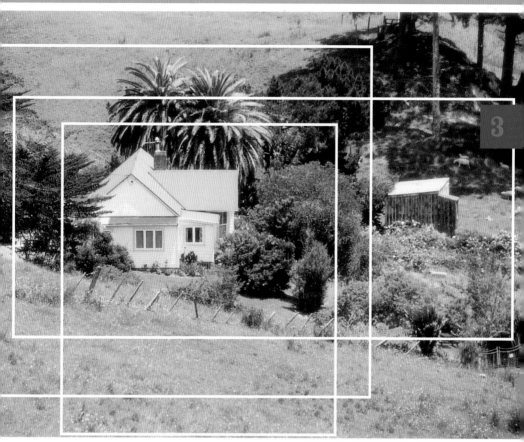

Discover Format Possibilities

In this photograph of a farmhouse in New Zealand, you can see that a square, horizontal or vertical format can be developed from almost any image.

5 EASY COMPOSITION FORMULAS

Composition is the framework of your picture. It gives your art flow, direction and stability. Have the confidence to move and adjust objects to fit your composition. Do not feel locked into what you see. Good composition creates unity and a pleasing design. Without this, all else fails.

Composition is based on an assortment of forms or types of design principles. These principles may vary and overlap, but they are seldom used as a single design element. Some of the most common design principles are: the rule of thirds; pyramid or triangle; steelyard; "S," "O" or Circle; "three spot;"and radiating lines.

Rule of Thirds

Artists use the rule of thirds design principle to develop a well-organized and easy-to-use composition. The rule

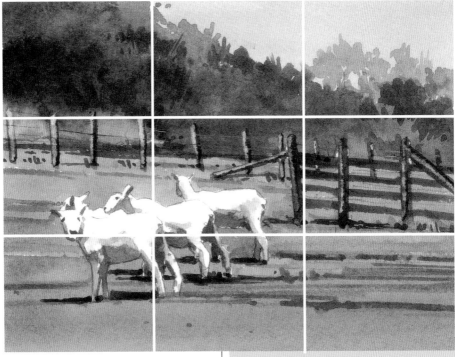

Rule of Thirds Composition
The center of interest should fall on or be near one of the four focal points created by the intersecting lines.

SHEARING SEASON
Watercolor on 140-lb. (300gsm) cold-pressed paper
5" × 7" (13cm × 18cm)

Triangle or Pyramid Composition
The center of interest and eye flow follow the general shape of the triangle. Secondary elements generally support this directional movement.

of thirds is a traditional way of finding an appropriate place for the center of interest or focal point. Artists have used it for hundreds of years to find the point with the strongest visual impact. Develop the rule of thirds in a composition by visually estimating or mathematically dividing the picture plane into thirds, both vertically and horizontally. The intersections of these lines are the focal points. This process also keeps the center of interest away from the edges.

Pyramid or Triangle

This shape naturally gives a composition a feeling of stability. It can be developed by the use of line, mass or points. The center of interest will fall within or near the top of the pyramid. The triangular shape directs the eye around the composition. Combine this rule with the three spot or circle compositions.

Steelyard

Visualize a teeter-totter or a bar balanced on a point. The bar is unevenly placed on the point. A large weight or image is on the short side of the bar. A smaller weight or image is on the long end of the bar. The distance to the center point balances the size of the images. The line or space between the two images becomes the visual link. Since the two images visually relate, their value needs to be similar.

Circle (or "O")

The name implies the look of the composition. Either line, edge, mass or value work well to move the eye around the composition. As the eye moves

around the outside edge of the composition, the center of interest is found on or inside the circle. It is not found in the center. This works well with the rule of thirds or pyramid compositions.

"S"

This form of composition relies on line, mass or value to lead the eye to the center of interest. It uses graceful curves to suggest rhythm and movement between areas of the composition. The center of interest is placed on or near the convergence of the lines. Rivers, roads and paths are good subjects for "S" compositions, which are often used in designing landscape paintings. The "S" leads the eye back into the painting.

IN THE SHADOW
Watercolor on 140-lb. (300gsm) cold-pressed paper
5" × 7½" (13cm × 19cm)

Steelyard Composition
This is the most popular of the composition formats, easily used because of the balance and eye flow.

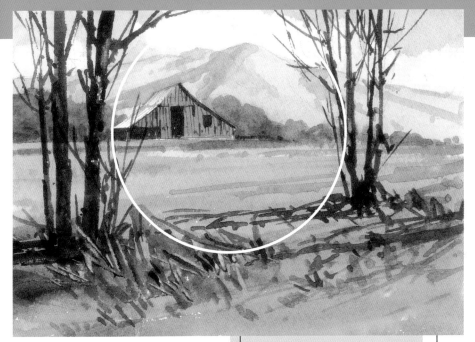

Circle Composition
This composition surrounds and captures the subject.

COUNTRY BARN
Watercolor on 140-lb. (300gsm) cold-pressed paper
5" × 7" (13cm × 18cm)

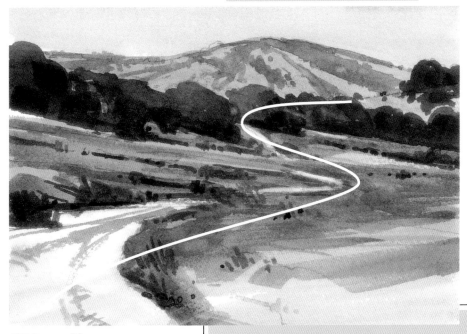

"S" Composition
Landscape artists use this composition frequently. The "S" shape brings the viewer's eye into the picture and leads it to the focal point.

DISTANT MOUNTAIN
Watercolor on 140-lb. (300gsm) cold-pressed paper
5" × 7" (13cm × 18cm)

EDITING FOR STRONG COMPOSITION

It is often difficult to analyze the composition in a subject. There can be too much information, which makes the composition visually confusing. You can develop a strong, dynamic composition by editing your image. Thumbnail sketches help in editing because they eliminate unnecessary detail and capture the essence of the subject. Use thumbnails as a starting point in developing a vertical or horizontal format. After making a thumbnail, create a comprehensive, detailed sketch to develop the value and line elements of the design. Edit and develop the composition as you work toward the painting process.

You can also use a commercial viewfinder to isolate and edit unwanted information. If you don't want to buy one, use an empty slide holder or an old mat.

Practice developing your personal expression, or artistic license. Subjects seldom come ready to paint, especially when you're painting a landscape. (Mother Nature supplies too much information.) You must eliminate unnecessary elements. In a still life, you can move or adjust objects to strengthen the composition. You can also change or edit textures and values to accent the focal point.

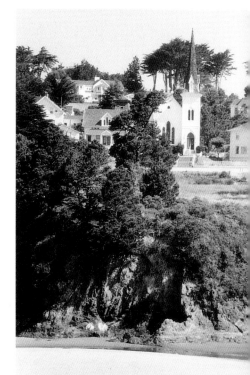

The Tower, Reference Photo
Reference photograph

USE A VIEWFINDER

A commercial viewfinder looks like a square mat with one adjustable side. By sliding the adjustable edge in and out you can create your own format. The viewfinder should be large enough to easily hold and look through. A good viewfinder will also have standard frame sizes marked along the edge. This helps give you reference sizes to paint by. Crop into the image by extending your arm and looking through the viewfinder.

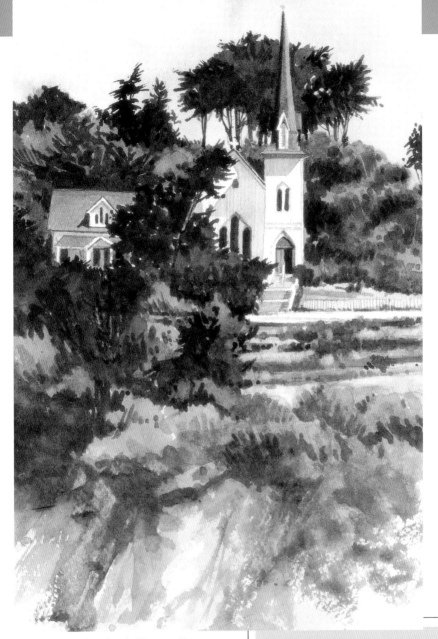

Edit Features You Don't Want to Use

With this painting I took out unwanted buildings and simplified areas of foliage, especially near the church tower. I also simplified the cliff and vignette areas in the lower right side of the photograph. By doing this I was able to create a path for the viewers eye to move from the bottom of the painting upwards toward the building.

THE TOWER (MENDOCINO, CALIFORNIA)
Watercolor on 140-lb. (300gsm) cold-pressed paper
5½" × 8½" (14cm × 22cm)

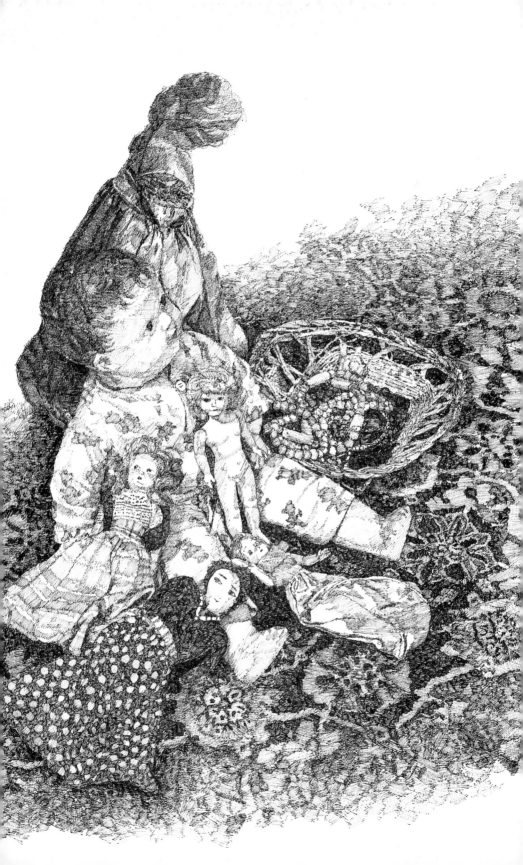

Drawing Techniques

Drawing is a quick and easy way to express an idea. By learning this basic skill, you will develop confidence and have success in your paintings. The more time devoted to drawing, the easier and more enjoyable it becomes. Set aside time for practice. If possible, work at it every day, even if it is for just fifteen minutes. You will be amazed at how quickly you improve. Start today and you will develop a lifetime of enjoyment and pleasure.

Start with simple subjects. You will discover that most objects can be created from the basic shapes: a sphere, cube, cylinder or cone. Think of the tissue box or book as a lengthened or flattened cube, an arm or tree limb as a cylinder. See the basic shape first and it will be easier to draw the subject. Creating thumbnails, sketches, value studies and contour drawings all develop your ability to see and strengthen your drawing skills.

Experiment with different materials. Use a graphite pencil and sketch pad first. As you improve and build confidence, try a variety of pencils and pens. Charcoal, Conté, and pastels are all very expressive, but there are no rules in your choice of materials—choose whatever suits you.

THE DOLL COLLECTION
Technical pen and India ink on blotter paper
17" x 22" (43cm x 56cm)

57

SKETCHING

Sketching plays an important role in developing drawing skills by capturing ideas. Sketching helps you look for and isolate subjects, and eliminate unwanted objects from a composition. The more often you sketch, the more proficient you will become.

You can sketch in line or value. A graphite pencil is expressive and creates a variety of values with shading. Pen and ink work well but they can be difficult to show halftones. An almost dry felt-tip pen is a wonderful sketching tool.

The subject may also influence what medium you use. A delicate teacup could be done with a 2H graphite pencil, while an old building might require a broad carpenter's pencil. Try sketching the same subject at different times, for instance, landscapes at various times of the day or year. The idea is to sketch wherever you are, as often as possible. Capture ideas and memories in a sketchbook. A few written notes with a drawing add information and interest. Your sketchbook can contain ideas for future paintings, and also serve as a journal of your travels. When you fill an entire book, look at it as a body of work and forget how well the individual pages turned out.

PICK A SKETCHBOOK

Hardbound sketchbook: Protects the pages and has better quality paper.

Large sketchbook: If it's too large, it becomes a burden to carry and attracts unwanted attention.

Small sketchbook: Is great for thumbnails. Too small a book limits your ability to capture the subject or idea.

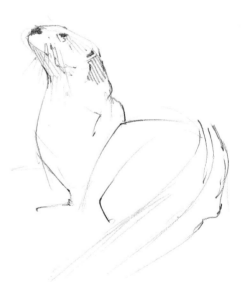

Soft and Expressive
This graphite pencil sketch requires full arm movement to get the flowing line movement. Minimal lines capture the graceful characteristics of the animal. Spray graphite drawings with a fixative to prevent smudging.

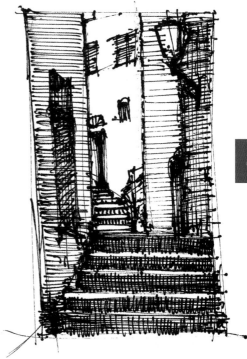

Fast Sketching
I drew this tower on location with very little time to sketch.

Create Values in Your Sketch
I used crosshatching to create values in this pen-and-ink sketch. It was difficult to create halftones and took longer to do the sketch than it should have.

Capture Basic Shapes
You must see through the subject to capture the basic shapes. These sketches require full arm movement. As the structure is established, you can add linear detail.

SKETCHING WHILE YOU WAIT

Always be prepared to sketch. You can sketch anywhere and with just a few simple materials. Take advantage of time waiting for food in a restaurant or while standing in line. Opportunities to sketch abound, not only because ours is a society profuse with waiting rooms, but because sketching can be done so quickly. Record the large shapes and forget about any detail. Sketch on anything that is available—cocktail napkins, memos, envelopes, anything. You may not always have a sketchbook handy, but don't let that stop you.

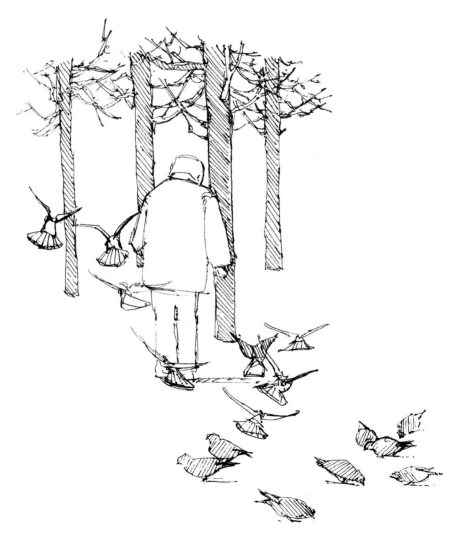

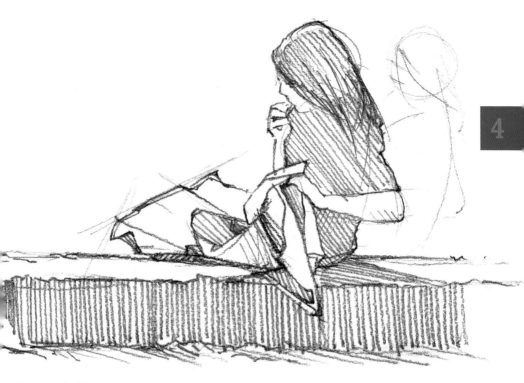

Capture the Moment

I was in a very small New Zealand costal village looking for a place to have lunch. The fish and chip shops are wonderful. The fish are caught from local waters and served wrapped in newspaper. We received our order and decided to eat in the park. The young girl who had ordered her lunch before us was sitting on the seawall across the street. Without disturbing her I took a couple of photos. I grabbed a watercolor pad and quickly laid out a loose pencil sketch. I never know when a subject will catch my eye. This sketch is more for memories than a painting—I will use the photos for that.

◀ **Sketch Quickly**

I sketched only the man and worked quickly as he fed the pigeons. I'll add trees and birds at my leisure and as the composition dictates.

> ## TAKE NOTES
>
> If I am sketching for a painting I may also include color or texture notes. I will also write mood or weather notes to help in the translation to a painting.

THUMBNAILS

Thumbnails are small, quick idea sketches. They are your first step in creating either a painting or final drawing. Use them to capture a situation without any detail—they are useful to develop compositions quickly, because they capture only the large elements such as gesture or compositional flow. Do several thumbnails before moving on to a more comprehensive sketch. Thumbnails sketches are not limited to any medium. However, because they are done so quickly, graphite lends itself particularly well to this technique. Graphite can be smudged and erased to create values. Colored felt-tip pens also work well because it's possible to vary line value and width.

Create a Values-Only Thumbnail
This thumbnail is a little large but very effective. It is a values-only sketch with a definite background, foreground and middle ground. I spent only two to three minutes on this thumbnail.

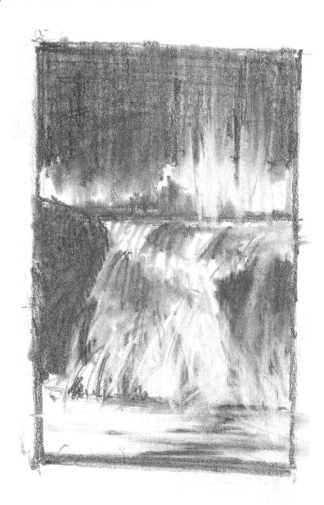

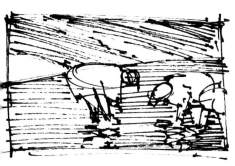
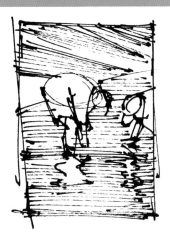

Sketch Quick Thumbnails
A quick thumbnail focuses on the subjects and
helps define a vertical or horizontal format.

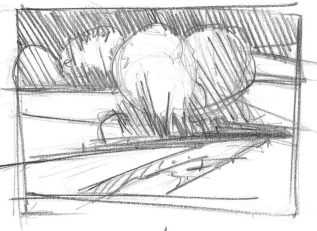

**Use a Thumbnail to
Create a Composition**
Varying your view of a
subject by moving a few
feet in one direction or
the other can make a
great deal of difference
in the success of your
drawing or painting. A
thumbnail can quickly
help you decide where to
set up to paint or draw.

GESTURE DRAWINGS

Gesture drawing is the technique that helps to capture movement within a composition. It also refers to how the viewer's eye moves around the format of your painting or drawing, rather than statically focusing on a subject or capturing a particular shape. Try not to overwork a gesture sketch. You can use line, value or shapes, but focus only on the overall movement. The movement can often be the preliminary idea for a painting. Use this technique in thumbnails or sketches to capture the flow throughout the composition.

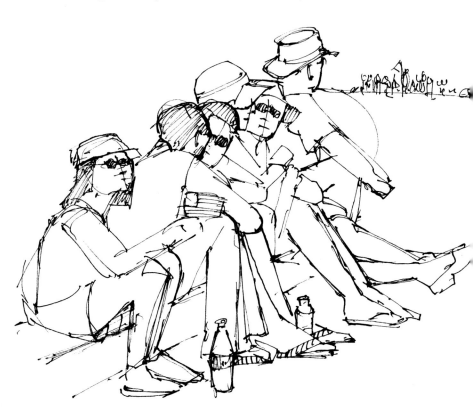

Capture Shapes and Values With a Quick Gesture Drawing
The dark values move into the drawing and surround the subject. The lighter values break up areas and move the viewer's focus from area to area. The top of the sketch will be cropped for the final painting, because, as is, the clothesline and handrail split the image in half. This demonstrates the value of a small study.

◀ **Use Gesture as a Guide**
This gesture drawing has too much detail but captures the idea of gesture nonetheless. It shows the direction of the bodies in size as well as leaning. The legs and arms move toward the center of the figures. This central core swings upward toward the approaching parade.

CONTOUR DRAWINGS

Contour drawings help develop eye-hand coordination, teaching you to look carefully at what you see and translate that to the surface of the paper. Try to keep focused on the subject as much as possible, only occasionally looking at the paper. Move the line around the outside of the subject. Rely on your instincts to tell you where your pen or pencil is on the paper. Start with simple subjects and work up to more complicated ones. With practice, you will achieve very pleasing drawings.

Eliminate Detail With Contour Drawings
Vala is a friend's dog that wanted to be painted. He actually wanted to play and would wait for attention. I used a contour drawing to capture his image with only a short period of time available. The contour drawing eliminated all detail and caught the basic shape of the animal. I use this technique to practice eye-hand coordination. It also helps me remember what I see. It is strictly a drawing technique and not meant to have composition or value information.

4

Warm Up With Contour Drawings

I find contour drawings difficult. If I use a large marker it makes me simplify the subject by eliminating any detail. If you are just beginning to contour draw, this is a good way to practice. A subject like an apple, orange or pear has very little detail, but requires skill in capturing the shape. I like to use this drawing method as a warm up technique for more complicated sketches.

ADVANCED DRAWINGS

A final or advanced drawing can range from a nicely executed sketch to a finely executed drawing. You can draw in pen and ink, pencil, charcoal or any medium of your choosing. I recommend graphite—it's convenient, versatile, inexpensive and permanent.

Study your subject to pick the best vantage point. Look for shadow pat-terns that help define your drawing. Decide on the composition by using thumbnails to find gesture, shadows and scale. Using your arm from the shoulder down, block in large areas to establish basic shapes. As you develop these areas, movement will be more confined to the wrist and hand.

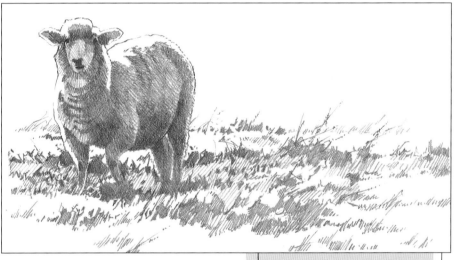

Use Dark and Light Values
I used a linear crosshatch technique to create this drawing. Little detail is shown, relying on strong light and dark patterns to describe the features. The softer graphite was used for the darker values. Since there is not a wide range of values only three degrees of hardness were used.

WOOLY
Brystol 4-ply cold-pressed paper
3½" × 6¼" (9cm × 16cm)

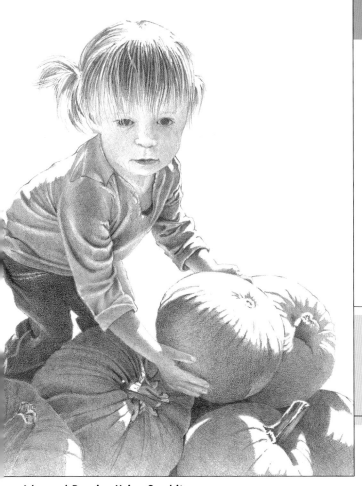

LITTLE PUMPKIN PICKER
5H through 3B graphite pencils, Brystol 4-ply cold-pressed paper
6¾" × 5¾"
(17cm × 15cm)

Advanced Drawing Using Graphite

This drawing required a range of graphite pencils from 5H to 3B. Each value is placed down in a crosshatch technique until all lines are no longer visible. Crosshatching fills in any texture on the surface of the paper and a nice clean value is achieved. The light on the face may require one or two different pencils to reach the correct value. To achieve the value on the dark area of the pants, I used the full range of pencils. This also demonstrates that you do not necessarily push harder on a pencil to get a darker value. Too much pressure with a hard pencil scores or dents the surface of the paper, creating unwanted texture.

Make a Value Chart

I used an H graphite pencil to demonstrate the crosshatching method of getting a value. The shirt in *Little Pumpkin Picker* required 4H through 2B to get the values.

69

LINE TECHNIQUE

You can use many different mediums to create line and all are very expressive. Experiment and find the one that suits your style. Your subject may also be best represented by a certain line choice. I drew *The Doll Collection* (page 56) with a technical pen on very soft, absorbent blotter paper. This helped achieve an old-fashioned look. I used soft pencils on *Wooly* (page 68) with a visible linear crosshatch technique. Combine different techniques to create effective textures. Use permanent, non-fading inks with archival paper so your work will stand the test of time.

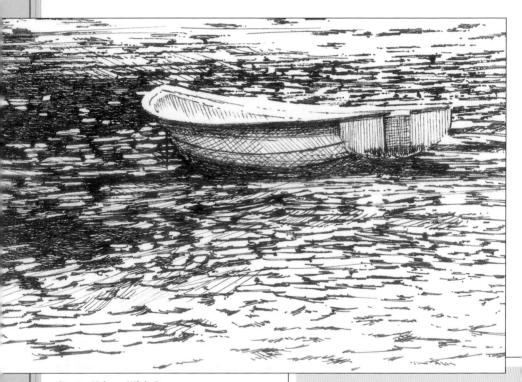

Create Values With Pens
It is difficult to achieve value changes with a pen; try using crosshatching or directional lines.

AT ANCHOR
Pigma Micron archival ink pen, 4-ply cold-pressed paper
4½" × 7" (11cm × 18cm)

4

Notice Line Weight and Direction

Achieve numerous line weights by varying the pressure you put on the quill pen. Use a cross-hatch technique to create the dark values. Line direction and weight proved an important aspect in drawing the clouds.

CLOUDY DAY
Quill pen and India ink, 4-ply cold-pressed paper
7" × 4½" (18cm × 11cm)

PROPORTION

Proportion in art is the relationship of one part to another or as it relates to the whole. You can see this in size, quantity or degree. If you are discussing the proportion of a building or tree, for instance, you may say it is three times as high as it is wide. You have stated its proportions. The success of this rela-tionship has a great deal to do with the overall harmony of the artwork.

HISTORICAL PROPORTION

Vitruvian Man by Leonardo da Vinci is another example of harmonious proportions.

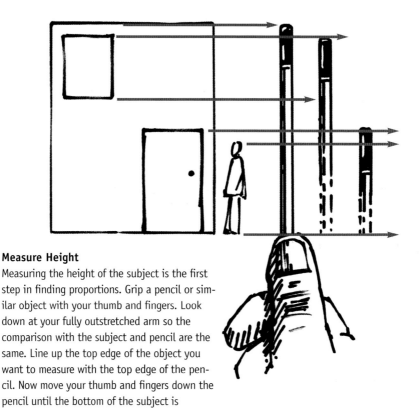

Measure Height

Measuring the height of the subject is the first step in finding proportions. Grip a pencil or sim-ilar object with your thumb and fingers. Look down at your fully outstretched arm so the comparison with the subject and pencil are the same. Line up the top edge of the object you want to measure with the top edge of the pen-cil. Now move your thumb and fingers down the pencil until the bottom of the subject is reached. You have established a height that can be related to a line or area in your drawing. Now compare the height with the width and you have estab-lished proportions within your work. You can now establish other heights and widths such as doors and windows.

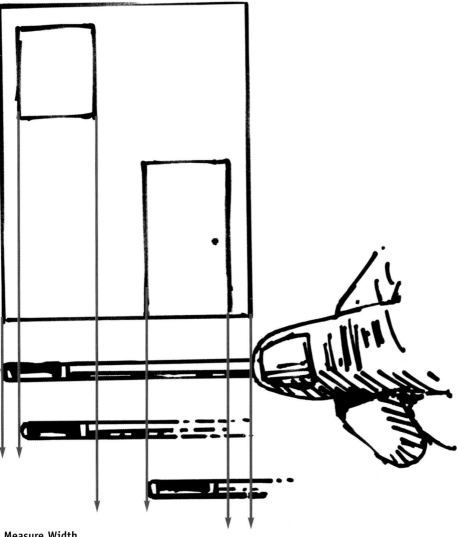

Measure Width

Finding the width is done in the same manner as the height. Once the width is established, you can compare that line to the height. You are now measuring and establishing proportions.

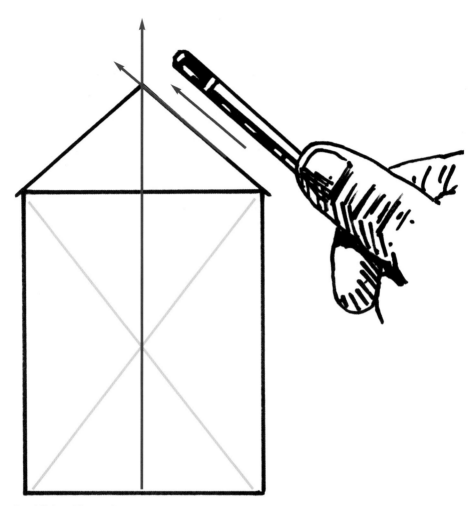

Establish a Diagonal

Use your pencil in the same manner you would to measure height and width. With your arm outstretched, hold the pencil so it parallels the diagonal. Transfer this diagonal to your drawing. This illustration also shows how to find the center of a rectangle. A vertical line through this center establishes how the height of a roof is found in conjunction with the diagonal.

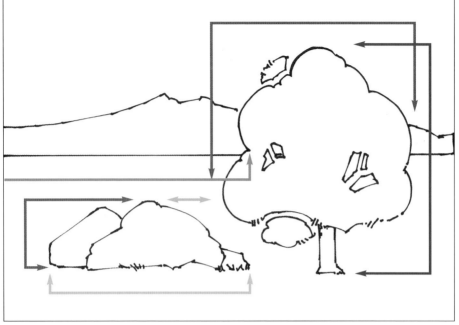

Find Proportions

The proportions of all elements for a drawing can be found easily. Use your extended-arm technique to measure and find various proportions. Compare the height of the tree to its width and the height of the rocks to their width.

LINEAR PERSPECTIVE

Perspective is what gives depth to a drawing or painting. The basic rule or concept of perspective is that receding parallel lines converge at a point on the horizon. This spot is called a vanishing point. The most common types of linear perspective are one- and two-point, named for the number of vanishing points involved. Railroad tracks, roads, telephone poles and fences are often used to demonstrate this concept. As objects move back in perspective, they grow proportionately smaller and closer together. Sketching the receding lines is better than plotting them. You just need to know where and why they are going there.

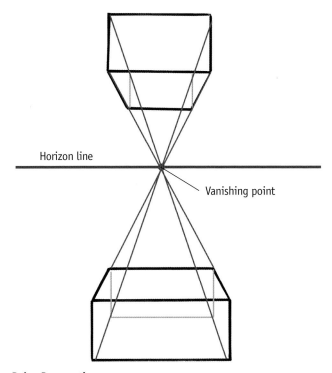

Horizon line

Vanishing point

One-Point Perspective

One-point perspective demonstrates how parallel lines go to a vanishing point. The horizon line is where your eyes look straight ahead. All horizontal lines are parallel to the horizon line. Converging parallel lines above the horizon line go down to the vanishing point, and those below the horizon line go up to the vanishing point.

Perspective consists of a horizon line (also called the eye-level line), a vanishing point and converging parallel lines. Vertical lines are at right angles to the horizon line. If you are looking up at your subject, you have a low horizon. If you are looking down on your subject, the horizon is high. Any converging parallel lines recede to a vanishing point.

Atmospheric perspective is a general rule which simply states that objects or planes receding into the background lose value and have less detail. In painting, colors become less intense and will shift to a blue-gray. But remember, rules are made to be broken.

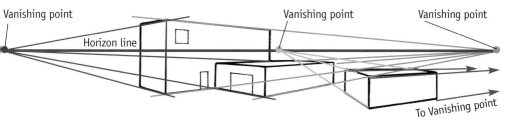

Two-Point Perspective

Two-point perspective consists of a horizon line, vertical lines and two vanishing points. The converging parallel lines go to their respective vanishing points. The vanishing point can be a visible point on the horizon line or may be situated at some spot off the paper. A box or rectangle that sits at a different angle from the primary rectangle will have different vanishing points. Plotting a subject in perspective is tedious and unnecessary. Learn the principle and sketch the perspective lines. You will have more fun!

TRANSFERRING *an* IMAGE

Transfer Paper

The best and easiest way to transfer a drawing or sketch to watercolor paper is to use a graphite transfer sheet. This is a commercially made paper that has a thin coating of graphite on its underside. When you draw on the top side of the paper, a line is transferred to the surface on which it has been placed. Some transfer papers have an oily residue that resists watercolor.

Projectors

Projectors, such as opaque, overhead or slide, make it easy to transfer drawings and adjust their size. However, it can sometimes causes you to follow the reference too closely. Don't be afraid to change or alter what is projected.

Grid System

To use the grid system, first create reference points on a grid over the drawing or reference to be enlarged or reduced. Then simply follow the points. This is an easy system to use, especially when you're working with several drawings or pieces of reference. Do the initial drawing on tracing paper. Lay additional sheets over the first drawing to easily see and adjust the original drawing. Continue to refine the drawing in this way until it is satisfactory. Then transfer the drawing with graphite paper to your watercolor paper.

DIY TRANSFER PAPER

To make your own transfer paper, cover the back of medium-weight tracing paper using a pencil or powdered graphite. Smudge the graphite around the paper, then soak bestine or lighter fluid on a cotton swab and rub the graphite. This causes the graphite to adhere to the paper. It is less likely to smudge or smear onto your watercolor paper but easily transfers to another page when pressed with a sharp pencil. If you are concerned with the graphite showing through your painting, use a colored pencil or pastel (instead of graphite) that is compatible with the colors with which you plan to paint. The lines will be less likely to distract.

Taped to support Final drawing

Graphite transfer paper Watercolor paper

Using Transfer Paper

Position a sketch or drawing on watercolor paper. Tape down the watercolor paper and sketch so they don't shift while transferring the drawing. Slide the graphite sheet facedown between the two papers. Trace the drawing with a 2H or 3H pencil. A sharp pencil will transfer a clean thin line. Don't press too hard or you will score the watercolor paper. Before removing the drawing, check that everything has transferred.

Using a Grid

Place a grid of any dimension over the reference. The grid on the sheep is based on a ½" (12cm) scale. By doing this you have created a series of reference points that can transfer to a larger or smaller grid. Follow as many of these points as possible and you will have successfully enlarged or reduced the reference.

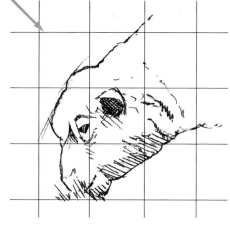

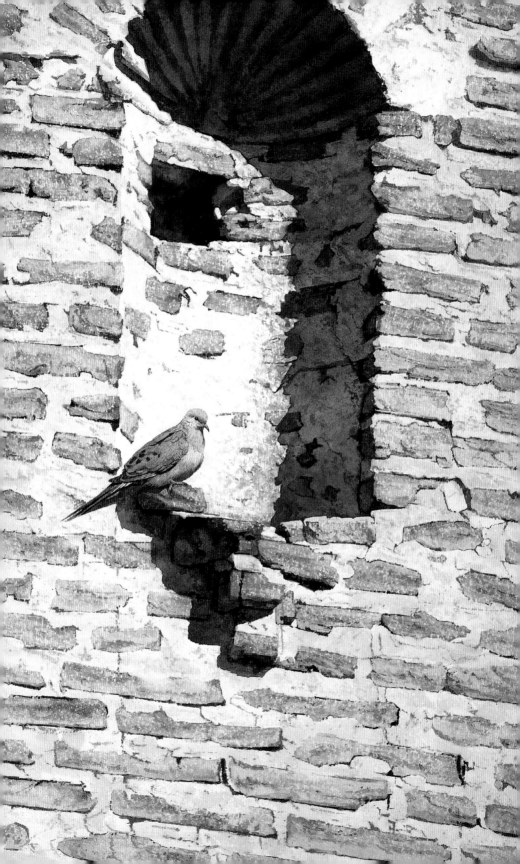

Paint Properties and Techniques

Learning how to control the medium is the most important aspect of painting with watercolors. Going from an idea to a finished painting is impossible and frustrating without control. Your style or technique can go from a very controlled dry brush approach to a spontaneous wet-into-wet method of painting. Some general rules that will help you develop technique are: Plan your painting, keep the colors transparent and work loose to tight and light to dark. The more you paint and become comfortable with the medium, the more easily you will be able to translate your technique and ideas to paper. Most experienced watercolorists will tell you that painting loosely and expressively is not much more than a series of controlled accidents. The satisfaction of glazing colors to create a rich vibrant painting is priceless.

SHADOWS OF TUMACACORI
Watercolor on 300-lb. (640gsm) cold-pressed paper
27" × 16½" (69cm x 42cm)

SATURATED *and* UNSATURATED COLORS

Saturation describes the vividness of a color. Pure colors (those that represent the red, yellow and blue colors on the color wheel) such as Cadmium Yellow, Permanent Rose and French Ultramarine are highly saturated. An unsaturated color has low purity and is dull; grayed colors have low saturation.

Using Saturated Colors

To make a saturated color appear brighter or more intense, place it in an area surrounded by neutral or unsaturated colors. Use this technique when painting landscapes or tonal paintings. Try painting the majority of the picture in unsaturated, muted colors with the focal point in bright, saturated colors. Using too many highly saturated colors causes them to compete with one another, making it difficult to focus on the center of interest. Saturated colors do not allow the viewer's eye to travel smoothly through the painting and cause the eye to bounce from one intense color to the next.

COLOR NAMES

Staining colors (page 86) are generally considered highly intense or fully saturated colors. These intense colors often have a trade name such as Winsor Yellow (Winsor & Newton) or Thalo Blue (Grumbacher). Colors that are considered unsaturated are earth colors such as Yellow Ochre, Burnt Umber, Brown Madder, Alizarin Crimson, Olive Green and Indigo.

Mixing Saturated Colors

When you mix a highly saturated color with another color, it loses saturation and will never recover its full vividness. Two saturated colors that are next to each other on the color wheel begin to lose saturation when mixed together. Mixing a complementary color with a saturated color immediately causes the saturated color to lose its intensity. You can also use a black, neutral tint or earth color to make an unsaturated color. Such additions begin to change the hue, which may or may not be the desired effect.

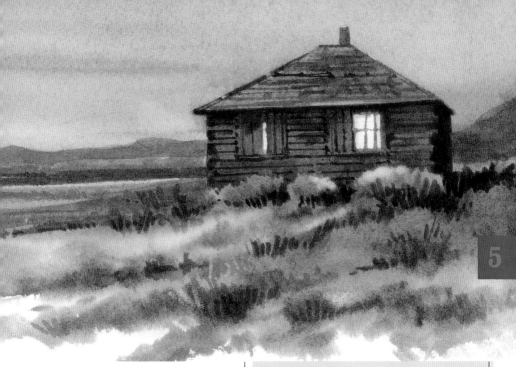

Emphasizing Saturated Colors

In this painting I used unsaturated colors to create an evening setting. Then I emphasized the window with the saturated color of Cadmium Yellow. I also lifted color from the brush area below the window and glazed a little Cadmium Yellow back into the area of lifted color. This gave the effect of light coming through the window.

END OF THE DAY
Watercolor on 140-lb. (300gsm) cold-pressed paper
4½" × 7¼" (11cm × 18cm)

SATURATED AND UNSATURATED COLORS

SATURATED COLORS

| New Gamboge | Permanent Rose | French Ultramarine Blue |

UNSATURATED COLORS

| Burnt Sienna | Olive Green | Indigo |

83

TRANSPARENCY *and* OPACITY

The characteristic of each watercolor varies from extremely transparent to opaque. The transparency of a hue is determined by how much light goes through the pigment and is reflected back to the surface of the paper to the viewer's eye.

Transparent Colors

Transparent colors mix well with other colors and reduce the opacity of opaque colors. Glaze an opaque colors over transparent colors because the pigment of an opaque color lays on the surface and is more easily lifted or reactivated when you apply a wash over it.

DISCOVER COLOR CHARACTERISTICS

Practice glazing with different pigments, transparent colors over transparent colors or opaque over transparent colors. See how the color tends to lift if you glaze a transparent color over an opaque. Create "mud" and see how flat and dull the color is. The key to success is practice. The more you understand the paints, the more success you will have in painting!

PAPER SURFACE

The paper surface absorbs transparent colors more than opaque colors, but it depends on how much sizing the paper had. Glazing transparent colors has a greater effect on the paper with little or no surface sizing (soft paper) than paper with a lot of surface sizing.

Opaque Colors

Opaque and semiopaque colors work a little differently. They allow less light to reach the paper surface, making them look less vibrant. Particles of the pigments lay on the paper surface causing three specific effects:

1. Mixing two or more opaque colors can produce "mud," which dulls transparency.
2. Opaque and semiopaque colors can generally be lifted or reactivated.
3. Granulation is a wonderful texture created by the pigment settling from a wash into the low areas of the paper, and can occur with opaque colors. Experience teaches which pigments granulate and how much water to use to create this effect.

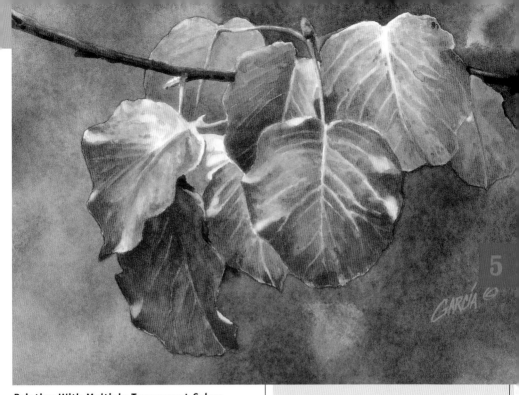

Painting With Multiple Transparent Colors

I painted these leaves with transparent Winsor & Newton Aureolin Yellow, Permanent Rose, Alizarin Crimson and Mauve.

FALL COLOR
Watercolor on 140-lb. (300gsm) cold-pressed paper
5¾" × 8" (15cm × 20cm)

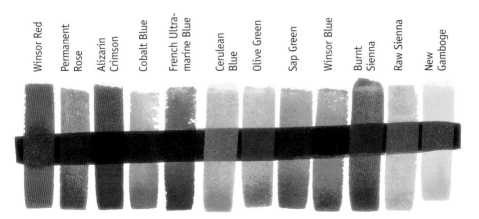

Winsor Red | Permanent Rose | Alizarin Crimson | Cobalt Blue | French Ultra-marine Blue | Cerulean Blue | Olive Green | Sap Green | Winsor Blue | Burnt Sienna | Raw Sienna | New Gamboge

Opaque and Transparent Color Characteristics

Each manufacturer's hue varies in transparency and opacity. Create a color chart to become more familiar with each color's transparency. Paint a bar of black waterproof India ink. Allow the ink to dry thoroughly. Paint swatches of color over the black bar. When the paint dries, you will be able to see the transparency or opacity of each color. Most organic and synthetic colors are very transparent, while earth colors tend to be semi-opaque or opaque.

STAINING *and* NONSTAINING COLORS

Learning how the color reacts to your surface is critical to the success of your painting. Colors have the property to stain or not stain. This characteristic affects the techniques that you use in your paintings. For example, if you want to lift out paint the way I did in the sky area of *Homeward Bound* it's best to use a non-staining color.

Nonstaining Colors

Nonstaining colors tend to be the most versatile of the hues. They have the most ability to create luminosity, the extent to which light passes through the pigment, strikes the painting surface and is reflected back to the eye. Glazes and washes of nonstaining pigments always capture this luminosity.

Staining Colors

Staining colors soak into the surface and cannot be totally removed. You can scrape, scrub or sand the surface, but it will still retain some of the pigment.

Add the staining pigment last because it greatly influences the color with which you mix it—a little pigment goes a long way. Staining colors mix well together. They are highly transparent, and when mixed as glazes they retain their luminosity.

Surface and Sizing

This staining ability is also affected by the painting surface. Three hundred pound (640gsm) paper absorbs a stain more deeply than lighter-weight paper does. It is much more difficult to lift a color—staining or nonstaining—from this paper than from the surface of a 140-lb. (300gsm) paper. Sizing also affects the staining ability of a color. Surface sizing does not allow as much of the pigment to be absorbed into the paper. A softer, more absorbent inner-sized paper receives a stain more readily. You can buy a commercially made sizing agent and apply it to the paper to make it less absorbent.

Work With Staining and Nonstaining Colors

I painted the sky with transparent Winsor & Newton Permanent Rose and Cobalt Blue, and the grass and reeds with Winsor & Newton Sap Green and Brown Madder. I used a flat, soft ¾-inch (19mm) flat to lift color.

HOMEWARD BOUND
Watercolor on 140-lb. (300gsm) cold-pressed paper
4½" × 7¼" (11cm × 18cm)

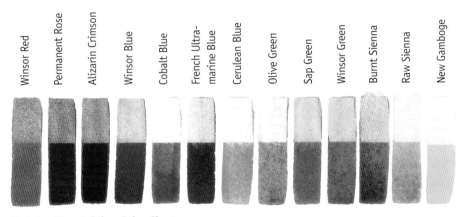

Winsor Red · Permanent Rose · Alizarin Crimson · Winsor Blue · Cobalt Blue · French Ultramarine Blue · Cerulean Blue · Olive Green · Sap Green · Winsor Green · Burnt Sienna · Raw Sienna · New Gamboge

Staining/Nonstaining Color Chart

With each color on your palette, paint an approximately ½" × 1¾" (12mm × 44mm) swatch. Allow the colors to dry thoroughly. Mask out approximately half of the swatch with masking tape. Now use a damp brush to scrub out as much pigment as possible without damaging the surface. With a paper towel or facial tissue, gently lift the moisture from the scrubbed area. Arches watercolor paper holds up best to the abuse of scrubbing and taping. Be extremely careful when removing tape from a softer paper.

WET-INTO-WET

The wet-into-wet wash—painting on a wet surface and letting colors blend as they may—is the essence of transparent watercolor painting. I like to call it "controlled accidents." Control comes from knowing the amount of water on the surface and how to use it. Paper texture and weight also play roles. On hot-pressed paper, colors float and remain on the surface. Cold-pressed and rough papers are more absorbent.

A wet-into-wet wash looks strong and vibrant while wet but loses intensity when the colors dry. Always make your washes stronger to compensate.

Create Soft Effects With Wet-Into-Wet Washes
I covered the surface with a wet-into-wet wash. As the wash dried, I added color to create the soft effect of the brush, still working wet-into-wet. I applied salt to add texture. When the paper was completely dry, I added the reeds and heron and then glazed over the entire lower portion of the painting to differentiate the value from the sky. The glaze helped bring this area forward. It is easier to control the richness and intensity of the wash when working with a small painting. A large painting requires more paint to be mixed, which tends to become diluted when placed on the wet surface of the paper.

DAY'S FINAL LIGHT
Watercolor on 140-lb. (300gsm) cold-pressed board
4¾" × 8" (12cm × 20cm)

Wet-Into-Wet Wash

1 | Completely saturate the paper with water. Be careful to wet the surface evenly; this affects the success of the wash. Mix a large solution of color on the palette. Use the largest appropriate size brush available to apply the color. If it's too wet, you have little control of the wash; too dry, and the wash will not flow freely.

5

2 | While the surface is wet, add a second and third color. If the wash is doing what you want, lay the painting flat and allow it to dry. If you want more blending, pick up the wash and tilt and move it to control the flow of color on the surface.

3 | When the desired effect is reached, allow the painting to dry. If you use a hair dryer to dry the surface, be careful not to blow the wash around.

WET-INTO-DRY

A wet-into-dry wash is another term for a glaze, or layering wash. This term, wet-into-dry, can be applied to any wash that is applied to a dry surface. When doing a wet-into-dry wash, try not to reactivate or lift pigment that has already been applied to the paper.

A very transparent wet-into-dry wash creates a third color or value when glazed over a wash. A wet-into-dry wash glazed over an overactive texture subdues the texture but allows it to be seen.

Build Color and Value
I painted the terra-cotta pot with a series of wet-into-dry washes, starting with Aureolin Yellow and Permanent Rose, followed by a final wash of Cobalt Blue and Permanent Rose to create the shadow on the pot. I painted the green leaves with a series of washes layered to create negative and positive shapes. The floor is a series of very transparent wet-into-dry washes of New Gamboge and Permanent Rose. I painted the dark cast shadow with a wet-into-dry wash of Cobalt Blue, Permanent Rose and French Ultramarine. Much care was taken to avoid reactivating the lower washes.

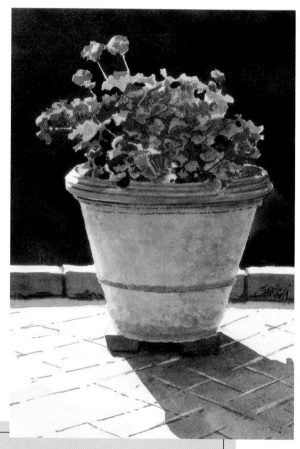

AN ITALIAN BOUQUET
Watercolor on 140-lb. (300gsm) cold-pressed paper
8" × 5½" (20cm × 14cm)

Examples of Wet-Into-Dry Washes

This is a series of wet-into-dry washes. Apply Aureolin Yellow on three-fourths of the paper and allow it to dry. Next glaze a wash of Permanent Rose over part of the Aureolin Yellow. Glaze a transparent wash of Cobalt Blue over the yellow and red. All are wet-into-dry washes.

Paint a wet-into-wet wash of Cobalt Blue, Burnt Sienna and Olive Green. When this wash is completely dry, apply a dark wet-into-dry wash of Sap Green and French Ultramarine Blue. Use this technique to layer values and create negative or positive shapes.

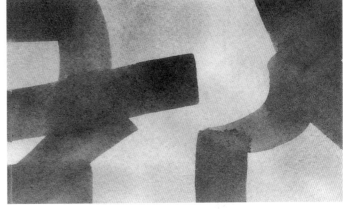

Subdue a very busy wet-into-wet wash of Cobalt Blue, Brown Madder and salt texture with a wet-into-dry wash. Glaze the first wash with French Ultramarine Blue, allowing a small amount of texture to show through. This technique can be controlled by the transparency of the wet-into-dry wash. Don't reactivate the texture.

DRYBRUSH

Drybrush is brushwork done on the dry surface of the paper. This technique is influenced by the type of paper and brush used and the creativity of the artist. Smooth paper (hot-pressed), lightly textured (cold-pressed) and heavily textured (rough) respond differently to dry-brush textures. You can push, pull, drag or dab paint to create dry-brush textures. It does not have to be done with a brush—try a sponge.

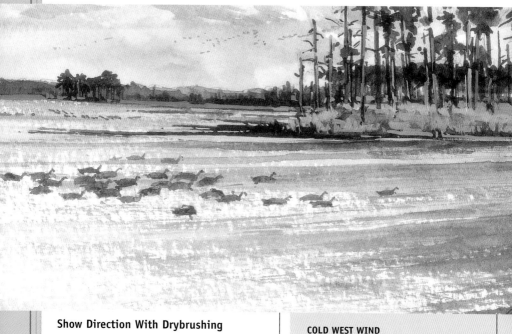

Show Direction With Drybrushing

I painted this on location with a dry-brush technique to emphasize the strong directional flow of the wind. I worked the painting from the background forward and painted the geese last. I dragged a partially loaded brush from right to left several times, lifting each stroke slightly while applying less pressure. The dragging caught the paper texture and created the choppy water. A steady, quick hand is required.

COLD WEST WIND
Watercolor on 140-lb. (300gsm) paper
4" × 7½" (10cm × 19cm)

Examples of Dry-Brush Technique

Drag a ¾-inch (19mm) flat, loaded with pigment across the surface of the paper. Layer various colors over the surface to create an old board or wood texture. A little sponge or spattering adds to the effect.

Drag a flat brush across the surface. Encourage the strokes to blend together. Turn this texture in different directions. It could be the texture of a waterfall or the sparkle on the surface of water.

Pull a large round brush over the surface of the paper. Cold-pressed 300-lb. (640gsm) paper works well for these textures.

FLAT WASHES

A flat wash is made from brushing successive strokes of color on a wet or dry surface. Each stroke is placed next to the other, creating an even layer of color. Of the three washes—gradated, variegated and flat—the flat wash is the easiest to do. All three washes can cover an entire sheet of paper or be placed in a very specific area. Use a large round or flat brush to apply the wash. Use the tip or end of the brush so its heel doesn't damage the soft, wet paper.

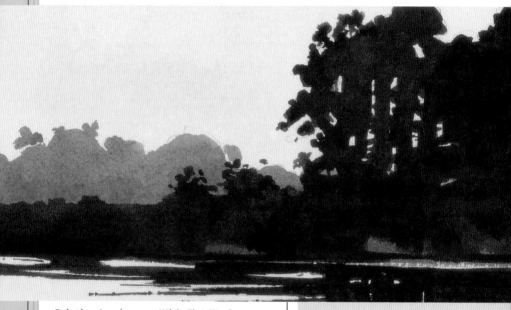

Painting Landscapes With Flat Washes
I used a 1-inch (25mm) flat to apply a flat wash of a mixture of Indian Yellow and Raw Sienna. I saturated the watercolor paper with clean water to keep the wash from drying too quickly. The middle ground is a flat wash of Cobalt Blue, Viridian and Permanent Rose in a medium value. In the final step I added a rich mixture of Alizarin Crimson, French Ultramarine Blue and Winsor Green as a silhouette in the foreground. This is a flat wash with a little variation to add interest.

LOW COUNTRY SUNSET (SKETCH)
Watercolor on 140-lb. (300gsm)
cold-pressed paper
4" × 8" (10cm × 20cm)

Creating a Flat Wash

1 | Mix a large amount of color on your palette—more than you expect to use.

2 | Start at the top and quickly brush horizontally to the bottom of the wash.

3 | Fill in the desired area as evenly as possible. Try to keep a consistent amount of moisture from top to bottom.

4 | Use vertical strokes to recover the area. Be careful to keep the wash transparent.

5 | Pick up the wash and tilt it from side to side and top to bottom to eliminate unwanted brushstrokes. If paint builds up along the edge, lift it out with a damp brush.

GRADATED WASHES

The value in a gradated wash changes from dark to light. Add water to dilute the pigment and make the value change. You can create a smooth transition with practice, but it's not always necessary. This wash can be started on a wet or dry surface. It is generally easier to work on a premoistened surface.

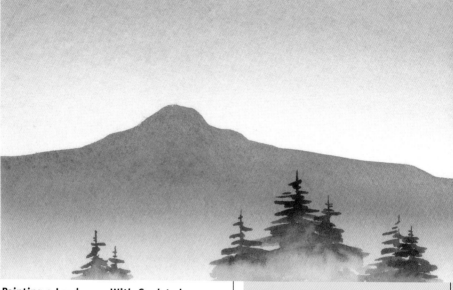

Painting a Landscape With Gradated Washes

The sky wash is Cobalt Blue on a premoistened surface, applied with a 1-inch (25mm) flat. Add water to dilute the color as you work it down the wash. Pick up the paper and tilt it from side to side, top to bottom to eliminate unwanted brushstrokes. Allow the wash to completely dry.

The mountains are a wash of French Ultramarine Blue applied in the same manner as the background. Remove excess water with a tissue, paper towel or damp brush to prevent blossoms on the edge of the wash.

The trees are a gradated wash applied unevenly. Do this by adding water to the wash without allowing it to even out.

MOUNTAIN AND TREES (SKETCH)
Watercolor on 140-lb. (300gsm) cold-pressed paper
4" × 7" (10cm × 18cm)

Creating a Gradated Wash

1 | Apply a rich stroke of color to the top of the wash. Use a large round or flat brush.

2 | Begin to dilute the color by adding clean water to the wash. Start to work toward the bottom of the wash.

3 | Move down and continue adding clean water to the wash. When you reach the bottom, there should be a slight amount of pigment left in the wash. Practice eliminating unnecessary brushstrokes. If streaks appear, the surface is too dry. Remember to pick up excess water.

VARIEGATED WASHES

A variegated wash is a type of wet-into-wet wash. The variegated wash tends to place colors side by side; then mix and blend them only along their edges (whereas a standard wet-into-wet wash blends much more of the overall color).

NEW GAMBOGE + PERM ROSE

Use Variegated Washes for Wet-Into-Wet Texture

Apply the wash top to bottom using Cobalt Blue and a mixture of New Gamboge and Permanent Rose. Wet the surface before applying the color. Control the blending to maintain the variegated wash. Paint the silhouette of the boat with a mixture of Alizarin Crimson, French Ultramarine Blue and Winsor Green.

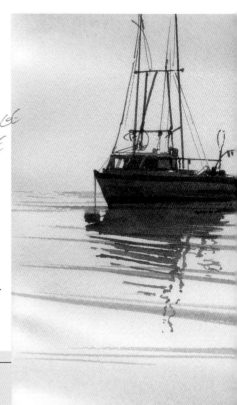

AT ANCHOR
Watercolor on 140-lb. (300gsm)
cold-pressed paper
7½" × 5" (19cm × 13cm)

BRUSH LINE (SKETCH)
Watercolor on 140-lb. (300gsm)
cold-pressed paper
3" × 6" (8cm × 15cm)

Use Two Washes

This is a combination of wet-into-wet and variegated washes. The sky is a soft wet-into-wet wash, allowing the colors to blend softly together. The line of foliage, while still a wet-into-wet wash, shows more control and the colors only slightly blend. The Olive Green edges also softly blend with the Burnt Sienna in this controlled manner.

Creating a Variegated Wash

1 | On a damp, saturated paper, place areas of Sap Green and Raw Sienna side by side.

2 | While the surface is still wet, add Cerulean Blue. There should be enough moisture left on the surface to allow the colors to slightly blend.

3 | Pick up the wash and tilt it side to side, back and forth to control blending.

GLAZING *and* LAYERING

Glazing and layering are basically the same process. They change value and direct the viewer's eye. Glazing uses very thin, transparent washes of one color over another color. Glazing with a warm transparent color creates a luminous, glowing glaze. Starting with a cool color gives a heavier, denser glaze. Use glazing as a means to unify a painting, add mood or change areas of color.

Use layering to apply premixed colors over another wash to change values or intensity. Layering is also used to direct the eye through value placement.

Controlling Technique

To glaze and layer, start with a completely dry surface. Premix your colors on a palette and keep brushstrokes to a minimum or the underlying pigment will reactivate and blend with the glaze, destroying the luminosity you are trying to achieve. Glazing and layering are more easily controlled on heavier watercolor paper. This paper absorbs the pigment more deeply and the paint is reactivated less easily. On a smooth surface, color lifts easily but is more difficult to glaze.

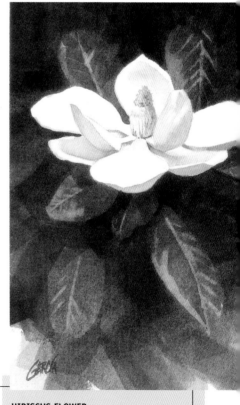

Create a Flower With Layers and Glazes

I drew the flower and leaves with a 3H pencil, arranging the leaves to lead the viewer's eye into the painting. I created the shadows on the flower petals with a series of glazes, starting with Permanent Rose, then Raw Sienna and finally Cobalt Blue. This creates a rich, transparent shadow color. I layered rich premixed color to create deep, dark values in the background to control eye movement. I lifted color to highlight the leaves.

HIBISCUS FLOWER
Watercolor on 140-lb. (300gsm)
cold-pressed paper
8" × 5½" (20cm × 14cm)

Glazing and Layering

Glazing

1 | Paint very thin transparent bars of color on your paper; I used Permanent Rose, Cobalt Blue and Aureolin Yellow.

2 | Paint thin glazes, using the same colors across the original bars. Note how values change and secondary colors are created. When warm colors are below the cool glaze, colors are more vibrant and transparent.

Repeat the exercise, combining the three original colors with three new colors. Try this with all your favorite colors.

Layering Washes

1 | Create a wet-into-wet, gradated or flat wash. Let it dry.

2 | Glaze a premixed color or value over the original wash.

3 | Glaze or layer a series of washes over the initial wash to build up values. Too many layers will result in an opaque, flat finish. Be careful not to reactivate the earlier washes.

101

BRUSHWORK

Brushwork can be as varied and creative as the artist chooses. Round, flat, bristle, synthetic and sable brushes all serve various purposes in the hands of the artist. They become the artist's creative tools. Experience will help you decide which brushes work best for you. I have found 80% of the time I use two flats—¾-inch (19mm) and 1-inch (25mm)—and three rounds—nos. 4, 6 and 8. I keep old brushes for scrubbing and lifting. Generally, rounds are for detail and washes and flats are for washes and texture, but they are often interchangeable. I use synthetic brushes almost exclusively because they are durable, can take a lot of punishment and are inexpensive to replace. Time and your technique will dictate your choice of favorite brushes.

PALETTE KNIVES

Using a palette knife is not a technique recommended for soft paper.

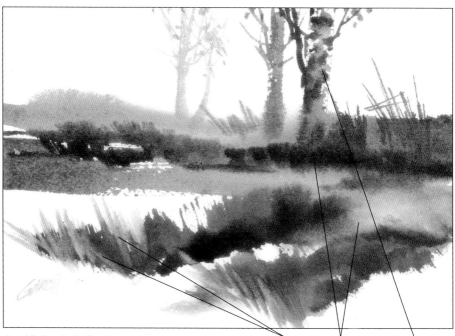

Combining Techniques
Take a few minutes to experiment with texture on a piece of scrap paper. This sketch illustrates a wet-into-wet wash, drybrushing, lifting, scrubbing and dabbing with a variety of brushes.

Lifting Wet into wet Drybrush

Hold a 1-inch (25mm) flat vertically and pull down to create dry-brush textures.

Create these textures with nos. 6 and 8 rounds.

Use a liner for the thin textures. Cut the tip of an old no. 6 round and press it down on the paper to create the texture using Raw Sienna.

Create these textures with a rigger brush.

Create these textures with a palette knife; while the paper surface is still damp, remove paint with the knife tip.

Use the palette knife to add pigment to the paper surface.

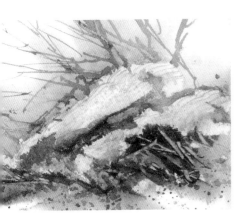

Palette Knife Textures

Place a wet-into-wet wash on the paper; wait until it has dried slightly to damp. Use the knife like a squeegee (a credit card will also work) and drag it across the page. If any part of the paper is too wet, the pigment and water will flow back over it, leaving a dark scar. Create the twigs at the base of the rocks by pulling the tip of the knife through the damp paint. Create the texture above the rock by loading the knife edge with paint and pulling it across the paper.

CREATING VARIED EDGES

Hard and Soft Edges

A hard edge defines a shape or a series of shapes. The eye focuses on a hard edge and follows the direction of its movement. A hard edge also holds a viewer's eye much longer than a soft edge does.

Fading or disappearing edges are called soft edges. They are often used to describe distance, as in atmospheric perspective. Contrary to the more descriptive hard edge, soft edges allow the viewer to imagine and interpret areas. They also denote movement while hard edges define stability.

Lost and Found Edges

These edges—also called broken or inferred edges—both create and suggest movement. Lost and found edges keep an area from becoming static and allow the viewer to move freely throughout the painting.

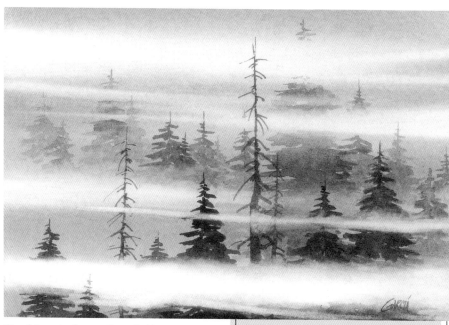

Use Edges to Accent Your Subject
This is a series of lost and found, hard and soft edges. The edges of the trees appear and disappear and accent the softness of the mist. The viewer can imagine shapes and edges and move through the painting.

FOREST MIST
Watercolor on 140-lb. (300gsm)
cold-pressed paper
5½" × 8" (14cm × 20cm)

104

Create Soft and Hard, Lost and Found Edges

Soft edges convey a sense or feeling of distance, especially in a landscape. Hard edges move into the foreground and tend to stop and direct eye flow.

Soft edges create a sense of movement. They allow the viewer to imagine or interpret what he or she sees. Hard edges describe shapes.

Lost and found edges move the viewer through a painting. By breaking an edge, they add variety and movement to an area.

5

LIFTING PAINT

Lifting paint can correct mistakes, develop textures, create highlights and change values in a painting. You can lift paint while it's wet or dry. A wet surface that has not allowed all the pigment and color to settle lifts more easily. While the surface is wet, use paper towels, tissue, sponges or brushes to lift color. A dry surface requires more work. First rewet the pigment, then gently scrub.

PAINTING SURFACES

The type of painting surface you're working on influences lifting. Color lifts immediately from hot-pressed paper, but 300-lb. (640gsm) cold-pressed and rough paper absorb the pigment and make lifting color more difficult. Lifting can damage softer papers.

Lifting Color With a Brush
I placed a soft wet-into-wet wash of Cobalt Blue, Permanent Rose and Raw Sienna on the paper. As the pigment settled into the paper I used a ¾-inch (19mm) synthetic flat brush to lift color. As the wash continued to dry, more edges were defined. Where appropriate, I used tissue to lift additional color. After the surface was completely dry, I painted the branches and, with a small no. 2 synthetic brush, lifted off color around the branches.

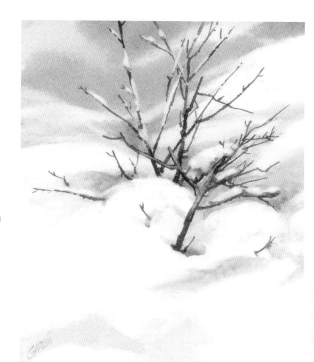

DEEP SNOW
Watercolor on 140-lb. (300gsm) cold-pressed paper
6½" × 5½" (17cm × 14cm)

Practice Lifting Color

Use a soft synthetic brush to lift color from a dry, wet-into-wet wash. Use a tissue and synthetic brushes of various sizes to pick up the reactivated pigment.

Drop water onto a damp, wet-into-wet wash. Use a soft synthetic brush to gently scrub and lift color.

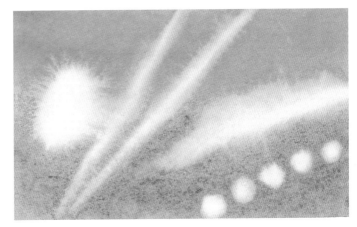

Use a flat ¾-inch (19mm) synthetic brush to apply water, gently scrub and lift color.

Lifting Color With Tissue

It's important for a watercolorist to learn how to use tissue or paper towels to lift color. The lifting ability of paper towels and tissue differs greatly; tissue is much more absorbent. Have both available.

Use Tissue and Paper Towels to Lift Color

Crush paper towels into shapes and press over the surface of the wash while it is still wet. This technique is good for depicting ice on a window or pond. The paper towel's surface texture is left on the watercolor paper when color is lifted from the wash, leaving a good or bad surprise.

Use a soft tissue to create shapes. I used Olive Green and French Ultramarine Blue in this graduated wash. Lift immediately after the wash is applied to remove a majority of the wash.

Shape paper towels and press onto the surface of the paper. Allow the pigment to soak into the surface and lightly stain the paper. I used Raw Sienna and Permanent Rose here.

Lifting Color With Paper Towels and Tissue

I used paper towels and tissue to lift color from a wet-into-wet wash of French Ultramarine Blue, Cobalt Blue and Winsor Green. I shaped a paper towel and pressed it onto the wash, then used tissue in the smaller areas. A darker value was brushed onto the curl of the wave, and color lifted with a soft flat synthetic brush in the direction of the wind.

MIDNIGHT OCEAN
Watercolor on 140-lb. (300gsm)
cold-pressed paper
4" × 8" (10cm × 20cm)

SCRUBBING

Scrubbing is a dry-brush technique used to both lift pigment from an area and add pigment to one. Load a flat synthetic or medium-size bristle brush with pigment. Gently scrub or push the brush over the surface of the paper. You can also hold the brush at a low angle to the paper. Use an old brush for best results.

Cold-pressed or rough paper is recommended for this technique.

SCRUB GENTLY

Scrubbing too long or hard damages the surface of the paper.

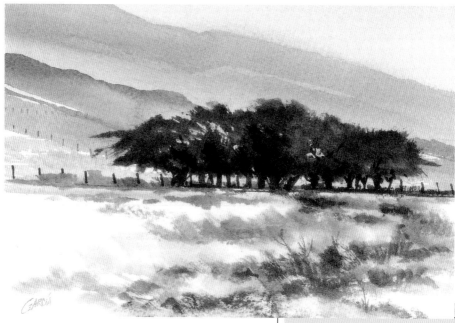

Use Scrubbing to Create Various Effects
This sketch was painted from the background forward, loose to tight. I used 300-lb. (640gsm) cold-pressed paper to take advantage of the texture of the paper. I scrubbed the trees onto the dry surface of the paper using a ¾-inch (19mm) synthetic flat. The scrubbing follows the direction of the foliage. I scrubbed the foreground onto a damp surface. When the paper was dry, I scrubbed it with additional color. Use the scrubbing technique to create texture on rocks, walls and other surfaces and structures.

FENCE LINE
Watercolor on 300-lb. (640gsm) cold-pressed paper
5½" × 7½" (14cm × 19cm)

Practice Different Ways of Scrubbing

Use a ¾" (19mm) flat synthetic brush to create this texture. Partially load the brush with paint and push and pull it with small strokes. A textured or rough surface works best for this technique.

Use a ¾-inch (19mm) flat synthetic brush partially loaded with paint and push it across the surface. You can scrub on damp or wet paper.

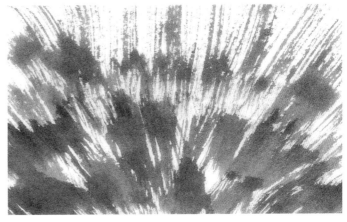

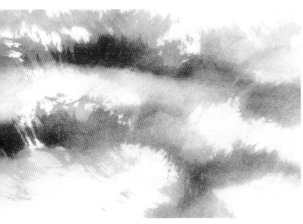

This is similar to the first example, but the color is softened and partially lifted from the surface of the paper. This is a very effective technique for depicting shrubs, trees and weeds.

CORRECTING MISTAKES

A common misconception about watercolor is that it's one of the most difficult mediums to use because you cannot correct mistakes. Although it sometimes is best to start over, with experience and confidence you can correct or adjust mistakes. Everyone laughs about unwanted splatters in the sky that become birds, but it works! You can alter compositions, lift colors and change values. Learn from mistakes, and know when not to try to correct a lost cause. Allowing yourself to become frustrated is the biggest mistake of all!

Lifting a Smudge

Problem
In this demonstration wash I accidentally painted areas that I wanted to remain white. Fortunately, I used two non-staining colors, Cerulean Blue and Olive Green. (Staining colors such as Alizarin Crimson and Sepia do not lift as well and the mistake cannot be corrected.)

Solution
To lift unwanted paint in this situation, burnish down masking tape to protect areas where you do not want color removed. Use a synthetic ¾-inch (19mm) flat to gently scrub the area where the paint is to be removed. Continuously rinse your brush with clean water (a dirty brush will push the reactivated pigment into the fibers of the paper). Remove the moisture with a soft tissue. A paper towel will work, but tissue is more absorbent. Make sure the paper is completely dry before removing the masking tape, as a damp surface will easily tear.

Changing an Unwanted Value

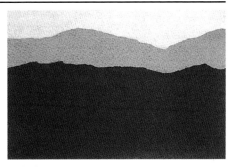

Problem

I used Sepia, Burnt Sienna and French Ultramarine Blue to create this flat, dark wash. I wanted to change the values and make the wash more interesting. I have used staining colors and cannot get back to the white of the paper.

Solution

Tear masking tape in strips to create a ragged edge. Burnish down the tape over the area you want to protect. With a ¾-inch (19mm) flat, re-wet and gently scrub above the taped area. Remove the moisture with tissue paper or a paper towel. Remove the tape when the surface is completely dry (a damp surface will easily tear). Repeat the process and lift more color from the surface to make the flat wash more interesting.

Unifying Areas with a Glaze

Problem

A painting can have too many separate values or colors and not feel cohesive or unified. You can use a glaze to unite, change mood or direct the eye to lighter values in the painting. In this demonstration I have used Cobalt Blue to create a blue sky. The white and blue need to be glazed over with a color so the two areas work together.

Solution

Glaze a wash of Permanent Rose and Raw Sienna over the area. The glaze helps unify the area and brings the values closer together. Paint trees with French Ultramarine Blue to help create scale change between the clouds and trees.

ADDING HIGHLIGHTS

Highlights are the icing on the cake. They give a flat image volume, become the twinkle in the eye of a portrait, the sparkle on flowing water or the shine on glass. Create highlights by removing paint from the surface of the painting. Drag the point of a utility knife or sandpaper across the painted surface; or scrub and lift the paint with a brush. Masking areas with tape or liquid latex to preserve the white of the paper will also create clean, sharp highlights. Experiment with these and other techniques to create highlights in your paintings.

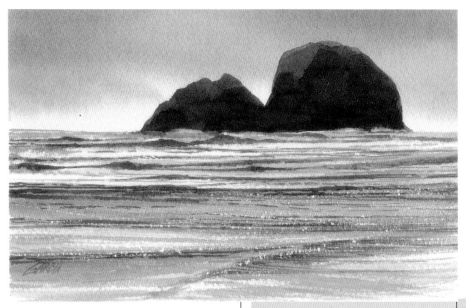

Creating Water Highlights
A wet-into-wet underpainting of Indian Yellow and Quinacridone Gold created the bright highlights in the water. Drybrushing Cobalt Blue and Alizarin Crimson created the dark shadows over the dry underpainting. Use a light touch to get the texture. After the paint dried, I scratched the water with a utility knife to add a few more highlights. Don't overuse the sandpaper or knife texture or you will lose the effect of highlights.

OCEANSIDE, OREGON
Watercolor on 140-lb. (300gsm) cold-pressed paper
4¾" × 7½" (12cm × 19cm)

ADDING WHITES

Add whites to your paintings by using white gouache and Pelican Graphic White (an opaque white ink). Use these conservatively, they will turn transparent watercolors chalky and flat if used improperly. Use these opaque whites for a specific purpose or texture, but not to correct a mistake.

Practice Adding Whites to Your Painting

Splatter white gouache on a dry or damp surface to create soft or hard-edged textures. On the damp surface the gouache picks up some of the pigment. Try not to reactivate the underlying pigment.

Be creative in developing textures. Any tool can be used to apply gouache; as long as the technique works you can push, pull or dab opaque white on the surface of a painting. In this sample, create the textures with a brush. Use a sponge, tissue or palette knife to apply gouache. Can you think of any other tools? The edge of a piece of mat board?

White mixed into transparent watercolors makes most colors flat and chalky. New Gamboge was used to get this chalky yellow color in this sample.

SAVING WHITES

Learning to reserve the white of the paper is fundamental to watercolor painting and equally as important as learning about color and value. The white of the paper can add contrast, impact and highlights to a painting.

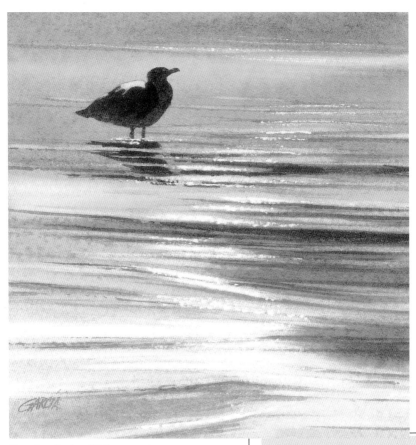

Practice Saving Whites

Create a rich wet-into-wet wash from Indian Yellow and Quinacridone Gold. Brush Mauve into the wash just before it dries to get the dark value. Then gently lift the color out of the wash using a clean, damp ¾-inch (19mm) flat; this brings out the white of the paper. After the surface dries completely, paint the bird in a dark value. Add the sparkle of pure white by drawing the tip of a utility knife across the paper's surface.

GOLDEN GLOW
Watercolor on 140-lb. (300gsm) cold-pressed paper
5¾" × 5¼" (15cm × 13cm)

116

Practice Saving Whites

Paint around an area to reserve the white paper. If the paper is dry, the paint or water won't run into it. The darker the background, the more contrast.

Paraffin reserves the white of the paper and adds texture. Not all of the wax will lift from the surface; however, placing paper towels over the wax and heating them with a hot iron removes most of the wax.

Paint wet-into-wet washes up to a dry area. Drop clean water into this dry area and allow it to flow out into the wash. If the wash is almost dry, a blossom will occur. Keep the area on the right white by using a tissue to stop the pigment from flowing into the water.

Coarse sandpaper removes pigment and brings back the white, though it severely damages the paper.

Masking tape, placed on the lower area, preserves the white.

Use the point of a utility knife or razor to scrape and scratch the surface of dry paper. This removes the paint and leaves a broken sparkle texture. Lifting with a bristle brush gives a soft highlight effect.

Use an old dampened synthetic or bristle brush to scrub the area. Use a tissue or paper towel to pick up the reactivated pigment.

Use a ¾-inch (19mm) flat brush to lift color in a specific direction. Carry or lift the white into the darker surrounding value.

MASKING FLUID

Masking fluid is liquid latex. It is used to preserve the white of the paper and also to create textures.

Application

Masking fluid must be applied to a completely dry surface. You can use a stick, sponge or old brush to apply it. Use a toothpick to make a long, thin, delicate line.

Removal

Use a rubber cement pickup or gently rub with your finger or a soft eraser to remove the masking fluid from the paper. Rubber cement pickup works best because the mask adheres to its surface. The masking fluid removes a small amount of fiber from the surface of the paper and slightly changes its texture. This might appear as a scar on the paper when a wash is applied.

BRUSH TRICK

If you use a brush, saturate it with soap, wipe off the excess and then dip the brush into the fluid. After you have applied it, gently wash your brush. The soap will keep the masking fluid from penetrating the brush.

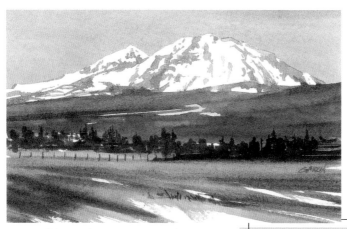

Use Masking Fluid to Create Contrast
I applied masking fluid on the mountain in places where I wanted to reserve the white of the paper. After the latex was completely dry, I painted the sky. When the painting was dry, I removed the masking, revealing the white of the paper. The contrast makes the snow stronger and defined.

SNOW COVERED MOUNTAINS
Watercolor on 140-lb. (300gsm)
cold-pressed paper
4" × 7" (10cm × 18cm)

118

Practice Creating Textures With Masking Fluid

Splatter masking fluid with a brush or dab on with a sponge. After it is completely dry, paint over it; then remove the masking to reveal the white.

On the left I used an old hog-hair brush to apply the masking fluid. In the middle I applied it with a toothpick. I used an old synthetic brush on the right.

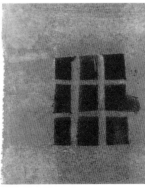

Paint masking fluid on the left side and allow it to dry. Then gently rub it to create a texture. Don't lift or remove too much latex. Paint a wash over the texture and let it dry. Remove the remaining masking to reveal a unique texture. Paint a wash on the right and allow it to completely dry. Apply masking fluid over the area, leaving the windowpane shapes uncovered. Apply a dark wash to the window area and let it dry. Remove the masking, lifting some of the original wash and revealing a spontaneous texture.

MASKING TAPE

Masking tape and plastic packing tape are good products to use as a resist or to protect the surface of the watercolor paper; you can also use tape to create positive and negative shapes.

Protecting Large Areas

Tear masking tape to create an uneven edge. Then apply it to the surface of the paper, overlapping each strip of tape. You can usually see the drawing through the surface of the tape. Cut and remove the unwanted tape with a sharp utility knife. Packing tape is a little easier to see through, but breaks easier. It can also be more difficult to remove from the paper. Burnish down the tape to prevent moisture from penetrating the edge. Don't cut into the surface of the paper when cutting the tape.

Taping Techniques

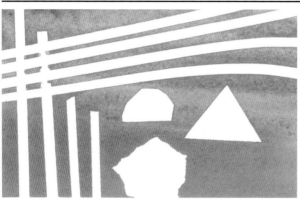

Cut or tear tape to mask shapes. Cut sharp angular shapes or thin lines from tape to create effective resists.

Tear masking tape to create a ragged edge. Use wide masking or packing tape to cut out positive shapes and protect the background or outer edge at the same time. You can also cut long thin lines of tape and bend them into shapes as you apply them to the surface of the paper.

Create Texture With Tape

Use a sharp utility knife to cut out the shapes of the sails with packing tape. Use torn masking tape to create the white water below the ship and the shoreline. Soften the hard edge with a utility knife to add texture to the shoreline.

SAILS ARE SET
Watercolor on 140-lb. (300gsm) cold-pressed paper
5" × 8" (13cm × 20cm)

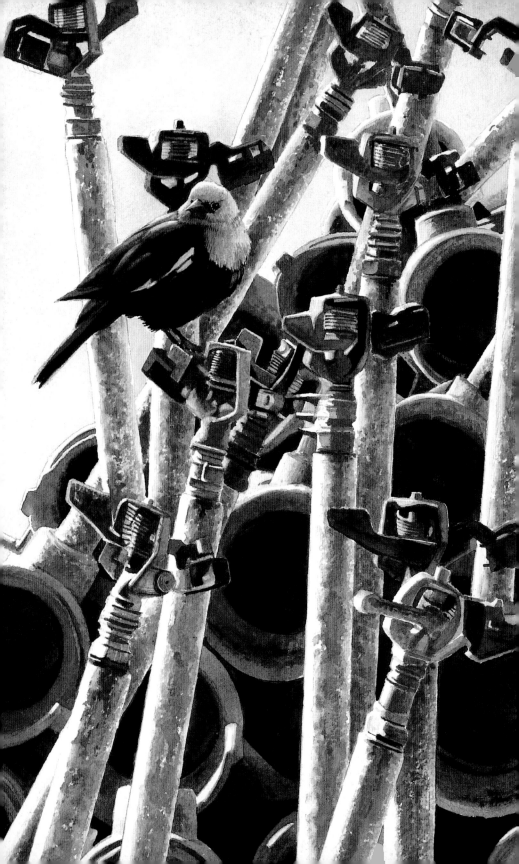

6

Color

Color is in everything we see. The translation of its elements brings excitement to your paintings. Color is a challenge to all artists. It is the one element of painting that can express emotion or mood, evoke passion or instill intimidation or doubt. The use of color can unlock your creativity and allow you to take your work to the next level and really make it your own. Like signing your name, the use of color can be the trademark or signature of your art.

Let your use of color be intuitive as well as theoretical. A successful painting is based partly on how well the colors work together, so it is important to understand and use the rules and theories of color. How does the intensity or value of color work? How does the temperature of color affect the painting? Just as important, if not more so, learn to listen to the voice within. Understanding the rules gives you confidence, but the intuitive side of painting lets you stand out from the crowd. Painting is more than copying your subject or following the rules. Express your creativity in a personal and unique way with color.

RAINBIRDS
Watercolor on 300-lb. (640gsm) cold-pressed paper
28¼" × 12½" (72cm × 32cm)

COLOR PROPERTIES

Good use of color, while intuitive to a degree, requires study and practice. Color is a never-ending journey that offers surprises and challenges. With color you can take an unexciting subject and turn it into a dynamic piece of art. Here are some definitions you should know:

Hue
A color's common name, for example, Cadmium Red or Red Apple.

Temperature
How warm or cool a color is, depending on where the hue is situated on the color wheel.

Intensity
A color's saturation, brightness or strength.

Value
A color's lightness or darkness, as compared to a black-and-white value scale.

Simultaneous Contrast
Colors seen at the same time modify each other. For example, gray will appear dark against a light background or light against a dark background.

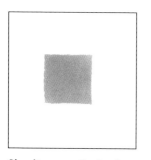 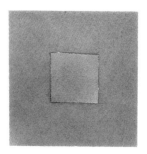 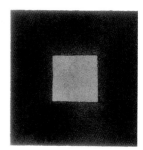

Simultaneous Contrast
The three gray cubes are the same value but have a perceived value change. The gray against the white looks darker. The gray in the blue square is flat, and the gray in the black square appears lighter in value.

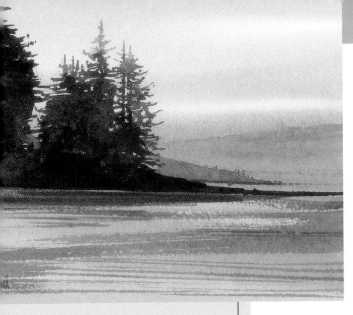

Color Temperature
This painting has all warm colors that are analogous on the color wheel.

SUNDOWN AT GARIBALDI
Watercolor on 140-lb. (300gsm) cold-pressed paper
5¼" × 6½" (13cm × 17cm)

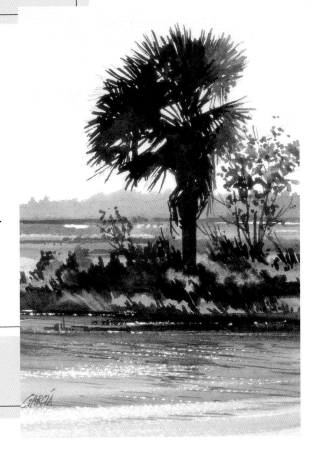

Value
A painting's "key" means the range of light and dark tones used. A high-key painting has a very light, bright range of values, while a low-key painting has a dark, low-intensity range of color. A moonlight or nighttime painting is an example of low-key painting. The painting at left has a wide range of values from a very light sky to very dark shadows.

PALMETTO
Watercolor on 140-lb. (300gsm)
cold-pressed paper
7½" × 5¼" (19cm × 13cm)

COLOR WHEEL

The color wheel is a logical, organized way to visualize color. Primary, secondary and tertiary colors make up the twelve hues of the basic color wheel. The lightest primary color (yellow) is at the top and the darker primaries (red on the left, blue on the right) are on the bottom. The color wheel also has a warm and cool side. Notice the secondary and tertiary colors.

Primary Colors

These are the colors you cannot mix from any other color combination: red, yellow and blue. Theoretically, you can mix all other colors from the primaries.

Secondary Colors

Secondary colors result from mixing two primary colors, such as yellow and red to get orange. The secondary colors are orange, green and violet.

Tertiary Colors

You get tertiary colors by combining a primary and a secondary color, such as red and violet to get red-violet.

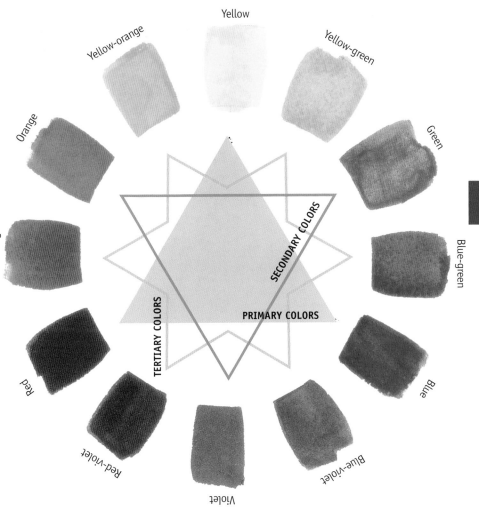

Yellow

Yellow-orange

Yellow-green

Orange

Green

Red-orange

Blue-green

SECONDARY COLORS

PRIMARY COLORS

TERTIARY COLORS

Blue

Red

Blue-violet

Red-violet

Violet

6

COMPLEMENTARY COLORS

Complementary colors are directly across from each other on the color wheel. You create them using a triadic mixing system: Mix a primary and a secondary, which is mixed from the other two primaries. For example, the complement of red is green (yellow and blue), the complement of blue is orange (red and yellow), and the complement of yellow is violet (red and blue). If you mix complements equally, you will get a completely neutral gray.

Temperature

Complements have either a cool or a warm tendency. When you place them near or next to one another, they can bias or intensify each other. For example, a blue feels cooler next to a warm. This temperature relationship also allows grays to be "pushed or pulled" to add visual interest to a painting. "Pushed or pulled" refers to the use of receding cool or advancing warm colors. Remember, the moment the complements are used together they begin to neutralize, or gray, each other's intensity. If an area of your painting is too intense, you can tone it down by glazing over a color with its complement, creating a vibrant gray.

Finding Complements
A color's complement is the one directly opposite on the color wheel.
Another way to think of complements: the complement of any primary
color is the color made from the two remaining primaries.

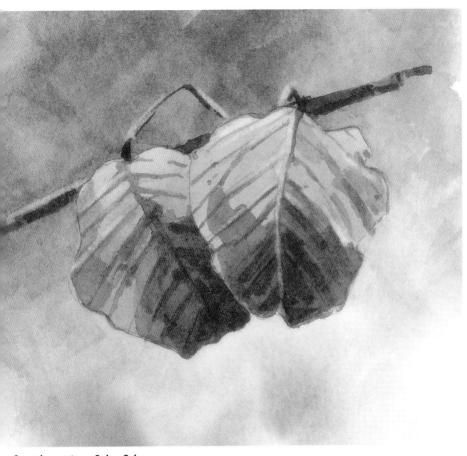

Complementary Color Scheme
The complementary colors orange and blue have contrasting color temperatures (warm orange vs. cool blue). The "push-pull" effect of warms and cools helps create depth in this painting.

COLOR TEMPERATURE

Colors have a physical and a psychological relationship to temperature. Cool colors feel fresh, clean or wintry. Painters use them to paint shadows, seasons and certain moods. Painters use warm colors for movement, excitement, anger and warmth. The sayings "seeing red" and "feeling blue" demonstrate the correlation of emotion to color. The temperature of a painting's color scheme carries emotion to the viewer.

Temperature and Atmospheric Perspective

Color temperature creates depth. Cool colors recede and warm colors advance. As colors lose intensity, they become cooler and recede and, conversely, as colors gain intensity and value they advance. Using this warm/cool, light/intense value relationship creates what is called "atmospheric perspective," a fundamental rule for landscape painting. Using the wrong temperature and value in an area can disrupt the flow of a composition.

Temperature and Focal Point

Color temperature influences the importance of a painting's focal point. If the color scheme of a painting is cool and the focal point is warm, emphasis is placed on the subject.

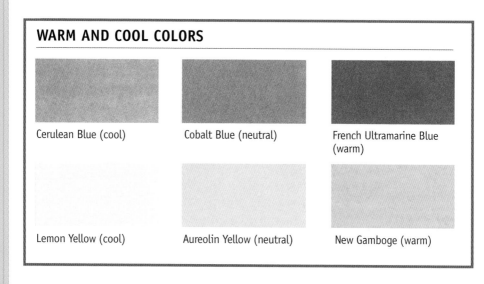

WARM AND COOL COLORS

Cerulean Blue (cool)

Cobalt Blue (neutral)

French Ultramarine Blue (warm)

Lemon Yellow (cool)

Aureolin Yellow (neutral)

New Gamboge (warm)

Atmospheric Perspective
This sketch shows the use of warm colors as they advance into the foreground. I used Cobalt Blue and Cerulean Blue in the sky and French Ultramarine Blue and Permanent Rose in the waves. The foreground is Burnt Sienna and French Ultramarine Blue.

INTENSITY

Intensity is purity, brilliance and the visual strength of a color. A color is at its most intense on the color wheel; however, don't confuse strong intensity with value. Pure colors such as Winsor Red, Winsor Yellow or French Ultramarine Blue have a high intensity. Use high-intensity staining colors carefully because only a bit of color can change or contaminate another hue.

Color Influence

Surrounding colors affect intensity. If you paint a color on white paper, you can make it look more intense by placing another color near it. For example, surround yellow with its complement. This change in intensity also happens when a dark area surrounds a light area or a dark value surrounds a light value.

INTENSITY STUDIES

DECREASING THE INTENSITY OF COBALT BLUE.	 Cobalt Blue/White	 Cobalt Blue/ Sap Green/Water	 Cobalt Blue/ Sap Green
INCREASING THE INTENSITY OF CADMIUM YELLOW.	 Cadmium Yellow/White	 Cadmium Yellow/ Burnt Sienna/Water	 Cadmium Yellow/ Burnt Sienna
INCREASING THE INTENSITY WITH COMPLEMENTS.	 Lemon Yellow/ Mauve	 Scarlet Lake/Indigo	 Winsor Green/ Cadmium Orange

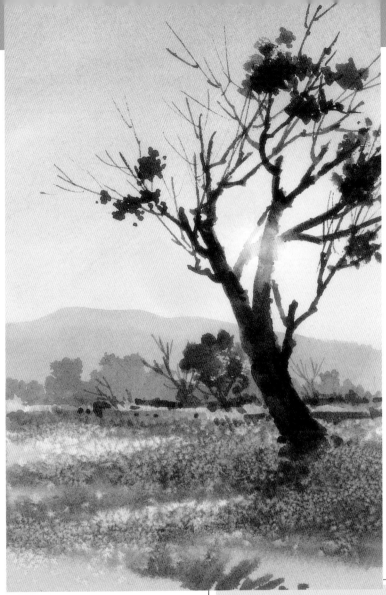

Increasing Intensity
Use a darker value and a complement to
increase the intensity of an area.

THE ODD TREE
Watercolor on 140-lb. (300gsm) cold-pressed paper
7" × 4½" (18cm × 11cm)

WATCH YOUR TINTS

Some highly intense colors, such as "phthalo" colors, require a lot
of water to lessen their intensity; however, if you use too much
water to thin the color, you will create a tint (page 142).

COLOR AS VALUE

Every color has a value, a relative lightness or darkness. Values help direct the compositional flow of your painting. When you are ready to start a painting, study the subject and think of it as a black-and-white photograph. Look for value patterns and how they can be translated into color.

A color's value changes depending on the color surrounding it. A color that's dark or intense standing alone or on white paper gains or loses intensity when surrounding values are added.

Use Value to Create Emotion

Limited color or value can create atmospheric or emotional paintings. Paintings that feature fog, night or the sunset are examples. These paintings often have a limited value range and require longer evaluation by the viewer. A painting with strong value or color changes has visual impact and easily draws the viewer's attention.

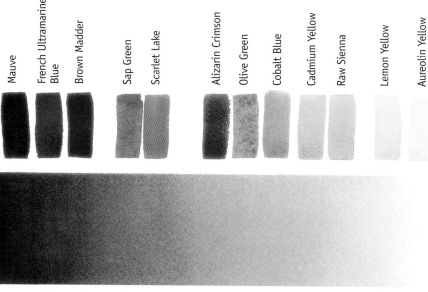

Gray Scale Showing Color Value
It is easy to see a color's value when you place colors next to a gray scale.
Aureolin Yellow is one of the the lightest values, while mauve is the darkest.
Red and green are almost identical in value.

Seeing Value
Compare the values in this black-and-white copy to the colors in the full-color painting below.

6

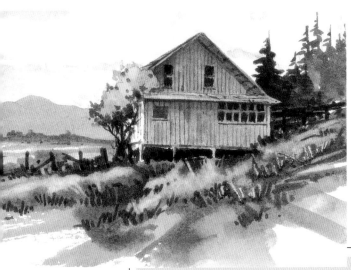

Full-Color Sketch
If the values work well in the painting, your colors are probably right.

SEEN BETTER DAYS
Watercolor on 140-lb. (300gsm) cold-pressed paper
4" × 6" (10cm × 15cm)

COLOR RELATIONSHIPS

Every color has a bias toward warm or cool. This property makes color mixing slightly complicated. Understanding the color bias of the primaries helps you mix high-intensity or low-intensity secondary or tertiary colors.

How Color Bias Affects Mixing

- Mixing two cool primaries produces the most vivid secondaries. You wouldn't get a vivid purple, for example, by mixing Alizarin Crimson with Ultramarine Blue because the former has a cool bias while the latter is warm. Instead, you might use French Ultramarine Blue and Alizarin Crimson, both cool primaries.
- Mixtures of warm primaries are less

intense than mixtures of cool ones.
- Mixing a warm primary with a cool one gives a low-intensity result.

Remember, too, that tertiary colors are less brilliant than secondary colors and secondary colors are less brilliant than primaries.

MIXING TRICK

If you want to mix a warm primary with a cool one, painting wet-into-wet or pre-mixing the colors might allow pigments to granulate or mix unevenly. Instead, glaze one of the colors over a dry wash of the other color.

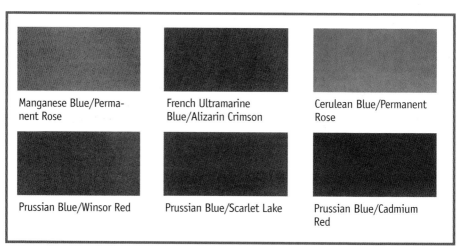

Manganese Blue/Perma-nent Rose	French Ultramarine Blue/Alizarin Crimson	Cerulean Blue/Permanent Rose
Prussian Blue/Winsor Red	Prussian Blue/Scarlet Lake	Prussian Blue/Cadmium Red

High- and Low- Intensity Secondary Colors
The top row of swatches shows how to create high-intensity secondary colors by using primaries that have the same color bias. All the colors in the second row have a yellow bias, which is the complement of violet. Those colors are all low-intensity, or unsaturated, hues.

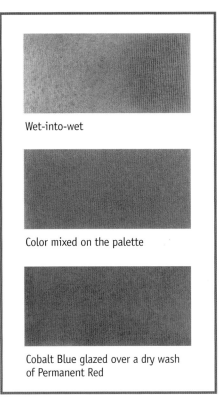

Wet-into-wet

Color mixed on the palette

Cobalt Blue glazed over a dry wash
of Permanent Red

Yellow-orange

Orange

Red-orange

Mixing Secondary Colors

You can create secondary and tertiary colors by glazing them (page 100), painting wet-into-wet or premixing them on your palette. I used Permanent Rose and Cobalt Blue to create these examples.

Creating Tertiary Colors

The secondary color here, orange, is a mix of Scarlet Lake and New Gamboge. The tertiary color to the left has more New Gamboge added, while the tertiary to the right has more Scarlet Lake.

MIXING COMPLEMENTS

A complementary color always has a lower intensity because it is made up of two primaries. Whenever you mix two hues together, the intensity of the original color lessens. You will never be able to return to the purity of the original hues.

GRAYS *and* NEUTRALS

Mixing two exact complements creates a perfectly neutral gray—but that's a gray you seldom want. A better gray is biased toward the primary or complement that you used in your mixture, or one that is shifted to the left or right of the exact complement (creating a split complement). This shift makes a warmer or cooler gray and also opens the door to a larger variety of grayed or neutral values. For example, blue has red-orange and yellow-orange as its split complements. This split gives you a wider range of grayed warm and cool colors to use. A move to the left or right on the color wheel also allows you to push or pull your grays.

Mixing Grays

You can also make grays and neutrals with black, Payne's Gray or Neutral Tint. These colors neutralize a hue without using the complement; however, they absorb light and create a less vibrant gray. Mixing complements always gives you a larger, more luminous variety of grays.

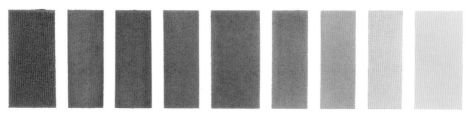

Create a Gray Scale With Complementary Colors
Using the complementary colors of Mauve and New Gamboge, create a neutral gray in the center of the scale. You can mix an endless variety of grays with a bias toward either complement.

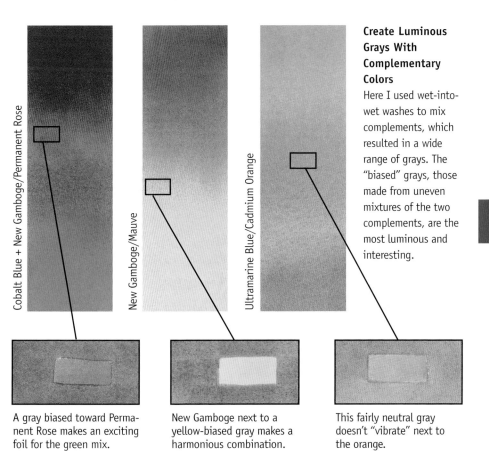

Cobalt Blue + New Gamboge/Permanent Rose

New Gamboge/Mauve

Ultramarine Blue/Cadmium Orange

Create Luminous Grays With Complementary Colors

Here I used wet-into-wet washes to mix complements, which resulted in a wide range of grays. The "biased" grays, those made from uneven mixtures of the two complements, are the most luminous and interesting.

A gray biased toward Perma-nent Rose makes an exciting foil for the green mix.

New Gamboge next to a yellow-biased gray makes a harmonious combination.

This fairly neutral gray doesn't "vibrate" next to the orange.

SHADES

A shade is a medium to dark value of a color. When mixing a shade, you want to make a color darker without changing its hue. Also remember when mixing that dark colors carry their identity longer, whereas shades of light value, such as yellow, lose their identity much more quickly. Create shades gradually and with care, because after creating a shade you can never return the color to its original brightness or intensity.

Using Achromatic Colors

You can create shades by adding Black, Payne's Gray or Neutral Tint. These colors are called achromatic because they absorb light, dulling colors with which they are mixed.

Adding Color Complements

You can also create a shade by mixing a color with its complement. Unlike an achromatic color, a complement lets light pass through to be reflected back by the painting surface. Consequently, shades made with complements are more luminous than those made with achromatic colors.

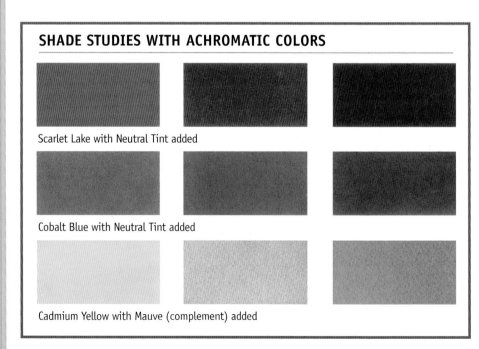

SHADE STUDIES WITH ACHROMATIC COLORS

Scarlet Lake with Neutral Tint added

Cobalt Blue with Neutral Tint added

Cadmium Yellow with Mauve (complement) added

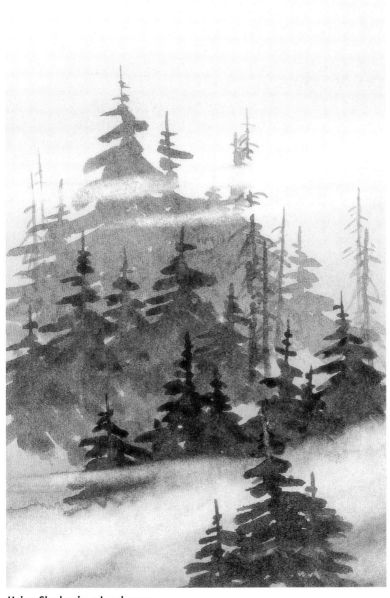

Using Shades in a Landscape
I painted these trees with Olive Green and
added Neutral Tint to darken shades.

TINTS

A tint is always lighter in value than the original color. In watercolor, you create a tint by adding water to the original color. The more you add, the weaker the intensity.

Not all colors have the same tinting strength. Some colors require more steps or a longer gradation to lose all their tinting strength. For instance, French Ultramarine Blue requires a longer gradation than Winsor Yellow. The perfect way to show a color's tinting strength is with a gradated wash (page 96). A gradated wash also shows how some colors change hues almost as the tint is created.

Tinting and Staining

A tint is different than a stain. Removing pigment from the surface of the paper creates a stain because the remaining pigment has been absorbed into the fibers of the paper. A tint, on the other hand, is created when water dilutes the color and floats the pigment over the surface of the paper.

TINT STUDIES

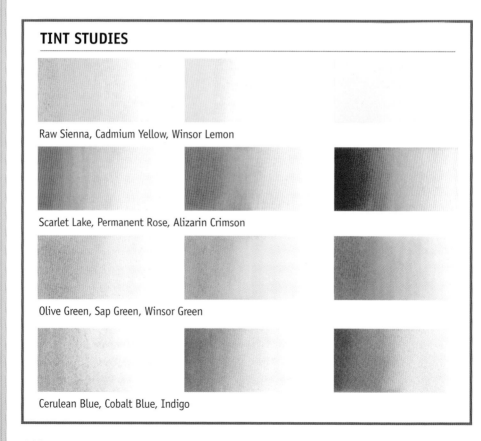

Raw Sienna, Cadmium Yellow, Winsor Lemon

Scarlet Lake, Permanent Rose, Alizarin Crimson

Olive Green, Sap Green, Winsor Green

Cerulean Blue, Cobalt Blue, Indigo

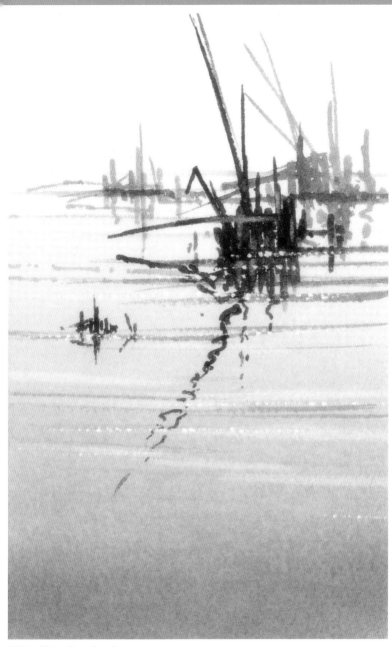

Using Tints in a Landscape
I used a tint of Cobalt Blue to indicate water in this landscape.

MONOCHROMATIC COLOR SCHEMES

A monochromatic color scheme is exactly what its name implies: *mono* meaning "one" and *chromatic* meaning "color"— a one-color painting method. It is the easiest of the color schemes to understand and use. Since there is only one color, there is no possibility for color conflict. Creating paintings with a monochromatic color scheme helps you see and understand values. If you use a dark or dominant hue, the range of values becomes almost limitless. Burnt Umber, Sepia and French Ultramarine Blue are good dominant colors to use. They provide strong, intense darks with excellent light-valued tints.

Value Movement

A monochromatic color scheme also gives you the opportunity to see how light values recede and dark values advance. This value movement creates a temperature change: Receding light values take on a cool bias and advancing dark values have a warm bias.

Monochromatic Color
This is a monochromatic use of Sepia applied with a wet-into-wet wash. It has a wide range of values and soft edges. Dark, hard-edged brushstrokes are used for contrast. The lower monochromatic sample uses French Ultramarine Blue with flat washes. The background, lighter in value, takes on a cool temperature. As the values move into the foreground, they become darker and warmer in appearance.

Monochromatic Sketch
This sketch uses French Ultramarine Blue to show a wide range of values. Using a dominant hue increases the range of values available.

HANG 'EM HIGH
Watercolor on 140-lb. (300gsm) cold-pressed paper
4½" × 6½" (11cm × 16cm)

Black-and-White Reproduction
This is a black-and-white scan of the former monochromatic sketch. The black and white version is still effective as a composition, indicating good value choices in the original painting.

ANALOGOUS COLOR SCHEMES

Analogous colors are three or four adjacent hues on the color wheel, including one of the primary colors. Using only a third of the color wheel in a painting makes a wonderful system for creating harmonious or moody scenes because the adjacent colors have so much in common. Study your subjects to see if they lend themselves to this color scheme. Some candidates might be winter or foggy scenes or spring or fall landscapes and seascapes.

Creating Values

Painting with three or four analogous colors makes colors that are clean and

Analogous Sketch
This sketch uses an analogous palette of Cobalt Blue, blue-violet, blue-green and green. I used the complement, orange, to gray the analogous colors, and tints to push the values of the distant trees into the background.

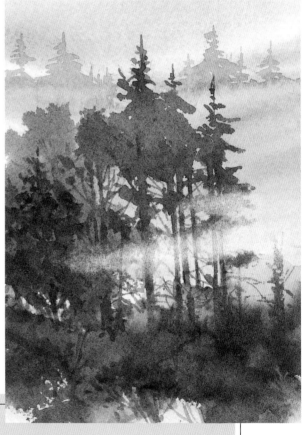

AS THE FOG ROLLS IN
Watercolor on 140-lb. (300gsm) cold-pressed paper
4" × 5½" (10cm × 14cm)

146

vibrant. To help create value changes, add complements. This helps widen your choices of values but still keeps you in the analogous color system. Certain hues are darker and stronger, which makes them easier to work with as analogous colors.

You can also start with one or two analogous colors that are already grayed. Use the complement to gray the colors and to highlight the analogous colors. Don't overuse the complement or you'll move your painting into a split complementary color scheme.

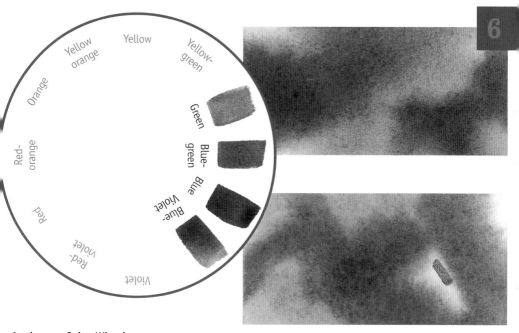

Analogous Color Wheel
Any four adjacent colors create an analogous color scheme. Here French Ultramarine Blue is the primary and orange is the complement. The upper rectangle uses only analogous colors in a wet-into-wet application. The lower rectangle uses grayed analogous colors made by adding orange to the mix.

147

Color palettes are like people—they come in a wide range of colors and personalities. Each palette has the power to create mood and emotion. They can be simple or complex in nature. Color palettes have a variety of names that refer to the number of colors used (monochromatic or analogous) or to the colors' characteristics (intense or opaque). When you're first starting to paint, keep the color palette simple. A limited palette will force you to learn the different characteristics of color, and the fewer colors used, the easier they are to understand. You should base your palette on personal experience and painting style. These qualities will develop and grow throughout your

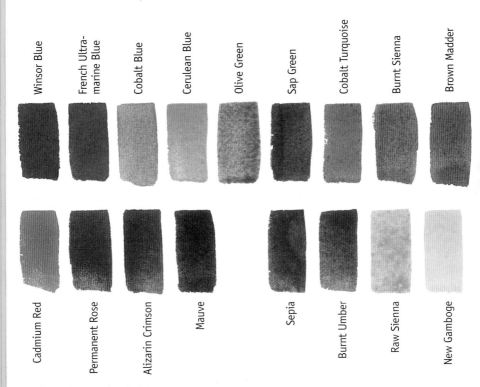

My Basic Watercolor Palette
These colors work well with the subjects I like to paint. My palette has evolved over time and is always open to change. It has a wide range of characteristics: warm and cool, staining and non-staining, transparent and non-transparent. Though it includes Mauve, Burnt Umber and Sepia, I seldom use them and may eventually take them off the palette. I keep a few wells empty so I can add colors.

career, and over time your color palette will change as well. You'll add colors, drop others and experiment constantly.

Arranging Your Palette

Arrange your palette logically. Set it up like a color wheel to make it easy to work with and understand. You can also place colors from warm to cool or light to dark. You could even separate your colors by qualities such as staining or transparency. It's your choice. Intensity, transparency and tinting strength may play a role in your color organization as you gain experience.

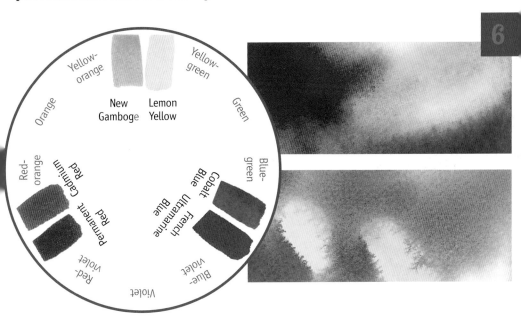

Split Primary Palette

A split primary palette uses a warm and cool version of each primary. This palette creates high-intensity mixtures. To get these brilliant mixtures, two of the mixed primaries must have the same temperature bias (they must be in the same third of the color wheel). Alizarin Crimson–French Ultramarine and Lemon Yellow–Cobalt Blue are color pairs that work well together. The top color swatch is a wet-into-wet wash of warm primaries: New Gamboge, French Ultramarine and Alizarin Crimson. The bottom one is a wash of cool primaries: Lemon Yellow, Scarlet Lake and Cobalt Blue.

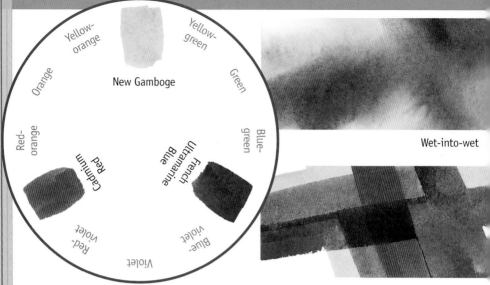

Wet-into-wet

Drybrushing and glazing

Standard or Traditional Palette

This combination of transparent, opaque and high-intensity should be on every palette. If you find Cadmium Red too opaque, try Permanent Rose or Alizarin Crimson. French Ultramarine Blue (semiopaque) and New Gamboge (transparent) make a nice natural green for landscapes.

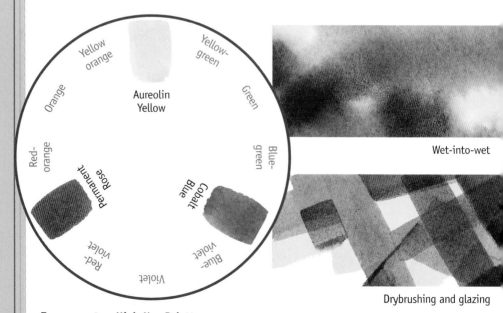

Wet-into-wet

Drybrushing and glazing

Transparent or High-Key Palette

This bright, transparent palette is especially suitable for florals, still lifes and high-key landscapes. These primaries produce a wide range of luminous colors that glaze well. Choose subjects carefully since this palette can't produce strong darks.

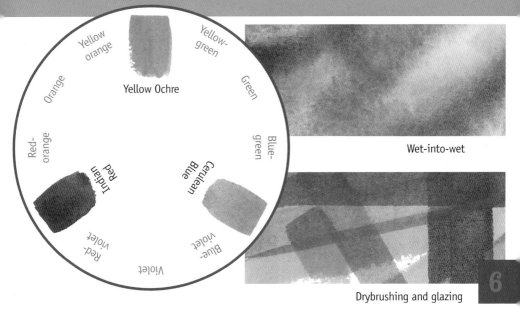

Wet-into-wet

Drybrushing and glazing

6

Opaque or Unsaturated Palette

This palette can be difficult to work with. The colors turn to mud when overmixed, so instead, let them mingle, dilute them, or use them as tints. It is difficult to create dark values because the colors are low-intensity and unsaturated. Greens tend to be dull. The colors create subtle textures because of their opacity, especially when you use them on a rough paper.

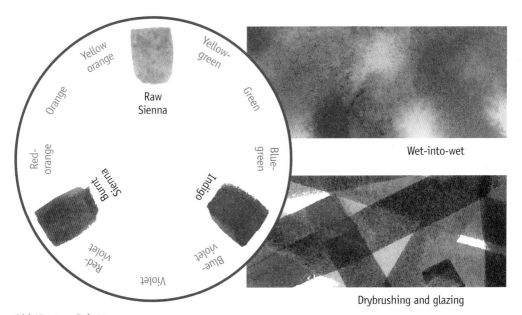

Wet-into-wet

Drybrushing and glazing

Old Masters Palette

These semitransparent colors create rich, low-intensity mixtures excellent for fall scenes or earthy landscapes. As with the Opaque palette above, don't overmix or you'll get mud. The green is subtle and must be mixed carefully. To glaze these colors successfully, use tints of each hue.

151

USING A LIMITED PALETTE

Few artists agree about anything; they base their likes and dislikes on personal choices. This is especially true when it comes to color. A limited palette provides a good way to sort out and approach color. It increases your understanding of value and color harmony.

Often artists base the choice of a color palette on local or actual color of the subject. A limited palette forces you to experiment and try various color schemes. Limited color palettes create moods and emotions that are often more interesting than local color. Select a limited palette with logic and order.

The choice of color is called a color scheme, and if chosen well, it creates color harmony. Color harmony gives

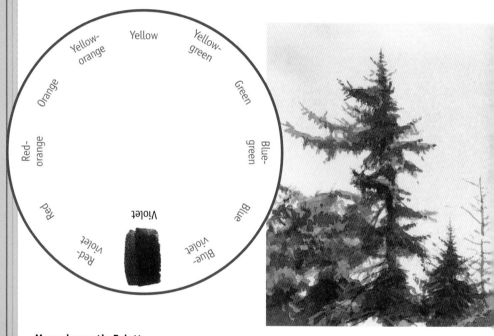

Monochromatic Palette
A one-color palette forces you to think about using correct values in your painting. This sketch, painted in Mauve, has a wide range of lights and darks. A light-valued hue such as Cadmium Yellow or Raw Sienna would not have the range of values needed for a monochromatic painting. Remember, there is always color harmony when a monochromatic color scheme is used. You cannot make a color mistake!

unity and imparts your personality to the painting. The choice of subject may also dictate how you choose your limited palette. Be willing to try various color schemes and change individual colors to suit your taste. Remember rules are made to be broken, so use a color scheme that suits you!

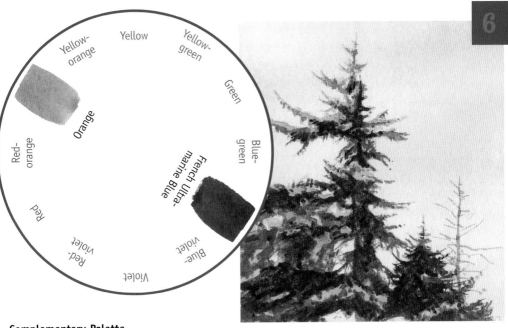

Complementary Palette

To make a complementary palette, take a monochromatic palette and add one complement or near complement. Since these colors are opposite or nearly opposite each other on the color wheel, they give the strongest color contrast possible. You can create additional contrast with value changes in the color mixtures. The luminous grays achieved by mixing the colors create a harmonious color scheme. The complementary color scheme tends to work better with nonintense primary and secondary colors. A wider variety of color options are available with the use of secondary colors.

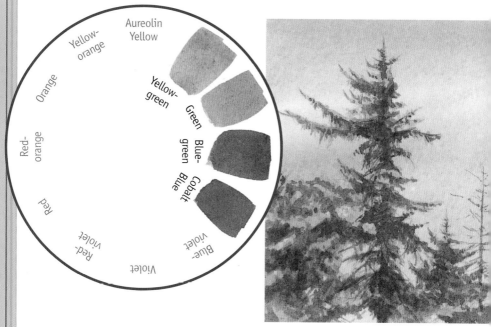

Analogous Palette

The analogous palette is considered an expanded color scheme because you can use three or four closely related colors. This close relationship of the colors creates color harmony. There are no complementary colors in this palette to mix grays or dull any of the colors. Since the colors are closely related on the color wheel, a color bias is established. The bias will be either warm or cool and may influence the choice of subject that you are going to paint. Establish contrast with values—not color relationships. This is also a wonderfully sensitive palette that can be used for moody, emotional paintings.

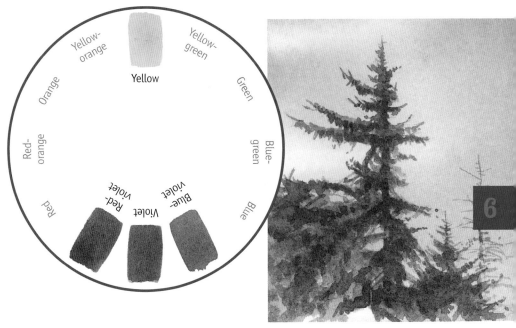

Analogous-Complementary Color Palette

Adding one more color (a complement or near complement) to your analogous palette opens up your painting to a wide range of possibilities. You now have color available for purity and contrast, including numerous vibrant grays. The addition of this complementary color gives an overall feeling of color balance. This is a good color scheme to try before taking the next step into full color.

USING TRIADS FOR UNITY

A triad is any three colors on the color wheel that would form a triangle when connected. Using triads in a painting creates color harmony, which can unify your work and create a pleasing visual impact.

Mixing With Triads

With a triadic scheme, there are no direct complements. This scheme uses colors that are not directly across from each other to create neutrals. The triadic system offers a wider variety of colors to mix and create neutrals or grays. Combinations you otherwise might never think of become logical and appropriate.

Creating a Triadic Palette

When you are adding colors to your palette, keep in mind where they are located on the color wheel. You can create beautiful and vibrant grays when any two of the triadic colors are mixed—especially when the two colors have the same temperature bias. When using triads, establish color harmony by choosing one color that dominates the other two. If all three colors have equal intensities, they will compete. By using the triadic system, grayed secondary or tertiary colors give the feeling of a full-color palette. Contrast is achieved by purposeful use of color, value or purity. Know where the convenience or tube colors are located on the color wheel because your choice of colors makes a difference in the intensity and value of the neutrals created.

TO AVOID MUD

Don't overmix triadic colors or use more than two of them in a mixture, or you will quickly create mud. Also, know the opaque colors on your palette. Opaque colors can quickly dull or muddy your mixtures.

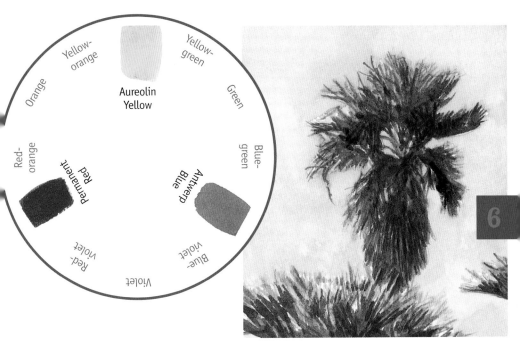

The Triadic System

The characteristics of each color on this palette play an important role in the success of their blending. The three colors in this triad are transparent and intense. Aureolin Yellow and Cobalt Blue have a neutral temperature bias, and Permanent Rose is a cool red. These colors are easy to mix and glaze and create a wide range of values and colors.

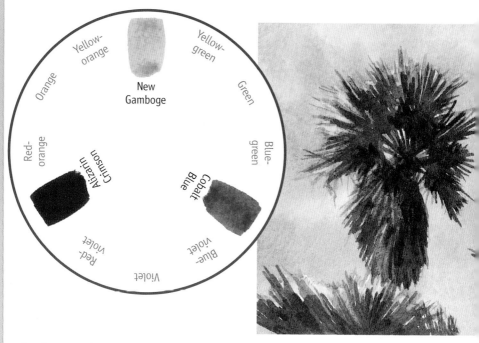

Use Strong Colors

This triad of primary colors uses Cobalt Blue, Alizarin Crimson and New Gamboge. They are strong, intense colors with a cool bias, and can create a wide range of values. Alizarin Crimson must be used carefully in this triad because it is a highly staining, transparent hue that can overpower the semitransparent, nonstaining qualities of the two other colors.

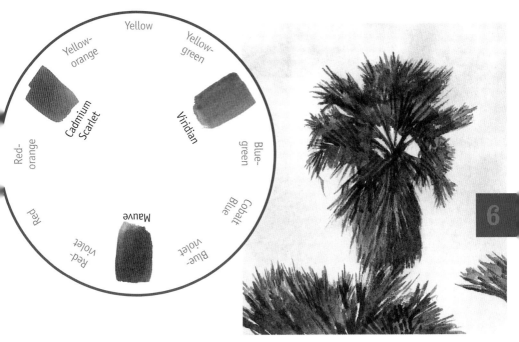

Using Secondary Triads

Secondary triads are made up of secondary colors
that the primaries create. Color combinations
can be unusual with a broad range of rich, vibrant
grays. Create contrast using value, color and
intensity. This triadic scheme used Mauve, Cad-
mium Scarlet and Viridian as the secondary
tube, or convenience, colors.

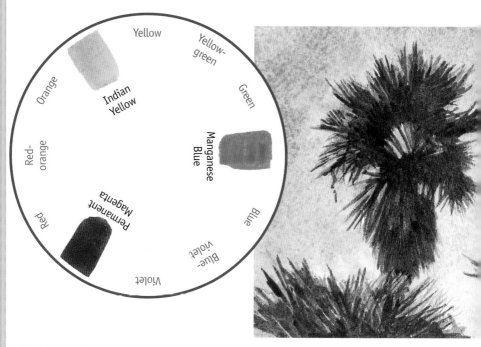

Working With Tertiary Triads

Tertiary triads are the colors created when you mix the secondary and primary colors. These color combinations are difficult to use as pure triadic colors. You will be more successful if one of the triadic colors is dominant. I selected Permanent Magenta, Manganese Blue and Indian Yellow for the tube colors in this triad.

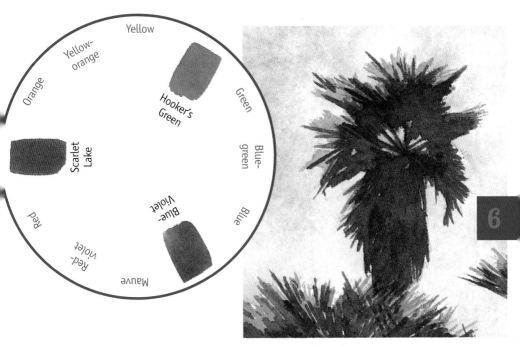

Tertiary Triad

This tertiary triad sketch of a date palm was painted with a bias toward the blue/green side of the color wheel.

The color wheel labels: Yellow, Yellow-orange, Orange, Red, Red-Violet, Mauve, Blue-Violet, Blue, Blue-green, Green, Hooker's Green, Scarlet Lake

SHADOWS *and* CAST SHADOWS

An object that blocks the direct rays of light casts a shadow. The light source can be man-made or it can be the natural light of the sun. Use shadows as a compositional aid to influence eye movement. Unify areas with shadows of different values and colors. Shadows that flow throughout the painting create interesting patterns or textures.

Shadow Color

Typically, shadows contain some reflected light that reveals the local color of the subject. Mix a shadow color with a touch of blue, the local color of the painting subject and its complement. Outdoor shadows contain more blue because of the reflection from the sky. You can also make your shadow colors more imaginative by accenting them with local color or bringing color harmony to the painting. Your choice in using shadows should express your personal approach to painting.

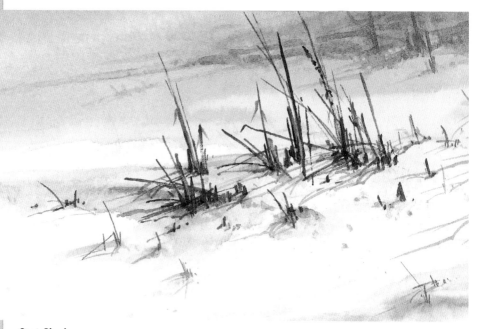

Cast Shadows
Shadows follow the contour of the surface onto which they fall. Use them to add volume, shape and dimension to a surface. Outdoor shadows, such as snow shadows, pick up blue from the reflection of the sky.

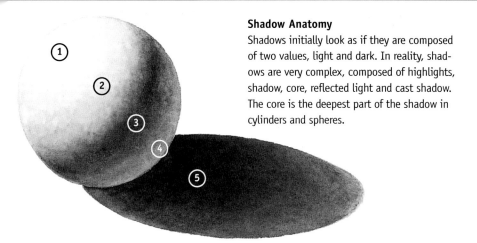

Shadow Anatomy

Shadows initially look as if they are composed of two values, light and dark. In reality, shadows are very complex, composed of highlights, shadow, core, reflected light and cast shadow. The core is the deepest part of the shadow in cylinders and spheres.

1 | HIGHLIGHT
The area directly in line with the light source. There is no texture visible in this area. It is too bright.

2 | HALFTONE
The area that is in transition from the highlight to the darkest area of the shadow.

3 | SHADOW
The darkest area, receiving the least light.

4 | REFLECTED LIGHT
Light that is reflected back into the shadow area. This light carries the color of the surface from which it is reflected. How much color is determined by the intensity of the light source and the surface that is reflecting the light.

5 | CAST SHADOW
The shadow that is created by the parameter of the object that interrupts the flow of light. The cast shadow follows the contour of any object it falls on. It grows lighter in value and less defined the farther it extends from the object.

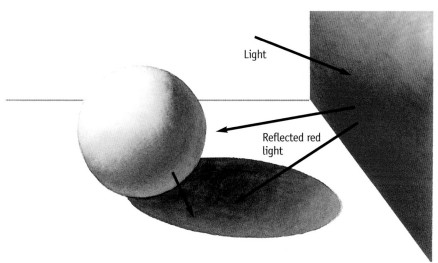

Light

Reflected red light

Reflected Light
Reflected light bounces from the red surface to the sphere and also onto the cast shadow. The surface the sphere sits on shows reflected color too.

Reflected light on the side wall and floor surface is not indicated.

SKIN COLORS

There is such a wide range of skin tones that it is difficult to choose specific colors to use. Variables of age, ethnicity, light source, reflected light and gender all play a role in painting skin color. The most profound variable, however, is you, the artist who chooses the color and interprets what is seen. Study your subject closely so you are familiar with these variables.

Look for the Light

Analyze how and where the light source strikes the surface. Ask yourself these questions: Does the light come from the top, side, bottom, or is there more than one light source? How much reflected light can I see in the shadows? What colors do the shadows introduce?

Make sure your subject is well lit before you decide on the skin color. This helps determine the value and color of the general skin tone. A strong light source creates a wide range of values from almost white (the highlight) to dark, rich shadows. As the light increases, the shadows become darker and sharper. As a general rule, shadows start at mid-value, or 40 to 50 percent of the overall skin color. This gives nice contrast to the light side and allows you to paint darker areas in the shadows. You can use reflected light and color; the shadows still retain the appropriate value.

OUTDOOR LIGHT

Outdoor light picks up blue from the sky and warm yellows from the sun. As the sun rises or sets, you will see less blue and more warmth in the colors.

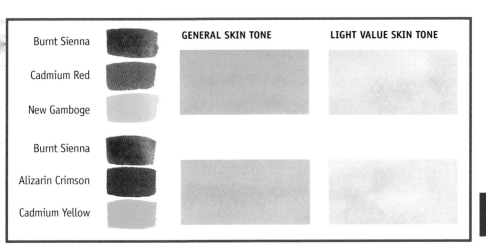

Burnt Sienna		GENERAL SKIN TONE	LIGHT VALUE SKIN TONE
Cadmium Red			
New Gamboge			
Burnt Sienna			
Alizarin Crimson			
Cadmium Yellow			

Light Skin Colors

Light skin tones feel transparent and vibrant. The three colors on the left are used to mix the general skin tone. The light value color sample sets the tone for the rest of the painting. I like to start a painting by placing my lightest light and my darkest dark. This helps me set the range of values in the painting. Use the individual colors to accent certain areas, such as the nose or cheeks.

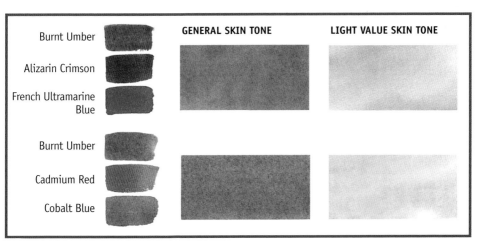

Burnt Umber		GENERAL SKIN TONE	LIGHT VALUE SKIN TONE
Alizarin Crimson			
French Ultramarine Blue			
Burnt Umber			
Cadmium Red			
Cobalt Blue			

Dark Skin Colors

Dark skin features a range of rich, exciting colors and values. Mix three colors to find the general skin tone. Using the same colors, create a light-value sample that allows some of the colors to stand on their own. Let the shadows push the rich purples and blues that can be mixed from the original three colors.

SKY COLORS

Sky colors can vary considerably depending on the time of day and weather conditions. How you render these changing colors is dependent on your style of painting. Whatever the variables, the final choice of color is yours. Do not feel that because the sky is blue you have to use a color that is straight from the tube. Create your own interesting skies by introducing other colors and textures.

Color Combinations

There are many combinations for mixing sky colors. You can use analogous colors, add a complement to gray colors, or be creative and use whatever colors your imagination dictates. The only concern is that the color of the sky harmonizes with the rest of the painting. Good value and color temperature help create this harmony.

Color Influences

Sky values become lighter as they near the horizon. The color gets darker and warmer as you look upward. Variables such as sunsets, storms, fog and your imagination influence sky color. Fog, for example, creates a flat, dull sky. As the fog thins, the sun may create a golden glow.

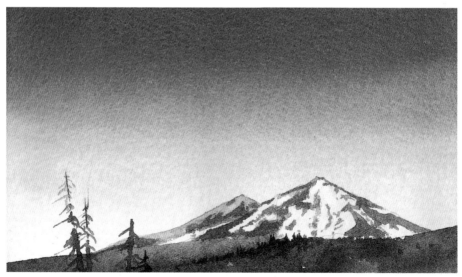

Traditional Sky Colors
The top of the sky is an Alizarin Crimson–French Ultramarine Blue mix. I added Cobalt Blue in the middle and Raw Sienna at the bottom and tilted the surface to help blend the colors.

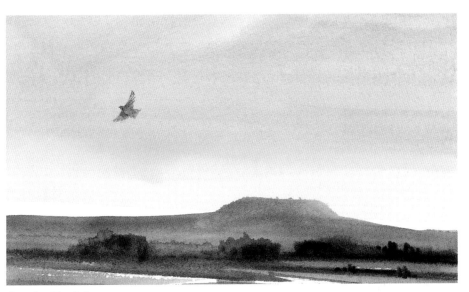

Creative Sky Colors

Use your imagination to make sky colors creative and exciting. I used a wet-into-wet wash of Raw Sienna, Permanent Rose and Cerulean Blue and allowed the colors to mix on their own.

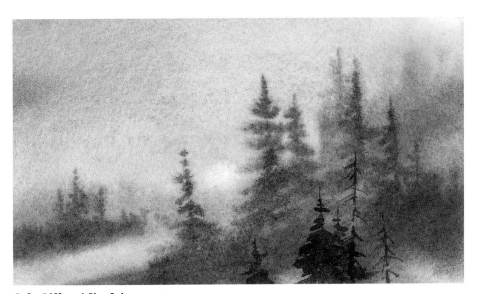

Soft, Diffused Sky Colors

Use complements of sky colors to create gray clouds or fog. Here I used Red-Orange to dull the intensity of French Ultramarine Blue. The soft yellow glow is Raw Sienna.

FOLIAGE COLORS *and* OTHER GREENS

When you think of painting foliage, green is probably the first color that comes to mind. In reality, foliage is a composite of colors and values. In spring new growth is light in value, so use transparent yellows and blues to show young leaves. Summer brings colors that have darker, richer values, and in fall the foliage shows intense warm colors and earth tones.

Mixing Green

You can easily mix green from yellow and blue, but you should understand opacity and color temperature to determine which yellows and blues make your desired green. Try mixing your greens on a palette, on paper, or as one color glazed over another in your painting. Your choice of mixing techniques personalizes your work. Create a limitless choice of greens by using these different mixing methods and varying the proportions of yellow and blue.

CONVENIENCE COLORS

Tube colors are often called convenience colors. If you need green, reaching for a tube of paint is certainly easier than trying to mix the color you need. But if you rely on tube colors too much, you might forget how to mix vibrant colors. Even worse, if you use only tube colors, all the colors in your painting will be the same value and intensity, making your paintings flat and lifeless. Try using mixed greens and tube colors together. They complement each other and give you an endless choice of greens to work with.

Foliage and Other Greens (Convenience Colors)
Greens come in a wide selection of tube colors. They range from very opaque, low saturation to transparent, high-intensity, staining color. Try not to rely on tube colors so much that you overlook mixing the colors yourself.

Cerulean Blue Cobalt Blue French Ultramarine Blue Indigo

Cerulean Blue Cobalt Blue French Ultramarine Blue Indigo

Cadmium Yellow Lemon

Aureolin Yellow

Foliage Colors and Other Greens (Mixed Colors)

Learning to mix colors, especially green, is essential. Take every yellow you have on your palette and mix it with every blue. This gives you an idea of the value and intensity of the greens you can mix. Notice that when you mix a cool yellow with a cool blue you get a bright, vibrant green. By mixing a warm and a cool or two warm colors, you get a dull or less intense green. The warm yellow and blue have red in their pigment. This is the complement to green and dulls or grays the color.

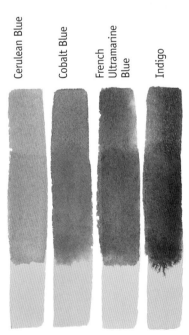

Cerulean Blue Cobalt Blue French Ultramarine Blue Indigo

Cadmium Yellow

Glazed Flat Wet-into-Wet

Mixing Greens With Glazes and Washes

Mix greens with yellow and blue washes on dry paper. Allow each glaze of color to dry before applying the next glaze. Thin washes of yellow and blue create wonderful, vibrant greens. Mix yellow and blue on the palette to create a flat or gradated wash. Vary the proportion of yellow or blue to get a wide range of greens. A wet-into-wet wash can also create greens. The colors blend on their own. Pick up the paper and tilt it back and forth to help the colors mix.

Glazed Wet-into-Wet

Create Greens by Mixing Colors

In the painting on the left, I used Cadmium Lemon and Cobalt Blue as thin glazes—one color over the other. I incorporated the dark background into the painting with French Ultramarine Blue as a glaze. The sketch on the right is a wet-into-wet wash. I used Quinacridone Gold and Cobalt Blue to create the color on the leaves. In the background I used Quinacridone Gold, French Ultramarine Blue and Sap Green as a wet-into-wet wash. This mixture creates a much darker, less vibrant green.

170

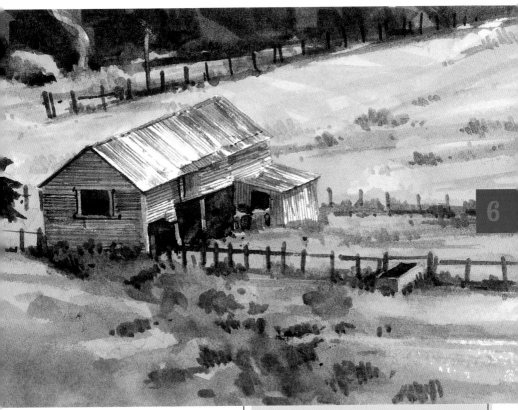

Mix Colors on a Palette and Paper

For this piece, I glazed the colors and used wet-into-wet washes. Throughout the painting, I mixed colors on the palette as well as on the paper. I used Quinacridone Gold, Cobalt Blue and French Ultramarine Blue to mix the greens and Alizarin Crimson to gray and darken some of the greens.

NEW ZEALAND OUTBUILDING
Watercolor on 140-lb. (300gsm) cold-pressed paper
5" × 7½" (13cm × 19cm)

FAVORITE COLOR MIXTURES

My color palette has changed greatly since I started painting. I have garnered a better understanding of how colors work together by experimenting, asking friends, observing and practicing with color. Although having too many colors on the palette is confusing, you should try new ones. Tried and true colors become old friends that are too dependable and comfortable. Make a point to try new colors or combinations that add variety to your color schemes.

Every artist has an inherent way of painting. In time you will develop a style and find subjects you like to paint. In turn, this realization will help you find a color palette for your work.

Using Special Color Mixtures
This is a sketch of New Zealand's favorite blossom from the Pohutukawa tree. I used Quinacridone Magenta and Permanent Rose for the flowers and New Gamboge and Cobalt Blue for foliage. French Ultramarine Blue, Alizarin Crimson and Winsor Green create the background. I used more Winsor Green in the mixture and allowed it to be more visible. I added a bit of Olive Green into the wet-into-wet wash to help the background and foliage work together.

POHUTUKAWA (SKETCH)
Watercolor on 140-lb. (300gsm) cold-pressed paper
5" × 7" (13cm × 18cm)

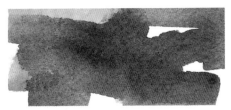

Sap Green/Burnt Sienna

Cobalt Blue/New Gamboge

Permanent Rose/New Gamboge

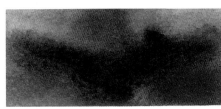

Alizarin Crimson/Winsor Green

Permanent Rose/Cobalt Blue

Alizarin Crimson/French Ultramarine Blue/
Winsor Green

Quinacridone Gold/Cobalt Blue

Favorite Color Swatches

These are some of my favorite color combinations. You can make a wide
range of tints and shades from these mixtures. Experiment on your own by
trying glazes and wet-into-wet washes with different color combinations.

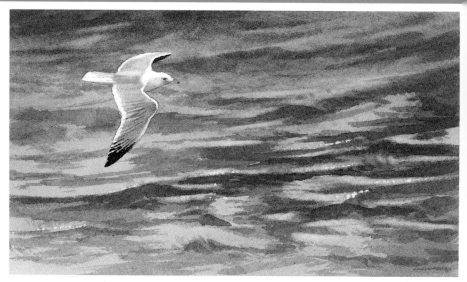

Creating Water

A favorite color combination of mine for mixing blues is Cobalt Blue, French Ultramarine Blue and Alizarin Crimson. With this mixture you can create a wide range of values. If you substitute Permanent Rose for Alizarin Crimson, a rich shadow color emerges, especially good for painting snow.

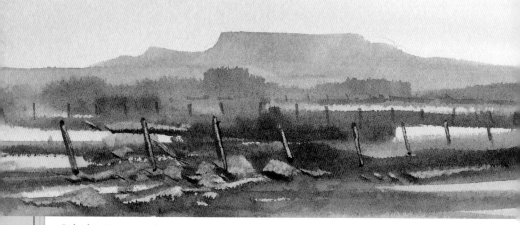

Painting Warm Backgrounds

I used Burnt Sienna and New Gamboge as a color mixture to create a warm background. I added Cobalt Blue to Burnt Sienna as a wet-into-wet wash in the middle ground. Soft blue-gray created the trees. The foreground is a mixture of Quinacridone Gold and Cobalt Blue for the subdued greens and browns. I used a palette knife to create the rocks.

Use Few Colors

You don't have to use exotic or numerous colors to create dramatic paintings. This is a great Alizarin Crimson and Winsor Green combination. The background is Permanent Rose and New Gamboge in a very soft wet-into-wet wash. I started the trees just before the paper dried to get the diffused effect. The Alizarin Crimson separates from the Winsor Green. Scrubbing with a bristle brush and lifting the color from the dark wash created the light coming through the trees.

6

Mix Rich Washes

I used a combination of French Ultramarine Blue, Alizarin Crimson and Winsor Green to make a rich wet-into-wet wash for the background. The shadow colors used on the flower are a mix of Cobalt Blue and Permanent Rose, one of my favorites for casting shadows on snow.

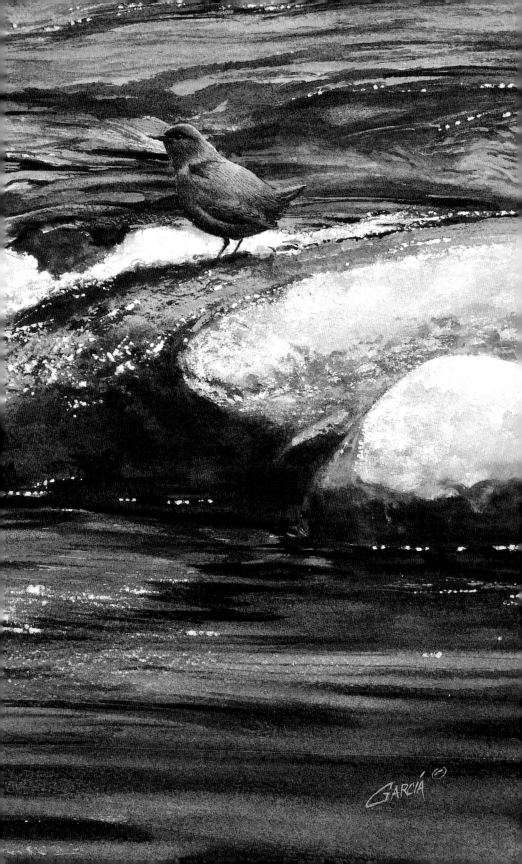

Special Effects

Trying to capture a three-dimensional subject on a two-dimensional surface is not an easy task. Special effects (some people call them "tricks") are ways of communicating a three-dimensional idea and showing mastery of the medium. Keep in mind that, while special effects encourage spontaneity and creativity, they don't always guarantee a successful painting.

I used several special effects in the painting on the facing page. Paraffin and sandpaper helped me capture the illusion of the fast flowing, rocky stream. I created the large rocks using a palette knife and sandpaper and I scraped in the sparkle on the water with the tip of a utility knife.

Be careful not to overuse special effects because they can become trite. Instead, develop and combine your own solutions to using watercolors. Learn from the examples in this chapter, and you will find you have only scratched the surface of possibilities.

FIRST DIP
Watercolor on 300-lb. (640gsm) cold-pressed paper
24" × 32" (61cm × 81cm)

SPLATTERING

Splattering paint is a useful technique used to create rocks, old paint, rust and old wood textures. You can also use splattering to create foliage or a loose foreground.

Tools and Techniques

A toothbrush or a flat, round, bristle or synthetic brush all work well for splattering. If you hold a flat brush horizontally to the paper, you can concentrate the splatter. Holding the brush vertically to the paper creates a long line of paint. Splattering paint onto a wet, damp or dry surface gives three distinct results. A toothbrush leaves a small, uniform texture. A bristle brush produces a larger,

more spontaneous texture. You can also splatter different colors together. Use a paper towel and gently lift away some of the damp splatter to change the value and intensity of the color. Try splattering with clean water onto a previously splattered area for an interesting effect.

Paint from very wet on the top to dry toward the bottom, using a ¾-inch (19mm) flat. Notice how the excess water lifts and carries the pigment toward the damp area.

Splatter the top area with a toothbrush, and the bottom area with a 1-inch (25mm) flat bristle brush.

Top: Splatter paint into clean splattered water. Middle: Splatter various colors into one another. Bottom: Use a paper towel to lift color.

SALT TEXTURE

Salt texture is a wonderful, spontaneous technique to use in watercolors. Salt crystals are like small sponges that absorb the water and paint. As the salt dries it leaves behind a texture. If the paper is very wet, most of the salt dissolves and leaves little texture. Damp paper creates a pronounced snowflake-like texture. Brush off the salt just before it dries or it will stick to the surface of the paper. Also, the weight of the paper (how much water it absorbs) and the color used influences how the salt works. For best results practice and experiment. The more familiar you become with this technique, the easier it will be to use.

SALT CONTROVERSY

The use of salt in paintings is controversial. The pH level of the paper is slightly lowered when salt dissolves and is absorbed into the fibers. Some believe that salt shortens the life of the paper and consequently the art.

7

Apply salt to a very wet surface. Most of the salt dissolves, leaving very little texture in the paint.

Apply salt to a damp surface. The paper doesn't dry evenly, creating a variety of textures.

Apply salt to a damp surface. A small, delicate texture develops. Each spot is a grain of salt.

STIPPLING

Stippling is a very creative and useful technique but can be time-consuming in its execution. It ranges from black and white dot patterns to dabbing the surface with a bristle brush. Using ink or paint in a pointillism fashion creates the texture. You can create values, patterns and even colors by the density or proximity of each dot to the next.

Create a wide range of values with a black and white pattern using a new fine-point permanent marker.

Use Indian Yellow, Cobalt Blue and Alizarin Red to create the stipple pattern with various size dabs using a round synthetic brush.

Use an old bristle brush to create this stipple pattern. Dab on Aureolin Yellow and Cadmium Red with quick, vertical strokes.

SPONGE

Sponges are versatile tools in painting the textures of trees, rocks and shrubs. Use it to paint with or to lift color off the paper. There are two types of sponges, natural and artificial. Natural sponges have wonderfully diverse surfaces. You may want to buy two or three because each has a unique surface texture. Most synthetic sponges are less textured and have a mechanical look to their surface patterns. Because sponges are so absorbent, you must mix up much more color than you would if using a brush. Apply the paint to a dry or damp surface with a sponge, pulling, dabbing or pushing to create unique textures or patterns.

MANIPULATE YOUR SPONGE

One benefit of using sponges is that they can be cut or torn and shaped into more manageable painting tools.

7

Use a large natural sponge to create textures on first a damp, then a dry surface.

Load an artificial sponge with paint and dab it on the surface.

Load a large natural sponge with paint and pull it down and across the paper.

MASKING FLUID

The basic use of masking fluid is to preserve the white of the paper. You can also use it to create textures. Use masking fluid to create everything from falling snow to water splashing on rocks to tree bark to fish scales. Masking fluid works well because you can apply it in many different ways and you can remove it easily.

Try a Toothpick

There are times when a toothpick or small stick works better than a brush for applying masking fluid. A toothpick leaves a thin long line of fluid on the paper. You can crosshatch with it or draw fence lines. I can create almost any linear texture by using this technique. A sponge is also a good tool for applying masking agent. If I dab the surface of the paper it leaves a very loose organic texture. This is good for masking out the highlights in trees.

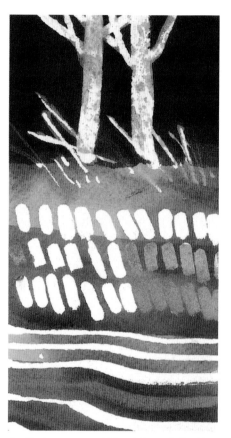

For the top, use an old brush to apply liquid latex to the two tree shapes. Let the latex dry. Gently rub the latex with your finger. Partially remove the latex creating a bark-like texture. Glaze Burnt Sienna over the area. Let the paint dry. Remove the remainder of the latex to complete the texture. For the middle sample, use the same concept of partially removing some of the dried latex. The texture was created by cutting the end off an old no. 4 round. For the bottom, apply liquid latex with a brush, but change the pressure to get a thin or wide line.

CREATE DYNAMIC TEXTURES

You can apply masking fluid with an array of tools. Use these tools to create a variety of textures:

- Flat brushes
- Round brushes
- Toothbrush
- Toothpick

Use a toothbrush to apply masking fluid on the surface. Gently drag your thumb over the bristles of the toothbrush to get a fine splatter effect. Flick your wrist while holding a ¾-inch (19mm) flat brush to get the large splatter. Practice these two techniques on a piece of scrap paper to judge how much latex is on the brush.

Apply masking fluid with an old round brush to create negative and positive shapes.

7

MASKING TAPE

Use masking tape to make resists. Tear it to create loose, broken edges or cut it to make clean, sharp lines. You can also make negative or positive shapes with tape. Use a good quality tape, apply where necessary and burnish it to prevent paint or water from creeping under the edge. Practice with scrap materials until you can cut through the tape without damaging the paper underneath. If you want a soft edge, remove the tape while the paint is still wet.

Inexpensive packing tape also works well. The thin packing tape allows you to easily see pencil lines through its surface and is easier to cut than masking tape.

USE DURABLE PAPER

When you remove tape from soft or poor-quality paper, it may lift paper fibers or even tear the paper. Heavier weights and good-quality papers will hold up better when used with masking tape techniques.

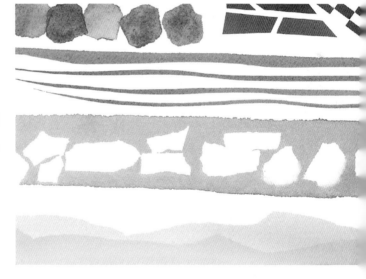

Cut or tear positive shapes from masking tape. Cut long, thin strips and paint over them. Bend tape to follow contours.

Tear pieces of tape and burnish them to get the white shapes. Then paint over the area.

Tear long pieces of tape and paint up to or over them. In this example, the special effect leaves a mountainlike image.

WAX

Wax works well as a resist and it leaves behind a very textural quality. It's easy to apply wax; simply draw, rub or drip it onto your paper. However, wax can be difficult to remove. After your paint is dry, lay paper towels over the wax. Then drag a hot iron over the surface of the towels. The wax will melt and most of it will be absorbed by the towels.

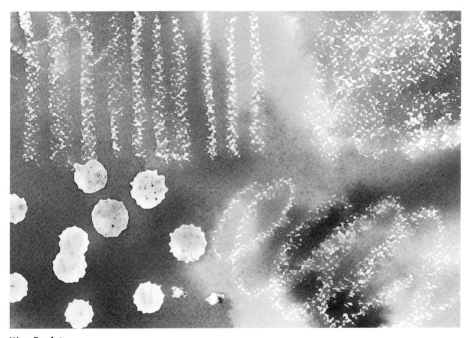

Wax Resist
Create a very loose, broken texture by drawing, rubbing or dripping wax on the surface of the paper.

PALETTE KNIFE

A palette knife is a good for removing wet paint or applying paint. Use the long edge or tip of a palette knife like a squeegee to push or pull paint away from a specific area. On very wet paper, paint may run back into the area where the palette knife is used, leaving dark lines which can be an interesting textural element.

Texturing with a palette knife will permanently dent the paper, so use a palette knife only when you are sure it will create the texture you want.

You can also paint thin and thick lines with a palette knife. Use the tip to paint branches, grass or fence posts. Use the edge to paint long thin lines such as wires or masts.

BEFORE USING A NEW PALETTE KNIFE

A new palette knife has a thin coat of varnish on its surface to prevent rusting. Before using the knife, sand it or hold it against a flame to remove the varnish so that paint can cling to the blade.

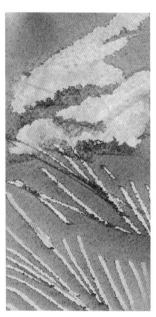

Use the edge and tip of the knife on damp paper to subtract or remove paint from a specific area.

Use the tip and edge of the palette knife on very wet paper to make the pigment run back into the affected area.

Load paint on the tip or edge of the palette knife and pull it across the paper.

PLASTIC WRAP

Place plastic wrap over a wet wash to create a unique effect. The surface of the paper and the wetness of the paint determine the plastic's effectiveness. The resulting texture depends on how much the plastic wrap is scrunched when placed on the wet paint and where the plastic touches the surface and prevents the paint from drying. When you remove the plastic wrap it picks up the wet paint, leaving behind an unusual and spontaneous texture.

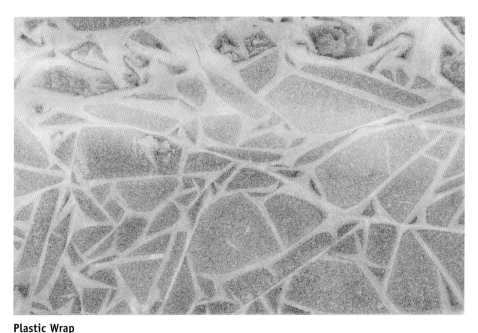

Plastic Wrap
Apply plastic wrap over a very wet-into-wet wash. Allow the wash to dry before removing the plastic wrap. A unique and unusual texture appears over the area of the wash.

ALCOHOL

Alcohol used as a special effect is difficult to control because it evaporates and dilutes quickly, losing its ability to create texture. You can effectively apply only one wash over an area of alcohol. Additional washes dilute the alcohol, causing it to lose its ability to resist paint. Very wet paint will flow back into an alcohol area leaving a dark smudge or blemish. You can brush or splatter with alcohol either before or after the paint is applied.

Splattered Alcohol
Splatter alcohol on a clean dry surface. With a 1-inch (25mm) flat, paint over the area before the alcohol evaporates. Don't repeat with additional layers of paint because the alcohol will be diluted and won't work.

TEMPLATES

A template is a way to create a pattern or texture of repetitive negative or positive shapes in a painting. Cut a template from tape, heavy paper or acetate. Strong tape works best for making a template of a detailed subject.

When lifting through a template, remember that a too-moist brush will encourage paint to slip under the edge of the template, ruining the template's effectiveness. To use a template for positive painting, apply paint over the template.

TRY YUPO STENCILS

Yupo, a plastic paper available at art supply stores, makes excellent templates that are reusable and stand up to strong lifting with a brush. Cut the Yupo with a sharp utility knife.

Using a Stencil
Cut the template material with a sharp utility knife to make stencils of various shapes or patterns. Create a wet-into-wet wash over an area, then lift shapes out through the stencil.

BLOOMS *and* BACK RUNS

Blooms, back runs, flowers and bleeds are all names for the texture created when you feed water or a wet wash into a wash that is less wet. As the excess water flows into the less wet area, it moves the original pigment. When this pigment flows outward, it creates a dark flowerlike edge.

A bloom is often created accidentally, as when clear water is dropped into a wash, but you can also use this organic-looking texture purposely to create weeds, trees, even clouds.

Forming Blooms

To create a bloom, first apply a wash of color. Allow the wash to partially dry. Now splatter, drop or brush color or water into this partially dry wash. A bloom will start to form. This is an exciting technique that is difficult to control. Timing is critical.

Controlling Blooms
The upper area of this demonstration is a mixture of French Ultramarine and Alizarin Crimson. Just before the wash dried, I added clean water to the edge of the wash and allowed it to run out. A bloom started to form. Lifting and tilting the paper controls the bloom to a certain extent. I used a flat brush in the lower area to feed water into the wash and allowed the color to lift and bleed out. This created two soft lines with blooms along their edges. At the very bottom, I added water to the edge of the wash and let it bleed outward.

OTHER FAVORITE TEXTURES

Favorite textures are often discovered by accident. Trying to create one texture leads to the discovery of another. Often favorite textures are a combination of special effects. Sandpaper and wax or splattering and opaque paint create unique textures.

A style can emerge from using special effects; an artist who uses resists in all of his or her work will develop a recognizable style. Technique tends to be a style or method of painting, while special effects are only a part of that style. It is best not to overuse special effects because they can lose their effectiveness. On the other hand, restricting your box of tools to only a brush limits the potential of watercolors. Use special effects and unusual techniques to explore your creativity and spontaneity.

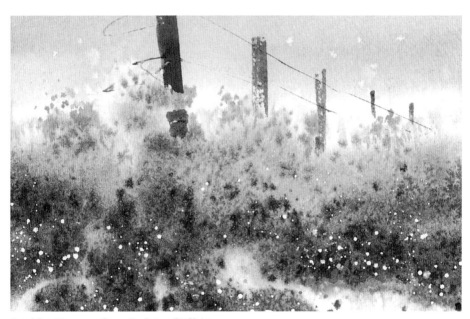

Combine Textures for a Variety of Effects
This is a combination of favorite textures. In the foreground I splattered color on a wet surface, then added salt. As drying continued, I splattered more color onto the original color. I brushed the salt off and added fence posts with scraps of mat board dipped in paint. Then I painted the wire with the edge of a palette knife. Finally, when all was dry, I splattered opaque paint over the surface. A series of favorite textures created a loose, quick sketch.

Mat Board

Use scraps of mat board to apply paint. Cut mat board into various lengths and load the edge with paint. Pull, twist and drag color over the surface of the paper to create textures.

Found Objects

Use found objects such as leaves, doilies, bottle caps, etc. to create interesting textures. The lower right texture was made with a rubber band dipped in paint.

More Found Objects
To create this texture, spatter color over bottle lids and pine needles. The
white of the paper demonstrates the overlapping of shapes. An initial wash
of color in place of the white background would be very effective. Try it!

Paper Towels
Use a crumpled paper towel dipped in paint to achieve this pattern. Shape
the paper towel to fit the area to be painted. Then gently dab the paint
onto the surface of the painting. Vary the pressure and dab away!

Popular Subjects

How often have you thought, "There is nothing to paint," when in reality you are surrounded by readily available subjects? Take a fresh look at the things around you. Not every painting must have a complex composition, dramatic color or a dynamic setting.

Creating a composition is a matter of choosing a subject and simplifying, subordinating or eliminating unwanted elements. A painting that is too literal leaves nothing to the artist's or viewer's imagination. As the artist, you can rearrange or combine elements or change the emphasis of the subject. This skill can be developed only with practice and self-confidence.

A composition should have flow and rhythm. Rows of cars in a parking lot, for example, can have a flow based on the cars' positions and rhythm created by their colors. Seeing, using and developing a subject's natural flow comes with practice. Don't have a preconceived idea of what a subject can be. Try painting commonplace subjects, such as a book of matches or an onion, to expand your skills of observation and to gain mileage in developing drawing and painting skills. Paint, paint and paint some more, and your enjoyment and skill will grow.

THE PACK
Watercolor on 300-lb. (640gsm) cold-pressed paper
19½" × 40" (48cm × 101cm)

FUR and FEATHERS

Animals are challenging to paint. However, painting a pleasing portrait of a bird or the family dog is within everyone's capabilities.

Start by using a good reference photo. Animals and birds generally don't remain stationary for long, so you'll probably need to use a camera to catch a pose. (See the list of tips for taking good reference photos on this page.)

To make the painting challenge less intimidating, take your time. Remember to start with loose washes and work your way toward tighter details. Work from light to dark and use strong value patterns. A painting of an animal can be a very complex and detailed composition or a series of loose, wet-into-wet washes with little or no detail.

Although you cannot expect every painting to be successful, developing your painting skills and your confidence will increase your success rate.

TIPS FOR TAKING GOOD REFERENCE PHOTOS

- Whenever possible, take reference photos in natural light. Flash photography leaves a halo of harsh shadows and tends to eliminate middle values. If you are indoors, use fast film such as ASA400 (27DIN) or above to reduce the need for flash.

- Try to photograph against a simple background so that the subject will be clearly visible.

- Take a variety of photos from different heights and angles so you can choose the one that works best for a painting.

Mountain Lion

Begin this painting with a clean, clear pencil drawing that indicates the placement of all major elements. Color, value and shadows all need to be defined before you start to paint.

Materials

BRUSHES
Nos. 4 and 6 rounds

WATERCOLORS
Burnt Sienna
Cobalt Blue
Raw Sienna

1 Create a Detailed Sketch

Indicate bone structure and fur direction on your pencil sketch. The degree of detail will be defined by your style of painting.

8

2 Establish Color and Value

Brush a wash of water over the drawing of the mountain lion. Then lightly wash a mixture of Burnt Sienna, Raw Sienna and Cobalt Blue into the appropriate areas, lifting some color near the eye and cheek before it dries. Let dry. Paint the nose and shadows with nos. 4 and 6 rounds. Keep detail to a minimum.

197

3 Add Details

Make brush-strokes that follow the direction of the fur. This is a necessary step when realistic definition is required.

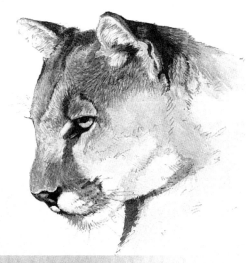

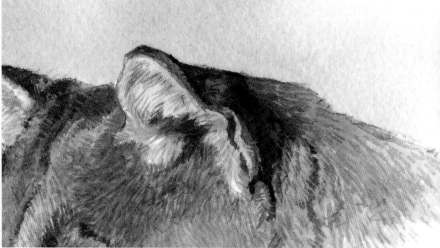

4 Add the Background

Let the painting dry thoroughly, then paint clean water on the background up to the edge of the portrait. (If the paint is dry, the water will not run into the portrait.) Brush Burnt Sienna and Cobalt Blue into the saturated background. Tilt the painting from side to side to enhance the flow of color.

Highlight the Eye

Add the Eyelashes

Paint the Whiskers

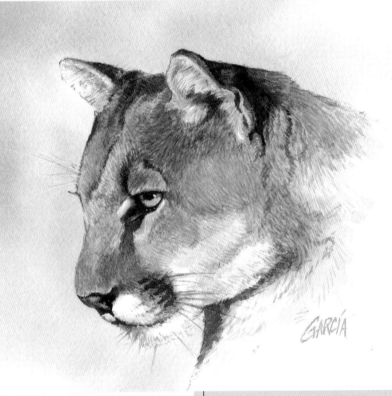

5 Add the Final Details

In the final stage, darken any weak values, especially in shadows or near the eyes. Use a no. 4 round to soften the perimeter of the portrait. Finally, add small details such as the highlight in the eye, whiskers and eyelashes.

PORTRAIT OF A MOUNTAIN LION
Watercolor on 140-lb. (300gsm)
cold-pressed paper
5½" × 6½" (14cm × 16cm)

Fat Cat

This painting requires a careful drawing that shows the placement of shadows and changes in fur color.

Materials

BRUSSES
¾-inch (19mm) flat

Nos. 2, 4 and 6 rounds

WATERCOLORS
Burnt Sienna

Cobalt Blue

Permanent Rose

Sepia

GOUACHE
Titanium White (or
 Pelikan Graphic
 White)

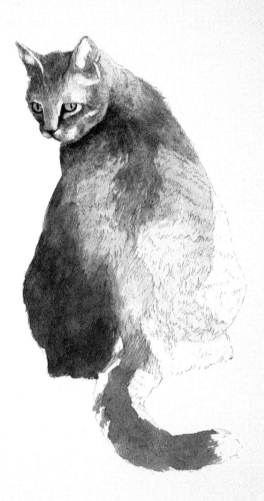

1 Draw, then Paint Base Washes
Draw the cat, then saturate the drawing with a wash of water. Paint wet-into-wet washes of Burnt Sienna, Sepia, and Cobalt Blue. As the washes are drying, add more dark values around the nose and eyes and in the shadow area under the jaw.

200

Add Whiskers and Eye
Reflections With Gouache

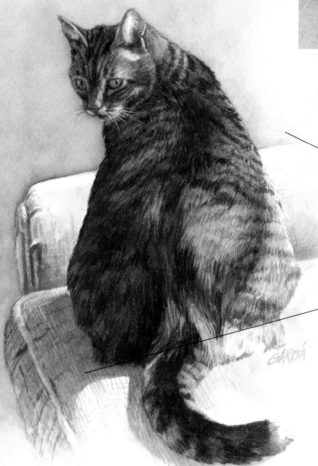

The background must
be dark enough to
define the couch but
not so dark as to lose
Snaps' head and
shoulders.

8

The shadow on the
couch must follow the
contours of both the
couch and the cat.

2 Paint Fur Details and Background

Paint the fur with thin strokes following the direction in which the hair lies, working from light to dark values. Use Permanent Rose on the nose and inside the ear. The background and couch are a series of washes using Permanent Rose, Burnt Sienna and Cobalt Blue. Detail the sofa and soften hard edges. After everything dries, add whiskers and eye reflections with white gouache.

SNAPS—FAT CAT, SWEETIE CAT
Watercolor on 140-lb. (300gsm)
cold-pressed paper
8" × 5½" (20cm × 14cm)

Black-and-White Dog

Convincing black fur is painted with multiple colors. I've used the white of the paper to represent white fur. For large dark areas, use a 1-inch (25mm) flat. As areas begin to dry, switch to the no. 6 round and add darker directional lines. Paint the more detailed areas of hair with the no. 4 or no. 2 round.

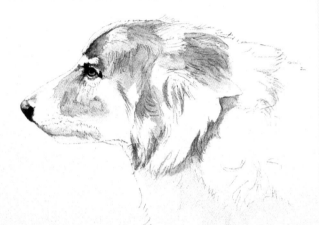

1 Draw, Then Paint Base Washes
Use a 3H pencil to make a drawing that shows the patterns of light and dark on Rocky's face. Use a light wash of Permanent Rose and Burnt Sienna to warm some areas. Add a light wash of Cobalt Blue, French Ultramarine Blue and Permanent Rose for the dark patterns.

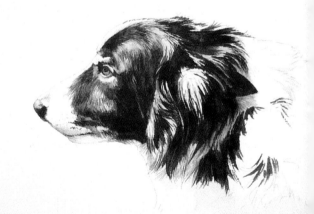

2 Define Lights and Darks
Mix French Ultramarine Blue, Brown Madder and Sepia; add this to the dark areas to define the facial patterns. The darker you paint an area, the lighter in value the adjoining area will seem. Now you can lift and soften some highlights in the dark areas. Warm the areas near the forehead and eye with a small amount of Burnt Sienna.

Highlight the Eye　　**Establish Fur Direction**

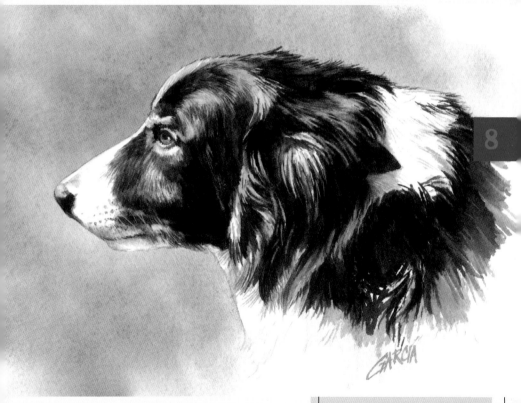

3 Add Fur Details and Background
Paint the fur with long thin strokes, indicating just a bit of light texture in the white fur areas. Let dry thoroughly. Brush clean water in the background up to the edge of the portrait. After the water has saturated the background, add a wet-into-wet wash of Quinacridone Gold, Cobalt Blue and French Ultramarine Blue. Let dry. Soften any hard edges. Finish by adding whiskers and eye reflections with gouache.

ROCKY
Watercolor on 140-lb. (300gsm)
cold-pressed paper
5½" × 8" (14cm × 20cm)

203

Golden Retriever

Josh is a water dog—a golden retriever full of vim and vigor. Make a careful drawing with a 3H pencil, leaving clean, light lines. Add a loose drawing of the water that surrounds him. Do not press too hard, or the pencil will score the paper.

Materials

BRUSHES
¾-inch (19mm) and
1-inch (25mm) flat

WATERCOLORS
Alizarin Crimson

Burnt Sienna

Cobalt Blue

French Ultramarine Blue

Permanent Rose

Raw Sienna

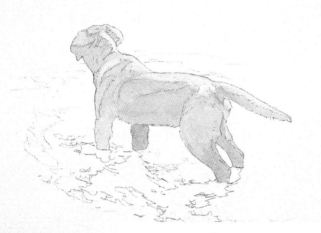

1 Paint the Base Wash
You don't need a preliminary clear water wash over this small an area. Just brush a light wash of Burnt Sienna, Raw Sienna and a touch of Cobalt Blue over the drawing. Allow the wash to dry.

2 Add Middle Values
Add darker values to Josh's fur using washes of Burnt Sienna, Permanent Rose and French Ultramarine Blue. Soften or lift colors to bring back highlights. Don't worry about detail too much at this stage; simply layer a series of light and dark washes until you reach the correct values.

Make the Water Sparkle

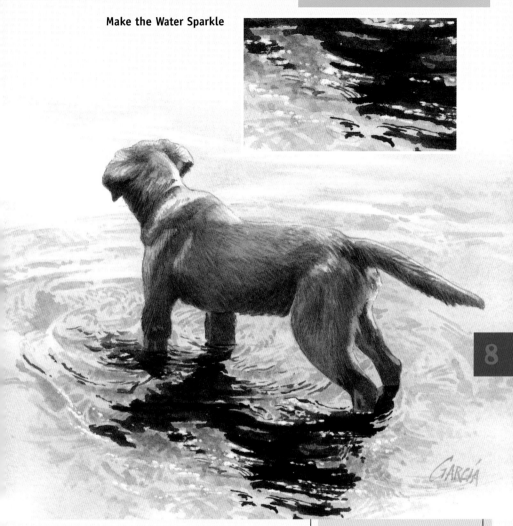

3 Finish Fur Texture and Paint the Water
Paint fur texture following the direction of the hair growth. Let dry thoroughly, then brush a wash of water around and up to the edge of the dog. Put a thin wet-into-wet wash of Cobalt Blue and Permanent Rose into the background. Tilt the painting back and forth to make the paint run. After this wash is completely dry, add the darker values to the water.

The last area to be painted is Josh's reflection. Use a very rich wash of French Ultramarine Blue and Alizarin Crimson and strokes that follow the water ripples. When the painting is dry, create sparkle on the water by scratching the surface with a utility knife—but do not overdo this technique.

JOSH
Watercolor on 140-lb. (300gsm)
cold-pressed paper
5 ½" × 7 ½" (14cm × 19cm)

Snowy Owl

This painting captures the essence of the bird and is not meant to be an anatomical rendering. The general feeling must be right, but you don't have to show every feather.

Materials

BRUSHES
½-inch (12mm) flat

WATERCOLORS
Alizarin Crimson

Cobalt Blue

French Ultramarine Blue

Permanent Rose

Quinacridone Gold

Raw Sienna

Winsor Green

1 Sketch, Then Lay On Washes

Sketch the owl very lightly. Loosely brush washes of Permanent Rose, Cobalt Blue and Raw Sienna over parts of the background and bird using a ½-inch (12mm) flat. Let dry. Add darker values and shadows, helping to define the shape of the bird and some of its feathers and facial features. These darker values are the same colors that were used over the background and bird; just use less water in the mixture.

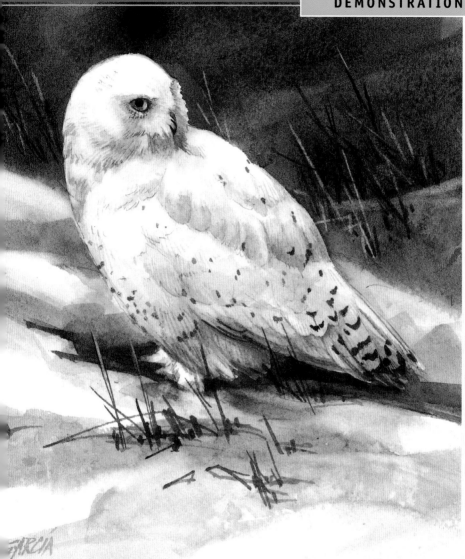

FARCIA

8

2 Add Dark Values

The way to make an area white in a watercolor painting is to surround it with a dark, rich value. Note that this owl is almost completely surrounded by dark values. Use French Ultramarine Blue, Alizarin Crimson and Winsor Green to achieve the dark value here, with a bit of Quinacridone Gold in some areas. Paint shadows and weeds. Lift out a few final weeds using a ½" (12mm) flat.

SNOWY OWL
Watercolor on 140-lb. (300gsm)
cold-pressed paper
7" × 6" (18cm × 15cm)

Cedar Waxwing

The cedar waxwing is a sleek, fast-flying bird that migrates throughout North America. This painting is an example of a dark subject on a light background.

1 Create Initial Washes
Make an accurate drawing with a 2H or 3H pencil. Do a wet-into-wet underpainting using Burnt Sienna and Permanent Rose on the head and Cobalt Blue and Burnt Sienna for the blues and grays. Let the colors blend softly. Keep the white areas on the wing and head free of color.

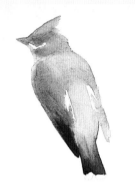

Materials

BRUSHES
¾-inch (19mm) and
1-inch (25mm) flats

Nos. 2, 4 and 6 rounds

WATERCOLORS
Brown Madder

Burnt Sienna

Cobalt Blue

French Ultramarine Blue

Indian Yellow

Permanent Rose

Raw Sienna

Sepia

2 Finish the Bird
Push the shadows and add dark values to make the waxwing look three-dimensional. For the black areas on the head and beak, use French Ultramarine Blue and Sepia. Lift out a bit of color from the top of the beak to give it form. For the body, add subtle directional strokes to indicate feather texture. Tip the tail feathers with Indian Yellow.

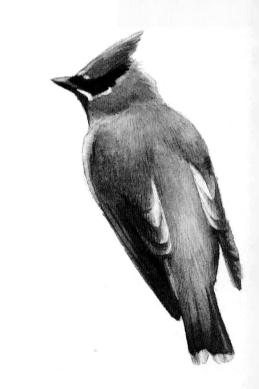

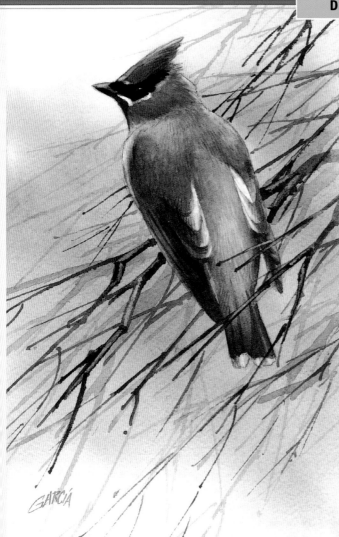

GARCÍA

MAYBE FOR OSCAR'S BACKGROUND (handwritten)

8

3 Add the Background and Branches

When the bird is dry, paint a light wet-into-wet wash of Cobalt Blue, Permanent Rose and Raw Sienna over the background, letting the colors run together. Let dry, then add the branches. The background branches are a bluish gray mixture of Cobalt Blue, Permanent Rose and Brown Madder. The foreground branches are Burnt Sienna and French Ultramarine. Use a palette knife to lift highlights from the branches while the paint is still wet. Pick out the eye highlight with the tip of a utility knife.

CEDAR WAXWING
Watercolor on 140-lb. (300gsm)
cold-pressed paper
8" × 5" (20cm × 13cm)

Gorilla

What a great expressive face! I did this painting on 300-lb. (640gsm) paper, knowing the heavier paper would retain moisture longer. If you prefer 140-lb. (300gsm) paper, you will have to work more quickly and carefully.

Materials

BRUSHES
1-inch (25mm) flat
No. 6 round

WATERCOLORS
Brown Madder

Burnt Sienna

Cobalt Blue

French Ultramarine Blue

Sepia

1 Draw, Then Paint Initial Washes

Do a loose pencil drawing. Saturate the drawing with water. As the water dries, mix large puddles of colors. For the warm areas, mix Burnt Sienna and Brown Madder. Mix a Cobalt Blue wash for the face. For dark areas, mix Sepia, Burnt Sienna and French Ultramarine Blue. Wait until the paper has just lost its shine before applying the washes. Timing is critical: If the paper is too wet, the colors will run and lose their shape, but if it is too dry, nothing will happen except a confined brushstroke. Paint the darkest values (the neck and chin shadows and the mouth line) last.

8

2 Add Facial Details and Highlights

The 300-lb. (640gsm) paper will stay damp for a long time. You can add darker values over each other and they will soften and blend. You will achieve highlights most easily while the paper is slightly damp. If the paper dries, scrub the area a little harder. A small bristle brush works well. Paint the dark facial details, the eyes and a few hairs around the face. Lift the highlights in the eyes with the sharp point of a utility knife.

MIGHTY JOE
Watercolor on 300-lb. (640gsm)
cold-pressed paper
7" × 6" (18cm × 15cm)

Cow

It is milking time and our old friend is ready to head home. Start this painting by sketching the cow without detail except for its black-and-white pattern. After you finish painting the darks, lights and background, you'll add texture to the ground with salt.

Materials

BRUSHES
¾-inch (19mm) and
 1-inch (25mm) flats

Nos. 2, 4 and 6 rounds

WATERCOLORS
Alizarin Crimson

Cobalt Blue

French Ultramarine Blue

Olive Green

Permanent Rose

Quinacridone Gold

Winsor Green

1 Block in Dark Colors
Mix a black using French Ultramarine Blue, Alizarin Crimson and Winsor Green. Fill in the dark areas and allow them to dry. Paint the chin, nose, belly, tail and legs with washes of Permanent Rose and Cobalt Blue. Do not worry about detail yet.

**Make Texture
With Salt**

Let the dark back-
ground surround and
define the white areas
of the cow.

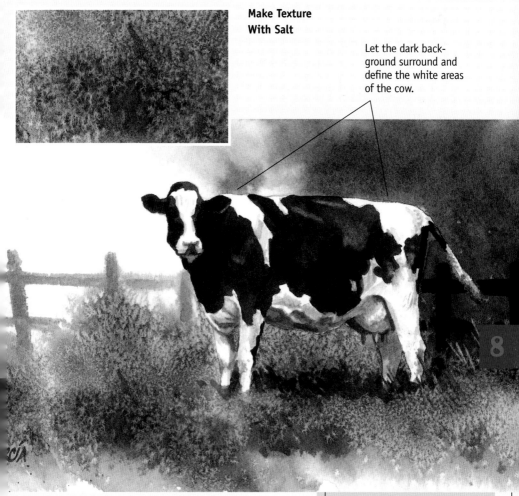

2 Detail the Cow and Add the Background

After the darks are dry, gently lift out a little of the color; keep it subtle. Darken the belly and udder by adding a wash of Cobalt Blue and Permanent Rose. Now comes the fun part. Paint a wet-into-wet wash onto the background using French Ultramarine Blue, Alizarin Crimson, and a little Quinacridone Gold. Paint the foreground with Burnt Sienna, Quinacridone Gold, Cobalt Blue and Olive Green. While the foreground is still wet, sprinkle a little salt onto the mixture, creating a very organic texture with no other detail. Brush off the salt just before the painting is completely dry (the salt will adhere to the surface if allowed to dry). Add the fence—the last detail of the painting.

MILKING TIME
Watercolor on 140-lb (300gsm)
cold-pressed paper
5" × 8" (13cm × 20cm)

Bear

What does a bear do in the woods? He gets painted! This is an example of painting a loose, free-flowing, abstract design over the background before adding the subject. Use a 2H pencil for the drawing. Make sure the drawing is dark enough that it won't get lost in the wash.

Materials

BRUSHES
¾-inch (19mm) and
 1-inch (25mm) flats
Nos. 2, 4 and 6 rounds

WATERCOLORS
Brown Madder

Burnt Sienna

French Ultramarine Blue

Olive Green

Permanent Rose

Sepia

1 Draw, Then Add Background Washes
Make a fairly dark sketch and saturate it with water. Paint background washes of Permanent Rose, French Ultramarine Blue and Burnt Sienna. Pull lines of color with a flat brush. As the water dries, paint Burnt Sienna, Olive Green and Brown Madder along the ground and make these colors flow upward by tilting the painting. Splatter a little clear water for additional background texture.

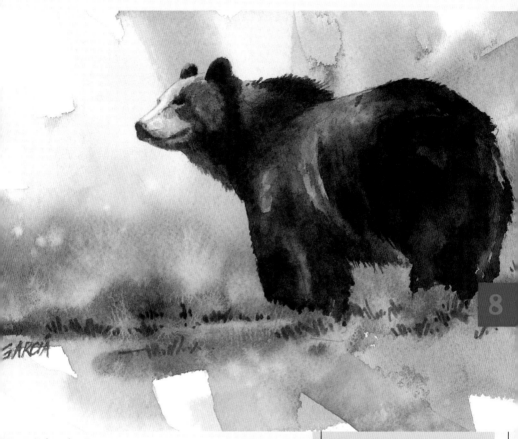

GARCIA

2 Paint the Bear

When the background is dry, cover the drawing of the bear with clear water. Apply a light wash of Burnt Sienna, Sepia, and French Ultramarine Blue on the damp surface. Build up the darker areas by adding stronger color. Paint the nose, ears and eyes, and create just a little fur detail around the outer edges of the bear. Try to achieve a loose, painterly effect with minimal detail. Add blades of grass with Olive Green.

BIG BRUISER
Watercolor on 140-lb. (300gsm)
cold-pressed paper
5 ½" × 8" (14cm × 20cm)

215

Prairie Dog

In this painting, the dark background surrounds and defines the head of the prairie dog. The rest of the textures add visual interest but are not too strong. As a result, the head is clearly established as the center of interest.

Materials

BRUSHES
¾-inch (19mm) and
1-inch (25mm) flats

Nos. 2, 4 and 6 rounds

WATERCOLORS
Alizarin Crimson

Brown Madder

Burnt Sienna

Cobalt Blue

French Ultramarine Blue

Olive Green

Raw Sienna

Winsor Green

1 Draw, Then Paint a Wash
Draw with a 3H pencil, being careful not to score the paper. Place a light wash of Burnt Sienna and Raw Sienna over the drawing. Add a bit of Cobalt Blue to the wash where the values darken. Add more Cobalt Blue and paint the ear, eye and nose.

2 Add Darker Values
Begin to give shape and volume to the prairie dog by darkening the shadow areas. Don't paint the paw yet. Add color and a bit of fur detail to the face, shoulder and hindquarters. Lift some color from the head and back.

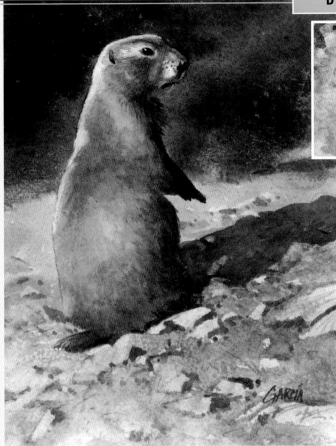

Paint Rocks With a Palette Knife

8

ON WATCH—PRAIRIE DOG
Watercolor on 140-lb
cold-pressed paper
5½" × 7" (14cm × 18cm)

3 Paint the Surrounding Areas

Evenly saturate the area around the subject with two or three coats of clean water. Wash a very dark, rich mixture of French Ultramarine Blue, Alizarin Crimson and Winsor Green onto the top third of the painting. Also add a few quick strokes of Burnt Sienna and Olive Green. Paint a lighter-value, wet-into-wet wash of Burnt Sienna, Raw Sienna and Cobalt Blue onto the lower two-thirds of the painting. Toward the bottom, add more Cobalt Blue and Brown Madder.

As the washes dry, sprinkle salt for additional texture. Create different sizes and shapes of rocks with a palette knife by pushing paint away from the areas that will become rocks. If the paper is too wet, the paint will run; too dry, and the palette knife will not work. Brush the salt off the painting just before it dries. Add the cast shadows, paint the little paw and pick out the eye highlight with the tip of a utility knife.

217

TREES *and* FOLIAGE

Trees would be difficult to paint (and the results wouldn't be very believable) if you tried to paint every leaf and twig. Instead, look at trees as three-dimensional objects with shadow sides and cast shadows. The shape of a tree can often identify it: Fir trees can be visualized as a triangle or cone, an orange or oak tree may resemble a ball or sphere, and other trees may be seen as a series of interconnected boxes.

The colors of trees vary widely. You'll find yellows and reds in the fall and countless greens in the spring. Winter provides everything from the mauves and grays of leafless branches to white snow-covered shapes. Fruit trees may present a solid mass of blossoms that last only a few days. Be observant, take photos and do sketches or quick paintings that catch the essence of various trees. Early in the day you may catch a tree in full sun, while sunset shows only a sensual silhouette. The better you know your subject, the more successful your painting will be.

Observe Bark Patterns
Certain trees such as aspen and birch have bark with a pattern of circumferential lines. Brushstrokes, shadows and bark texture should follow this pattern.

TREE BARK
Watercolor on 140-lb. (300gsm)
cold-pressed paper
4" × 7" (10cm × 18cm)

218

Create Depth With Values

In this painting, values create the sense of depth: darker values in the background, lighter ones in the foreground. Paint the snow-covered trees and the shadows on the snow first to establish a starting point for the range of values you'll use.

Materials

BRUSHES
¾-inch (19mm) and
 1-inch (25mm) flats

Nos. 2, 4 and 6 rounds

WATERCOLORS
Alizarin Crimson

Cobalt Blue

French Ultramarine Blue

Permanent Rose

Raw Sienna

1 Paint the Preliminary Washes
Block in the trees with a thin transparent wash of Permanent Rose and Raw Sienna. At this stage the value of the background trees makes them seem a little too close to the foreground tree.

2 Add the Background and Details
Add a flat wash of Cobalt Blue, French Ultramarine Blue and Alizarin Crimson to the background, covering the background trees. Let dry. Paint the background trees with a mix of French Ultramarine Blue and Alizarin Crimson. This darker value helps push the foreground tree closer. Paint the parts of the foreground pine that show through the snow. Softly lift color from the background trees to give an indication of snow, but keep this background snow darker than the foreground snow. Finally, add a few weeds in the foreground and paint the cast shadows.

COLD WINTER DAY
Watercolor on 140-lb. (300gsm) cold-pressed paper
7½" × 5" (19cm × 13cm)

Fall Foliage

"River Willows" captures the bright color and warm tones of fall. The sun is low in the sky, creating a backlit effect.

Materials

BRUSHES
¾-inch (19mm) and
 1-inch (25mm) flats
Nos. 2, 4 and 6 rounds
Natural sponge
Palette knife

WATERCOLORS
Alizarin Crimson
Burnt Sienna
Cobalt Blue
French Ultramarine Blue
Mauve
Indian Yellow
New Gamboge
Permanent Rose
Raw Sienna
Winsor Green

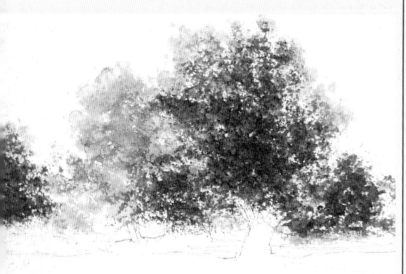

1 Draw, Then Paint the Basic Values
Loosely draw the tree shapes with little detail. Using a small natural sponge (sometimes called an elephant's ear), apply Indian Yellow to the tree area in two or three passes to build up texture and color. Create the shadow color by sponging on the complementary color—Mauve or a mixture of Cobalt Blue and Permanent Rose. Repeat until the desired value is reached. Let dry thoroughly.

**Add Texture With a
Palette Knife**

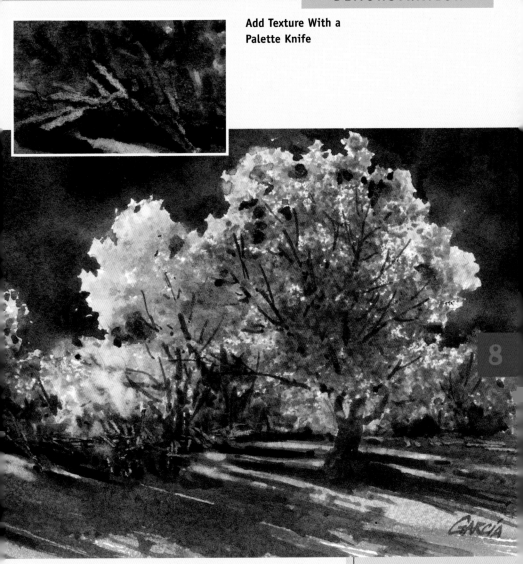

2 Add Surrounding Areas and Details

Paint a foreground wash of Burnt Sienna, Raw Sienna and
New Gamboge; sprinkle salt on it for texture. Paint the back-
ground with a wet-into-wet wash of Alizarin Crimson, French
Ultramarine Blue and Winsor Green. Dot background color on the
large tree to show that some sky is visible through the leaves. Let
dry, then paint branches and tree trunks. Glaze long, dark shadows
on the foreground. Add texture under the smaller trees with the tip
of a palette knife. Give the trees a bright backlit glow by lifting a
little color. Brush off salt just before the painting is fully dry.

RIVER WILLOWS
Watercolor on 140-lb. (300gsm)
cold-pressed paper
5½" × 7½" (14cm × 19cm)

Country Oaks

This demonstration shows how to paint trees in the distance. Loose to tight, light to dark works well here.

Materials

BRUSHES
½-inch (12mm) and
 ¾-inch (19mm) flats
No. 3 round
Palette knife

WATERCOLORS
Brown Madder
Burnt Sienna
Cobalt Blue
French Ultramarine Blue
Indian Yellow
Olive Green
Raw Sienna
Sap Green

1 Block in Basic Subjects

Paint the base washes wet-into-wet. The yellow in the sky is a mix of Raw Sienna and Indian Yellow. The middle and foreground are various mixtures of Brown Madder, Burnt Sienna and Cobalt Blue. Mix a gray out of Cobalt Blue and Brown Madder for the background trees, and paint them when the paper loses its shine and is slightly damp so that the brushstrokes soften slightly. Add Olive Green and French Ultramarine Blue to the wash and paint the trees in the middle ground in the same manner. If the surface is too wet, the middle-ground trees will bleed out too far and cover the background trees.

Lift Color From the Branches With a Palette Knife

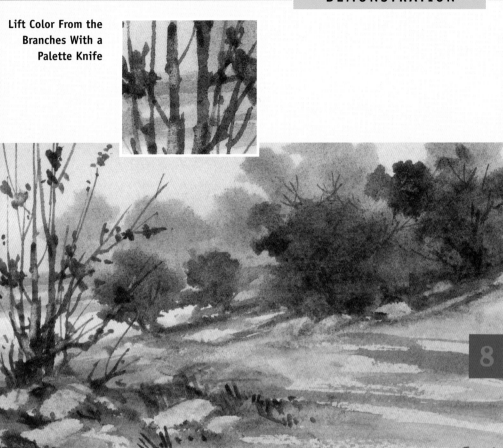

GARCÍA

2 Develop the Center of Interest

Dry-brush some color into the foreground, then scrape out some rock shapes with the edge of a palette knife. Use a no. 3 round to paint a bush in the foreground with a mixture of French Ultramarine Blue, Sap Green and Brown Madder. Paint the bush larger and with more detail to help push the oaks farther into the background. The added detail also makes the bush the center of interest in the painting. To finish, lift a little color from the branches of the bush by gently scrubbing with an old round brush and blotting with a tissue.

COUNTRY OAKS
Watercolor on 140-lb. (300gsm)
cold-pressed paper
4½" × 7½" (11cm × 19cm)

Tree Bark Up Close

Painting tree bark requires close observation. Young trees tend to have smoother surfaces, while older trees are more textured. Most bark has a texture that runs up and down the trunk, but birch and aspen have black texture that runs around the tree. Trunk texture flows around limbs and knotholes; limb texture follows the direction of the limb. Study your subject carefully before you paint it.

Materials

BRUSHES
¾-inch (19mm) flat
Nos. 2, 3 and 4 rounds

WATERCOLORS
Brown Madder

Burnt Sienna

Cobalt Blue

French Ultramarine Blue

Quinacridone Gold

1 Block in the Tree

Start the bark on this tree with light wet-into-wet washes of Cobalt Blue, Burnt Sienna and a little French Ultramarine Blue. As the wash begins to dry, lift some color out. Darken the shadowed undersides of the limbs. Vary the color temperature of the wash by controlling the amount of Burnt Sienna used. If additional color is needed, add Quinacridone Gold while the painting is still damp. Proceed to the next step before the painting dries.

**Flow the Bark Texture
Around the Knothole**

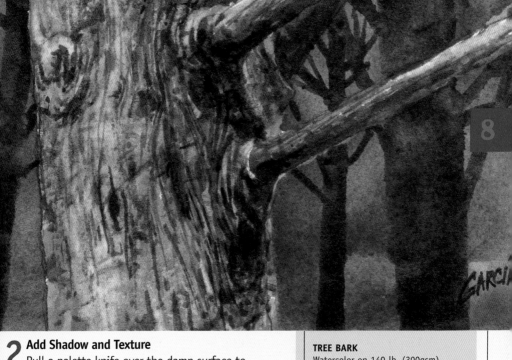

GARCI

2 Add Shadow and Texture

Pull a palette knife over the damp surface to remove some paint from the highest points of the paper's texture. With a small round brush, add lines of texture that flow up the trunk, around the knotholes and along the limbs. Let dry, then paint the background wet-into-wet with Quinacridone Gold, French Ultramarine Blue and Cobalt Blue. Let dry. Paint the dark trees with a mix of French Ultramarine Blue, Brown Madder and a little Burnt Sienna.

TREE BARK
Watercolor on 140-lb. (300gsm)
cold-pressed paper
4" × 6" (10cm × 15cm)

225

Fir Trees

Firs have a very distinct conical shape and an easily recognizable silhouette. Work this painting loose to tight and light to dark to create the sense of atmospheric perspective.

Materials

BRUSHES
¾-inch (19mm) flat
Nos. 3, 4 and 6 rounds

WATERCOLORS
Alizarin Crimson
Cobalt Blue
Cerulean Blue
French Ultramarine Blue
Olive Green
Sap Green

1 Paint the Background
Paint the top of the background with a wet-into-wet wash of Cobalt Blue, Cerulean Blue and Olive Green. Paint the bottom with French Ultramarine Blue, Cobalt Blue, and Alizarin Crimson. Before the paint dries, use the darker wash color to paint soft-edged background firs. Time it so the paint spreads just enough.

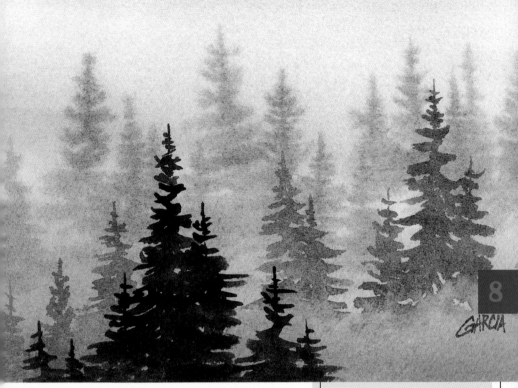

2 Add the Middle-Ground and Foreground Trees

Let the painting dry, then add the trees in the middle ground with a diluted mixture of French Ultramarine Blue, Sap Green and Alizarin Crimson. Add the dark trees to the foreground with a more concentrated mixture of French Ultramarine Blue, Sap Green and Alizarin Crimson.

FIR TREES
Watercolor on 140-lb. (300gsm)
cold-pressed paper
4¾" × 7½" (12cm × 19cm)

Pear Trees

This painting uses a combination of transparent watercolor and opaque gouache for a different technique and a different look. With gouache, one could also add foliage or flowers over an already painted background.

Materials

BRUSHES
¾-inch (19mm) flat
Nos. 3, 4 and 6 rounds

WATERCOLORS
Burnt Sienna
Cobalt Blue
French Ultramarine
 Blue
Olive Green
Permanent Rose
Sap Green

GOUACHE
Alizarin Crimson
Cobalt Blue
French Ultramarine
 Blue
Olive Green
Opaque Yellow
Permanent Rose
Sap Green
Titanium White (or
 Pelikan Graphic
 White)

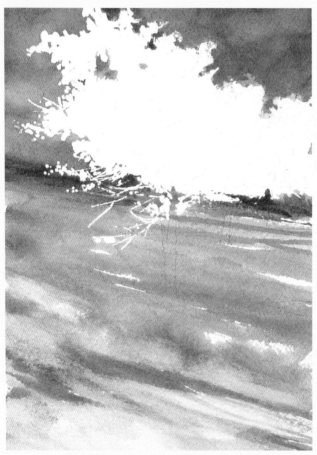

1 Draw Then Paint Around the Trees With Watercolor
Draw the trees with a 2H pencil. Mask the blossoms with masking agent; let dry. Paint around the trees using Cobalt Blue, French Ultramarine Blue and Permanent Rose for the sky; Sap Green, Olive Green and Burnt Sienna for the middle ground; and Olive Green, Burnt Sienna and a little palette "mud" for the foreground. When all is dry, remove the mask.

228

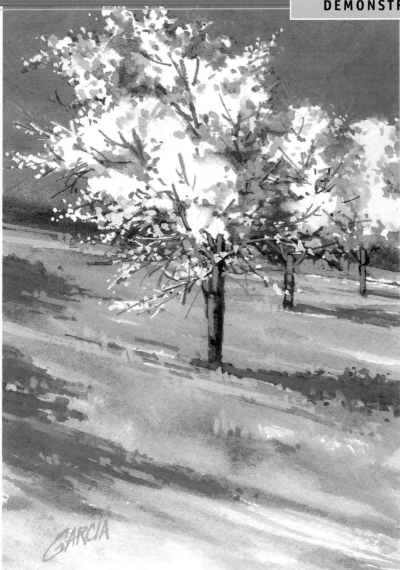

8

2 Paint the Sky, Shadows and Flowers With Gouache
Paint the sky with a mix of Cobalt Blue, French Ultramarine Blue, Permanent Rose and Titanium White gouache. Paint ground shadows and tree trunk highlights with varying mixtures of these colors. Paint Sap Green, Opaque Yellow and Olive Green gouache over areas of the ground. Add a few dabs of the sky color over pure Titanium White to show individual blossoms on the tree. Paint the small branches with a no. 2 round and a mixture of French Ultramarine Blue and Alizarin Crimson gouache.

PEAR TREES IN BLOOM
Watercolor on 140-lb. (300gsm) cold-pressed paper
7" × 5" (18cm × 13cm)

229

Foliage

When painting foliage, visualize it as a single mass rather than as branches or individual leaves. Do not paint detail you can't see from a distance, even though you know it's there.

Materials

BRUSHES
¾-inch (19mm) and
 1-inch (25mm) flat

No. 4 round

WATERCOLORS
Cobalt Blue

French Ultramarine Blue

Olive Green

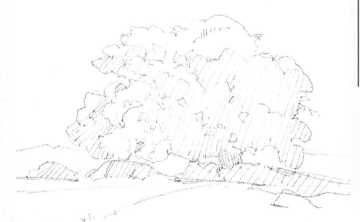

1 Draw the Composition
Draw an oak tree with an H pencil. Indicate shadows with diagonal lines to create the three-dimensional shape of the tree. The cast shadow on the ground provides a base for the drawing.

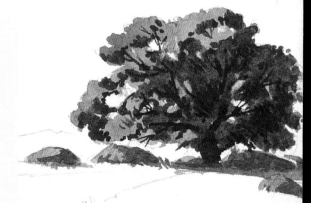

2 Add Flat Washes
Use flat washes to paint the overall shape of the tree and rocks. The foliage of the tree is a mixture of Olive Green and Cobalt Blue. After this wash dries, paint the shadow areas with Olive Green and French Ultramarine Blue add the trunk and branches. Let everything dry.

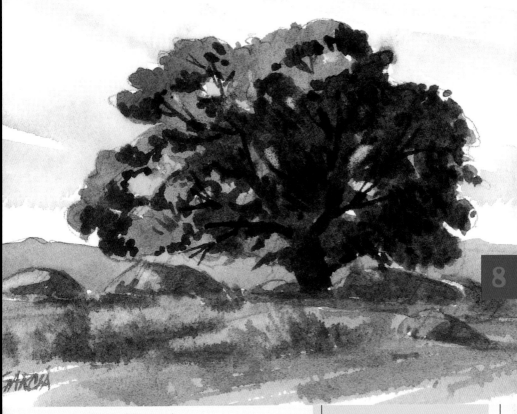

8

3 **Paint the Sky and Mountains**
Add the foreground, then the mountains with wet-into-wet washes in a quick loose technique. Drybrush the sky up to the edge of the tree with Cobalt Blue. Be sure to paint some blue sky amid the branches.

FOLIAGE
Watercolor on 140-lb. (300gsm)
cold-pressed paper
4" × 5½" (10cm × 14cm)

Leaves

The leaves of the California live oak are an interesting challenge to paint. They are translucent but they have a hard surface with highlights.

Materials

BRUSHES
¾-inch (19mm) flat

Nos. 3, 4 and 6 rounds

WATERCOLORS
Alizarin Crimson

Brown Madder

Burnt Sienna

French Ultramarine Blue

Raw Sienna

Sap Green

1 **Draw, Then Glaze on Initial Washes**
Do a light sketch. Wash Raw Sienna over parts of the leaf, let it dry, then glaze this on two or three more times. Paint darker values with Sap Green and French Ultramarine Blue in a series of thin transparent glazes. Shown here are leaves at various stages.

232

Add Dead Spots to
the Leaves

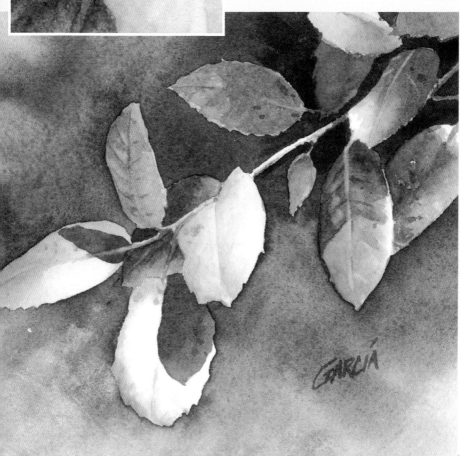

8

2 **Add Background and Final Details**
Finish glazing on darker values and let everything
dry. Paint a dark wet-into-wet wash of French Ultrama-
rine Blue, Alizarin Crimson and Sap Green in the back-
ground. Add final touches such as dead spots on the
leaves and color on the branches with Burnt Sienna
and Brown Madder.

LEAVES
Watercolor on 140-lb. (300gsm)
cold-pressed paper
6" × 6" (15cm × 15cm)

233

LANDSCAPE ELEMENTS

Landscape elements, such as clouds, rocks and birds, tell a story. They are the embellishments that add interest to your painting. Landscape elements can play a supporting role or dominate the entire painting.

How to Use Landscape Elements

The style or technique of painting these elements is not as important as how you use them. They play an important role in composition, value and scale. They can follow the general rules of light to dark, loose to tight or do exactly the opposite. These are the elements that describe distance, temperature, texture or time. You can paint them with a sponge, palette knife, brush, salt or your fingers—whatever works! The

important aspect of landscape elements is that they "fit" into your painting; that is, they must have the same light source, reside in the proper setting and be the right size in comparison with other features in the painting.

SIMPLIFY YOUR ELEMENTS

To paint landscape elements successfully, you must learn to simplify them. A landscape can present an overwhelming amount of detail—clouds, mountains, trees, leaves, grasses, water, and so on. Remember to paint only as much detail as is needed to tell the viewer what an object is. Too much information is difficult to paint and makes it hard for the viewer to know what you intend as the focal point of the painting.

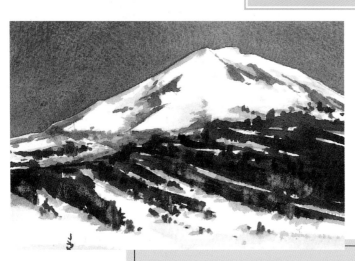

DISTANT MOUNTAIN
Watercolor on 140-lb. (300gsm) cold-pressed paper
5½" × 4" (14cm × 10cm)

Grass and Fields

Birds and fenceposts add depth and movement to this land-scape painting.

Materials

BRUSHES
¾-inch (19mm) flat
No. 4 round

WATERCOLORS
Brown Madder
Burnt Sienna
Cobalt Blue
French Ultramarine Blue
Indian Yellow
Quinacridone Gold
Raw Sienna
Sap Green

1 Paint the Foreground and Background
Paint wet-into-wet washes of Raw Sienna, Indian Yellow and Quinacridone Gold in the field and foreground; add a little Cobalt Blue, Sap Green and Brown Madder in the near foreground and in the background. As the paint dries, sprinkle salt across the foreground for texture. Brush off the salt just before everything dries.

8

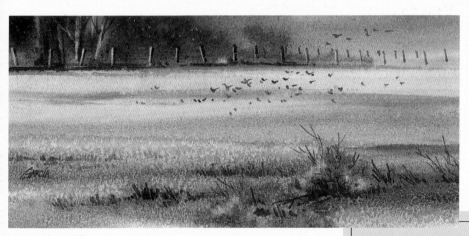

2 Add Detail
Indicate brush and grass with small brushstrokes. Paint the fenceposts and a few distant tree trunks with a mixture of Burnt Sienna and a touch of Cobalt Blue. Before the posts dry, use the tip of the palette knife to pull out some color from their entire lengths. Lift out the trees with a no. 4 round that has a worn tip. (The worn tip allows you to get a soft, thin line.) Add the birds with a mixture of French Ultramarine Blue and Brown Madder.

GRASSES AND FIELDS
Watercolor on 140-lb.
(300gsm) cold-pressed paper
4½" × 10" (11cm × 25cm)

235

Distant Mountains

This painting is a series of gradated washes. The sky, each mountain range and the foreground are dark-to-light washes. Each wash after the initial one is done wet-on-dry; there are no soft edges.

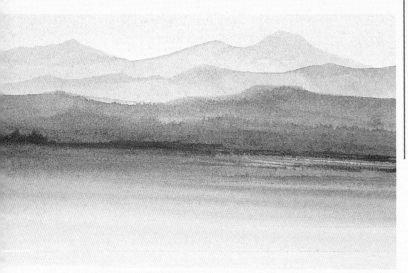

Materials

BRUSHES
¾-inch (19mm) and
 1-inch (25mm) flat
Nos. 3, 4 and 6 rounds

WATERCOLORS
Alizarin Crimson
Brown Madder
Cerulean Blue
Cobalt Blue
French Ultramarine Blue
Permanent Rose
Sap Green

1 Paint Base Washes From Back to Front

Paint the sky using Cobalt Blue, Cerulean Blue and Permanent Rose. Let dry. Paint the mountains in stages with French Ultramarine Blue, letting the paint dry between layers. Add Sap Green and Alizarin Crimson to the mountain mixture to paint the middle ground. Paint the foreground as a very wet gradated wash using a 1-inch (25mm) flat, starting with the middle-ground color but adding Raw Sienna as you move down. Allow the horizontal brush-strokes to show.

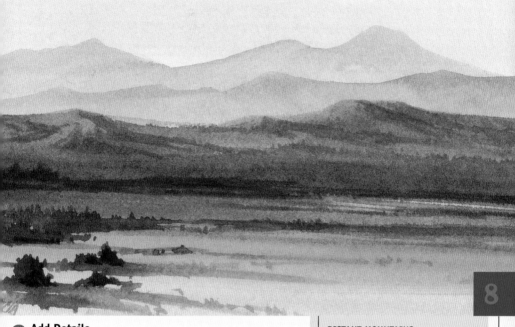

8

2 Add Details

Prepare a mix of French Ultramarine Blue, Sap Green and Brown Madder. Using a no. 4 or 6 round, quickly paint the trees in the foreground as silhouetted shapes. Add more water to the mixture to paint the more distant trees so that they are lighter in value. Subtly suggest detail on the closest mountain range.

DISTANT MOUNTAINS
Watercolor on 140-lb. (300gsm)
cold-pressed paper
4½" × 8½" (11cm × 21cm)

Sandy Beaches

Sandy beaches are constantly changing, from moment to moment, day to day, season to season. Because of this constant change, study the setting carefully. Imagine how you would paint the rhythm of the waves or the shine on the wet sand.

Materials

BRUSHES
¾-inch (19mm) flat

WATERCOLORS
Brown Madder

Burnt Sienna

Cerulean Blue

Cobalt Blue

French Ultramarine Blue

Raw Sienna

1 Paint the Water and Sand

Saturate the entire paper with clean water. Paint the sky wet-into-wet with a mixture of Cobalt Blue and Cerulean Blue. Paint the sand with Burnt Sienna and Raw Sienna, brushing in a little of the sky color. When the wash has dried to only slightly damp, lift out the waves with a ¾" (19mm) flat. When the painting has completely dried, darken the blue under the white water of the waves with a gray mix of Cobalt Blue and Brown Madder. For waves that are closer to breaking, use Cobalt Blue with a little Viridian or Winsor Green.

2 Add the Birds and Other Details

Paint the shorebirds as a silhouette using a mixture of French Ultramarine Blue and Brown Madder. The amount of water in the mixture will regulate the darkness of the silhouettes—the more water, the lighter the value. Add some lines to indicate encroaching water. Paint broken dark lines with a mixture of Cobalt Blue and Brown Madder to indicate shadow. Add French Ultramarine Blue to the mixture to darken the value of the broken line of advancing water. Use the point of a utility knife to lift paint and indicate sparkle. Use a little splatter to indicate shells or other texture.

SANDY BEACHES
Watercolor on 140-lb. (300gsm)
cold-pressed paper
4½" × 10" (11cm × 25cm)

8

Sand Dunes

Painting sand dunes is very similar to painting a beach. Look for the subtle changes in both. The colors are initially painted as a soft wet-into-wet wash. Sand dunes tend to be tan or yellow, so a complementary mauve or violet works well for shadows. Look for details such as wind-blown ripples or long cast shadows.

Materials

BRUSHES
½-inch (12mm) and ¾-inch (19mm) flats

Nos. 3 and 4 rounds

WATERCOLORS
Burnt Sienna

Cerulean Blue

Cobalt Blue

French Ultramarine Blue

Permanent Rose

Raw Sienna

1 Paint the Sky, Mountains and Shadows
Paint a very light wet-into-wet wash of Cobalt Blue and Cerulean Blue over the sky and a mixture of Raw Sienna and Burnt Sienna over the sand. Let dry. Paint the distant mountain using a mixture of Burnt Sienna, Permanent Rose and Cobalt Blue. Notice the increase in value intensity as the various shadows move into the foreground. The shadows are the only things that describe the shape or lay of the land. The shadow color is a mixture of Cobalt Blue, French Ultramarine Blue and Permanent Rose. A darker glaze for the sand helps define the slope of the sand dune as the area moves into strong shadows.

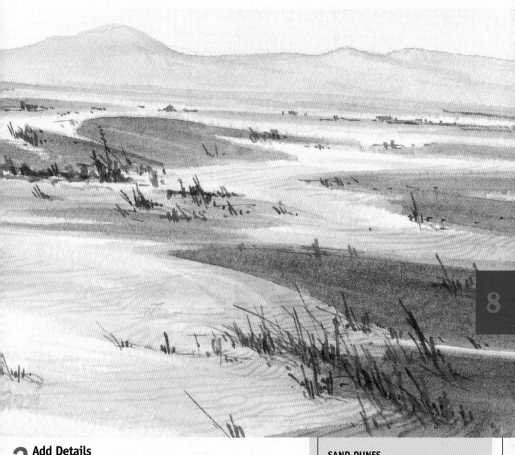

2 Add Details

After everything dries, glaze on sand ripples with the sand mixture and a light value of the shadow mixture. Add desert grasses for interest, making them larger as you approach the foreground to help set the scale.

SAND DUNES
Watercolor on 140-lb. (300gsm)
cold-pressed paper
4¾" × 7" (12cm × 18cm)

Painting Rocks

Rocks come in all shapes, colors, sizes and textures. Take time to study your subject and plan your painting. Look for textures, values, shadows and how you might describe these elements on paper. Notice how shadows follow the shape of a rock and help show its volume. Once you've planned your approach, you can paint with a free, spontaneous technique.

Materials

BRUSHES
¾-inch (19mm) flat
Natural sponge

WATERCOLORS
Alizarin Crimson
Burnt Sienna
Cobalt Blue
French Ultramarine Blue
Olive Green
Raw Sienna
Winsor Green

1 Create a Sketch
Do a quick sketch with an HB pencil. Indicate the size and shape of the rocks. Use this drawing to indicate the shadows, which also shows you where the light is coming from in your scene.

2 Apply Texture
Use a natural sponge that has small irregular openings on its surface. With scissors, shape the sponge for painting. Gently dab a light mixture of French Ultramarine Blue, Alizarin Crimson on the surface. Vary the texture by rotating the sponge as you go. Paint the shadow with a wash of the same colors but more concentrated, using a ¾-inch (19mm) flat.

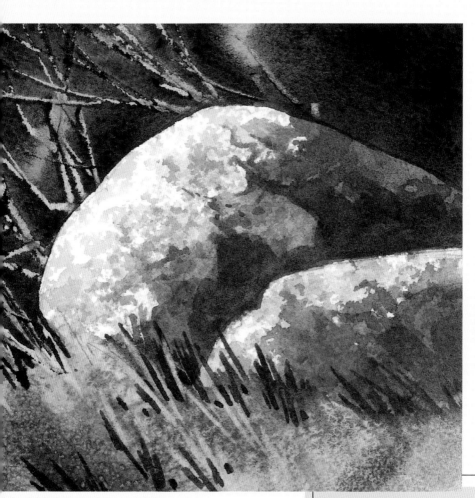

3 Paint the Foliage and Background

Paint the background with a wet-into-wet wash of French Ultramarine Blue, Alizarin Crimson and Winsor Green. Paint the foreground grass with a wet-into-wet wash of Raw Sienna, Olive Green, Burnt Sienna and Cobalt Blue, using a ¾-inch (19mm) flat.

TEXTURED ROCK
Watercolor on 140-lb. (300gsm) cold-pressed paper
4½" × 4½" (12cm × 12cm)

FLOWERS

You can paint flowers with a loose, spontaneous approach, or with one that uses multiple glazes to develop deep, luminous colors. Follow the same general rules as with other subjects: Paint loose to tight and light to dark, and use shadows to define shapes and reveal overlapping surfaces. There is not a right way or wrong way, just your way. If you make the most of this attitude, your paintings will be successful and flowers will become a special subject to display your skills.

Cherry Blossoms on Yupo

Fruit tree blossoms offer a wide range of colors and beautiful groupings of flowers. Yupo, a slick, synthetic paper, lends itself to a loose, flowing, spontaneous painting because color sits on the surface of the paper and moves easily.

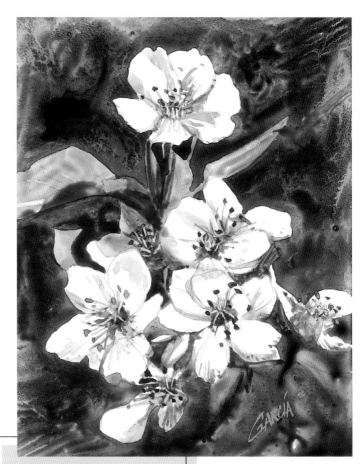

BLOOMS—CHERRY BLOSSOMS
Watercolor on Yupo synthetic paper
5" × 6½" (13cm × 17cm)

Daffodils

Painting a white flower presents challenges. Make the background dark enough that you can see the flower. Use shadows to help define the petals.

Materials

BRUSHES
¾-inch (19mm) flat
Nos. 2, 4 and 6 rounds

WATERCOLORS
Alizarin Crimson
French Ultramarine Blue
New Gamboge
Olive Green
Quinacridone Gold
Raw Sienna

1 Paint the Flowers and Shadows
Paint yellow petals with New Gamboge, adding violet for shadow areas. Mix French Ultramarine Blue and Alizarin Crimson for the shadows on the white petals. Glaze Raw Sienna over areas of these shadows to indicate reflected color. Let dry.

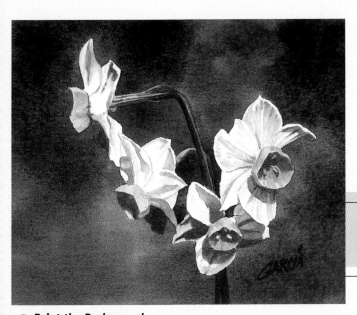

BLOOMS—DAFFODILS
Watercolor on 140-lb. (300gsm) cold-pressed paper
5" × 6¼" (13cm × 16cm)

2 Paint the Background
Paint green stems, removing highlights with the tip of a palette knife. Paint a wet-into-wet background wash of French Ultramarine Blue, Alizarin Crimson, Olive Green and Quinacridone Gold. Tilt the painting to eliminate unwanted brushstrokes.

Flower Groups

Botanical gardens, window boxes and arrangements in vases all present opportunities to paint groups of flowers. Flowers of different colors and heights make for a more exciting painting.

Materials

BRUSHES
¾-inch (19mm) flat
Nos. 2, 4 and 6 rounds

WATERCOLORS
Burnt Sienna
Cobalt Blue
French Ultramarine Blue
Indian Yellow
Olive Green
Permanent Rose
Quinacridone Gold
Sap Green
Sepia

1 Mask the Flower Blooms

Draw a group of flowers and mask out the blooms with liquid masking agent. Let dry completely.

2 Paint the Background

Paint the background over the dry masking agent using a wet-into-wet wash of Olive Green, Sap Green, Quinacridone Gold and French Ultramarine Blue. As this wash dries, add a little salt to the foreground for an organic texture. Let dry, then add shadows and the indication of stalks and weeds. Lift some soft-edged blooms out of the background to show distance and overlapping. Let dry thoroughly, then remove the mask.

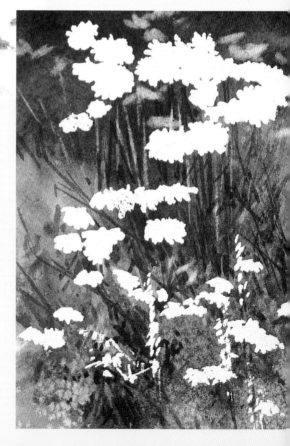

8

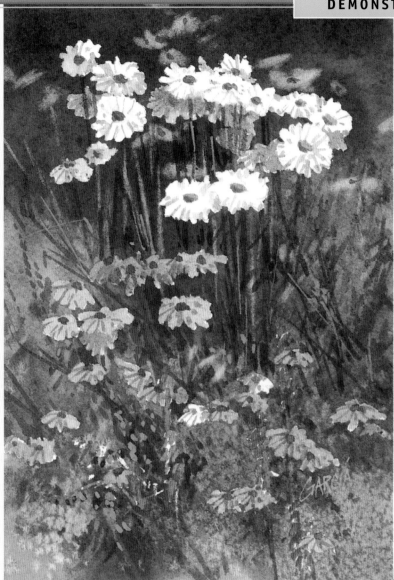

3 Detail the Flowers

Paint the yellow flowers with Indian Yellow for the petals and a Burnt Sienna–Sepia mixture for the centers. Paint red flowers with Permanent Rose. To the white flowers, add Indian Yellow centers and Cobalt Blue–Permanent Rose shadows.

GROUPS OF FLOWERS
Watercolor on 140-lb. (300gsm)
cold-pressed paper
4" × 6¼" (10cm × 16cm)

Bouquet of Flowers

I arranged this composition by choosing flowers that I found interesting. I wanted the arrangement to have movement from one side of the vase to the other. The small daisy-like flowers with long stems break the circular shape of the red and white roses. The leaves lend variation to the outer edge of the arrangement. Once the flowers were organized in an interesting display, I studied the arrangement from all sides and various heights until I found my favorite vantage point. Try setting up and painting your own floral still-life in this way.

Materials

BRUSHES
¾-inch (19mm) flat
Nos. 3, 4 and 6 rounds

WATERCOLORS
Cobalt Blue
New Gamboge
Olive Green
Permanent Rose
Raw Sienna
Sap Green
Winsor Green

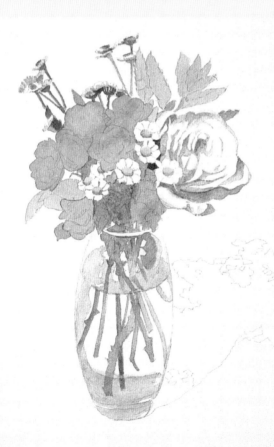

1 Lay in Transparent Glazes

Create a careful drawing with interesting positive and negative shapes. Use the cast shadow as a design element in the painting. Apply light glazes to the flowers and vase. Use Permanent Rose for the red roses and a wash of Raw Sienna and New Gamboge for the white rose. The shadows on the white rose are Cobalt Blue and Permanent Rose. The leaves are a flat wash of Sap Green, Olive Green and Cobalt Blue.

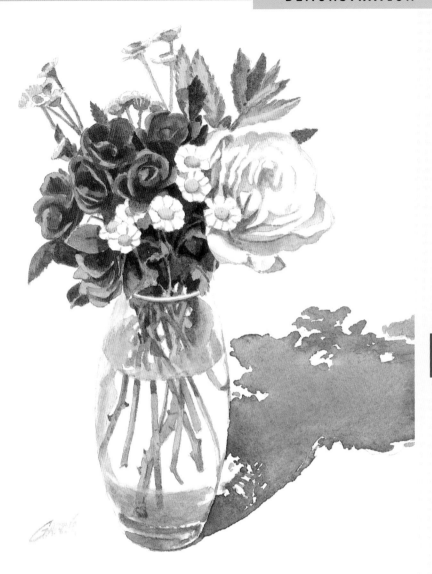

2 Paint the Shadows

Glaze shadows on the flowers and leaves to give them form. This is a careful, gradual process. Paint the cast shadow from dark to light with a wash of Cobalt Blue, Permanent Rose, and Winsor Green. Paint the glass in a series of light glazes. The colors in the glass are the same colors as the shadow, but lighter in value. Add Raw Sienna and more Permanent Rose at the base of the glass.

BOUQUET OF FLOWERS
Watercolor on 140-lb. (300gsm)
cold-pressed paper
8" × 6" (20cm × 15cm)

249

SKY

As you prepare to paint a sky, observe it closely to interpret its characteristics. Skies tend to get lighter in value near the horizon. They are darker and more blue with elevation because of the amount of atmosphere through which we look.

Use a gradated or flat wash for a calm, serene sky. A stormy, ominous sky may require scrubbing, lifting and glazing to get the desired effect. For wispy clouds, use a brush to lift out color in long, graceful strokes. Create puffy, cotton-ball clouds by gently scrubbing with a brush and lifting color with a tissue.

The sky is usually part of the background, supporting the main subject. If the sky is your subject, let it dominate the painting by covering the majority of the surface with it.

CLOUD EFFECTS

A cloud has a top, bottom and sides, and it casts a shadow. Wind also affects clouds and how rain falls. Study the sky and its various elements. A rainy, foggy day may be one of the best days to paint!

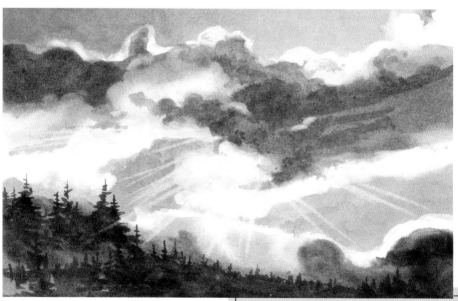

Using Backlight
I employed the contrast between the sky and clouds to create drama in this piece. The light is shining through the clouds and striking the water. I lifted paint to show the sun's location.

LIGHT IN THE CLOUDS
Watercolor on 140-lb. (300gsm) cold-pressed paper
4½" × 8" (11cm × 20cm)

Wispy Clouds

High, wispy cirrus clouds are sometimes called mare's tails. You can easily paint these shapes by using long strokes that drag across the surface of the paper.

Materials

BRUSHES
¾-inch (19mm) and
 1-inch (25mm) flats

No. 2 round

WATERCOLORS
Brown Madder

Cobalt Blue

French Ultramarine Blue

Permanent Rose

Viridian

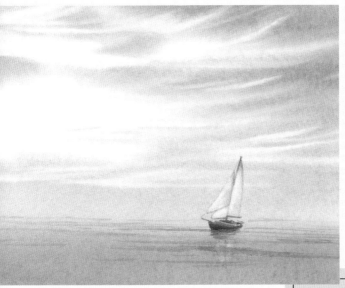

HIGH WISPY CLOUDS
Watercolor on 140-lb. (300gsm)
cold-pressed paper
5½" × 8" (14cm × 20cm)

1 Create the Basic Washes
Saturate the paper with water and then create a wet-into-wet wash with Cobalt Blue and Permanent Rose. Add Viridian to the wash at the bottom. As the wash begins to dry, use a ¾-inch (19mm) flat to lift color from the sky. Use the thin edge of the brush to lift the long thin lines.

2 Paint the Supporting Details
Since the clouds are the painting's main subject, the boat could almost be painted as a silhouette. Use a mixture of French Ultramarine Blue and Brown Madder for the body of the boat. Do not show much detail. Lift out some color from the sails and from the sails' reflection directly under the boat. Add gentle waves with light lines of the boat color.

251

Storm Clouds

Storm clouds are big, billowing and threatening. They indicate power and force with strong vertical movement. I look at these clouds as having a definite three-dimensional structure: a top, sides, and a bottom that is in shadow.

Materials

BRUSHES
¾-inch (19mm) flat
Nos. 3, 4 and 6 rounds

WATERCOLORS
Alizarin Crimson
Cobalt Blue
French Ultramarine Blue
Permanent Rose
Raw Sienna
Winsor Green

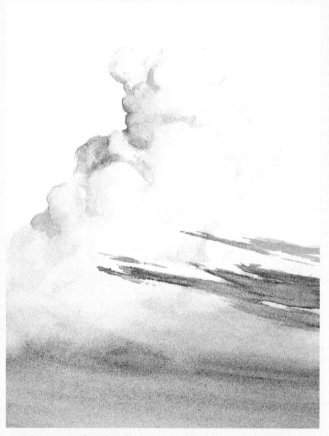

1 Structure the Cloud

Draw the cloud and lightly indicate shadows. Doing this will show you how much white of the paper you need to save. Paint the shadows using French Ultramarine Blue and Alizarin Crimson. The dark shadows give the cloud a feeling of being big and ominous. Let the dark shadows dry, then glaze a mixture of Permanent Rose and Raw Sienna over some of the areas to warm them and bring them forward. Paint the dark, wispy cloud in the foreground using a mixture of French Ultramarine Blue and Alizarin Crimson.

8

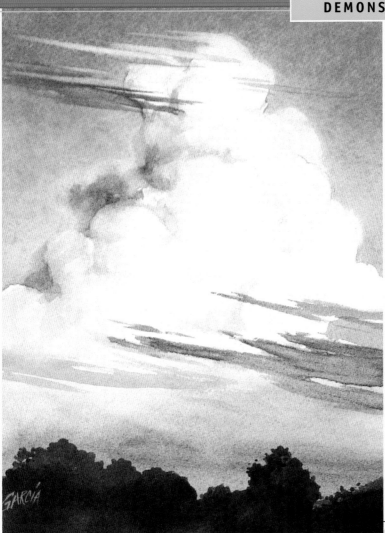

GARCIA

2 Paint the Sky and Foreground

Create the sky color by mixing Cobalt Blue, Permanent Rose and French Ultramarine Blue. Paint this wash from light to dark and from top toward the bottom. As the color is drying, soften some of the cloud edges by gently scrubbing and lifting the color with a tissue. Let the sky dry. Lift some horizontal lines at the apex of the cloud with a ¾-inch (19mm) flat. This indicates wind and helps break up the empty areas around the cloud. Finally, paint the silhouetted trees in the foreground with a rich mixture of French Ultramarine Blue, Alizarin Crimson and Winsor Green.

STORM CLOUDS
Watercolor on 140-lb (350gsm) cold-pressed paper
7¼" × 5½" (18cm × 14cm)

253

Fog and Haze

The soft, diffused edges of fog and haze are made for wet-into-wet washes. The very rapid change of values from light to dark The moisture-laden air tends to diffuse and absorb color, making for a rapid change of values from light to dark. Only as objects (such as the whitetailed doe in this painting) come closer do their sharpness and color reappear. Think wet-into-wet and use the largest flat brush possible to start this wash.

Materials

BRUSHES
¾-inch (19mm) and
 1-inch (25mm) flats

Nos. 2 and 4 rounds

WATERCOLORS
Alizarin Crimson

Brown Madder

Burnt Sienna

Cobalt Blue

French Ultramarine Blue

Olive Green

Permanent Rose

1 Draw the Doe and Paint the Fog

Draw the doe, then create the fog with a wet-into-wet wash of Permanent Rose, Cobalt Blue, French Ultramarine Blue and Olive Green. Paint from light to dark and let the white of the paper show through in some areas to indicate where the fog is heaviest. You can reinforce the drawing of the doe after the wash dries.

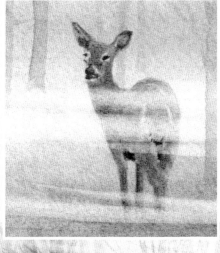

Paint the Doe

Paint the doe using a wash of Burnt Sienna, Brown Madder and Cobalt Blue using a no. 2 or 4 round. Make sure your brush has a nice sharp point for painting the nose and ears. Use French Ultramarine Blue and Brown Madder for the darks.

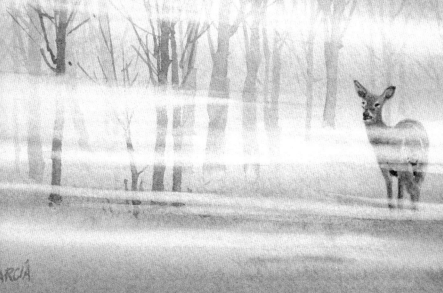

8

2 Paint the Doe and Add Final Details

Paint the doe as directed above. Fog and haze do not allow for strong shadows, so paint the trees and doe with few or no shadows. Paint the lightest trees first with a mixture of Cobalt Blue, Alizarin Crimson and Burnt Sienna, gradually increasing the value as the trees move into the foreground. Finally, use a ¾-inch (19mm) flat to lift out color and strengthen some of the mist areas. Lift some color in horizontal bands over the trees as well as the doe. This technique helps create overlapping and a sense of depth.

FOG
Watercolor on 140-lb. (300gsm) cold-pressed paper
4½" × 8" (11cm × 20cm)

Falling Snow

Paint falling snow as crisp white flakes, soft gray shapes, or both using the techniques shown here. The combination of snow with a wet-into-wet wash makes a good winter scene.

Materials

BRUSHES
¾-inch (19mm) flat

WATERCOLORS
Alizarin Crimson
Cobalt Blue
French Ultramarine Blue
Olive Green
Permanent Rose
Sap Green

GOUACHE
Titanium White (or Pelikan Graphic White)

Use Liquid Masking Agent as a Resist

Splatter liquid masking agent with a toothbrush for the small flakes. Create the larger ones by splattering liquid mask with a ¾-inch flat. Let the mask dry completely. Create a wet-into-wet wash of French Ultramarine Blue, Alizarin Crimson and Sap Green over the textured area. Make sure the wash is completely dry before removing the latex. Any dampness will smudge the white paper with paint.

Salt Texture

Create a wet-into-wet wash of Cobalt Blue, Permanent Rose and French Ultramarine Blue. As the wash dries, lightly sprinkle salt onto the surface. The salt crystals act as small sponges, absorbing water as well as pigment. Brush away the salt just before the paint dries or it will stick to the paper.

Salt and Opaque White

Use salt and Titanium White gouache or Pelikan Graphic White for this texture. Lay a flat wash of French Ultramarine Blue, then sprinkle salt over the wash when it is just damp. If it's too wet, the salt will leave large spots. Let dry. Brush away the salt and splatter the surface with opaque white. If the white has been diluted too much, the blue base color will show through, so practice first to get the correct consistency.

Falling Snow

This example of a snow painting began with a wet-into-wet wash of Cobalt Blue, Olive Green and French Ultramarine Blue. I created the falling snow with opaque white splattered with a ¾-inch (19mm) flat. The value of the wash had to be dark enough for the snow texture to be visible.

8

FALLING SNOW
Watercolor on 140-lb. (300gsm) cold-pressed paper
8" × 6" (20cm × 15cm)

Clear Sky

Paint a clear sky with a flat or gradated wash. These washes are perfect for indicating a sky without clouds or texture. Picking up the wash and tilting it back and forth and side to side helps eliminate any unwanted brushstrokes.

Materials

BRUSHES
¾-inch (19mm) and
 1-inch (25mm) flats

WATERCOLORS
Brown Madder

Burnt Sienna

Cobalt Blue

French Ultramarine Blue

Raw Sienna

Sap Green

1 Block In the Sky
Saturate the paper with two or three coats of water. Wash in Cobalt Blue using a ¾-inch (19mm) flat to bring the color from top to bottom. About three-fourths of the way down, apply Raw Sienna and work this color up into the Cobalt Blue. Quickly dilute this wash with water so the two colors don't mix and create green. Tilt the painting back and forth and side to side to even out the wash.

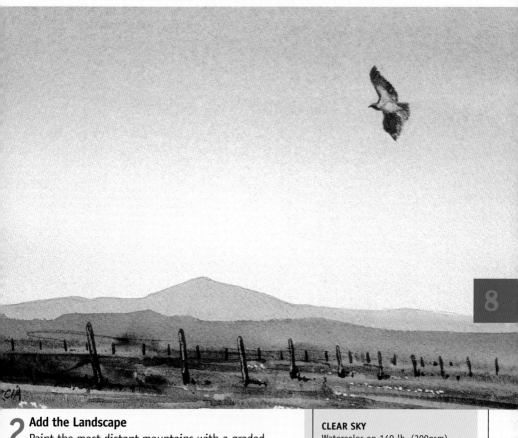

8

2 Add the Landscape

Paint the most distant mountains with a graded wash of Cobalt Blue and Brown Madder. Paint from dark to light. Paint the next mountain range with Cobalt Blue that quickly fades to the white of the paper. Paint the foreground using Brown Madder, Burnt Sienna and Sap Green. Use these colors with quick horizontal brushstrokes, letting the colors blend and bleed together. Let dry. Paint the fence posts with dark lines of French Ultramarine Blue and Brown Madder; then use a palette knife to scratch out highlights. Finally, paint the red-tailed hawk using Burnt Sienna and French Ultramarine Blue and a no. 2 round.

CLEAR SKY
Watercolor on 140-lb. (300gsm)
cold-pressed paper
5½" × 8" (18cm × 20cm)

Fluffy Clouds

Paint your clouds with personality. Wispy clouds are high and aloof, while storm clouds are bold and ominous. Fluffy clouds, not too dark and with soft edges, are just happy to be floating along. Be careful to not accidentally paint faces or recognizable features into clouds. Try painting these clouds by lifting color from the surface of the paper. You are less likely to create hard edges that will change their character.

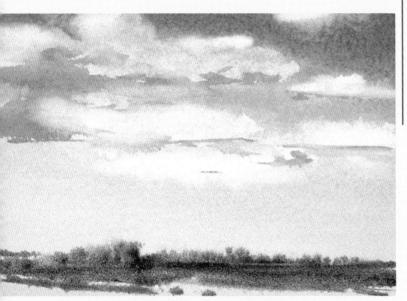

1 Block in the Sky, Clouds and Foreground
Paint a gradated wash with a mixture of French Ultramarine Blue and Alizarin Crimson, then add Raw Sienna to the bottom area of the painting. Before this lower area dries, apply Brown Madder, Sap Green, and Olive Green; allow these colors to bleed out. Apply salt for texture. While the sky area is still damp, use a ¾-inch (19mm) flat and a tissue to scrub and lift out color. Begin to add shadows to the clouds. Paint the darker value of the sky with a mix of French Ultramarine Blue and Brown Madder; this helps the lighter areas of the clouds stand out.

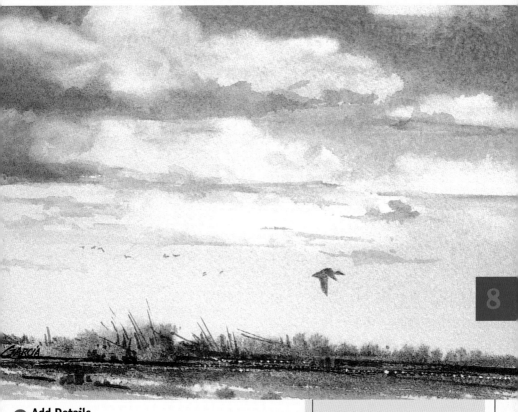

2 Add Details

Continue working on the clouds: scrub, lift color, add shadows, and use hard and soft edges. Watch for value changes as the clouds recede. Finally, glaze a mix of Raw Sienna and Permanent Rose over the clouds. Paint the duck and add a few spots representing distant birds with a mixture of French Ultramarine Blue and Brown Madder. Warm the foreground colors with a light glaze of Burnt Sienna. This helps establish scale and distance.

FLUFFY CLOUDS
Watercolor on 140-lb. (300gsm) cold-pressed paper
5½" × 8" (14cm × 20cm)

WATER

Water is a complex subject. It can be calm and clear, turbulent or murky. Whatever features you decide to paint, you must study them and convey them with textures or techniques. Use a flat or gradated wash to show reflections,. Try sandpaper to create turbulent, fast-flowing water.

You also must understand some basic principles of water to paint it realistically. Water reflects its environment, and the reflections generally are darker than the object being reflected. A reflection is not simply a mirror image of the object; eye level or horizon line plays a role. From a high vantage point, reflections appear short, whereas a low eye level results in a long reflection.

Ripples and waves generally have a pattern or rhythm, and they will distort or break up a reflection depending on their size. Even if ripples are evenly spaced, the distance between each one will appear to decrease as they move away from the viewer due to foreshortening. Waves also appear lighter in value as they recede.

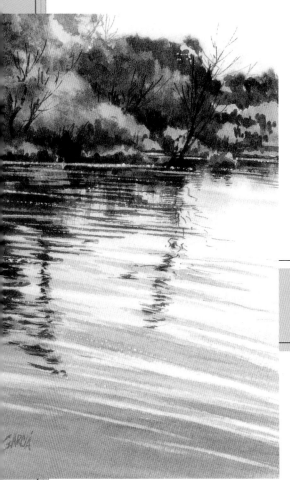

WATER REFLECTIONS
Watercolor on 140-lb. (300gsm) cold-pressed paper
7½" × 5" (19cm × 13cm)

STILL REFLECTIONS

You can create still water with a flat wash, as in this painting, or with a gradated or wet-into-wet wash using varied values and colors. Take the time to experiment with different ways of painting water.

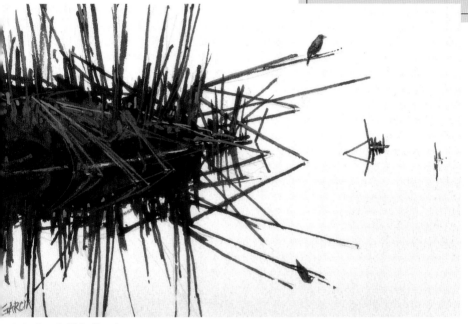

STILL REFLECTIONS
Watercolor on 140-lb. (300gsm) cold-pressed paper
5" × 8" (13cm × 20cm)

Painting Still Reflections

Indicate reeds and reflections with a loose drawing. Paint the water with flat wash of a Permanent Rose and Cobalt Blue mixture. Let dry. This painting has high contrast and lacks soft edges, so paint all the reeds with a very dark wash of French Ultramarine Blue, Alizarin Crimson and Winsor Green. Use a gouache mixture of Burnt Sienna, Olive Green, New Gamboge and Titanium White to paint the lighter-value reeds. Add Cobalt Blue and Titanium White to the dark mixture to indicate the shine on the mud. Indicate the shoreline with a little lifting and a few dabs of a light value.

Ripples

Think of ripples as small swells or waves on the water. They can have a pattern, rhythm or consistency to their movement or they can be very broken in flow. Ripples created by wind are less likely to have a pattern than those caused by an object dropped in the water.

Materials

BRUSHES
¾-inch (19mm) and
 1-inch (25mm) flats
Nos. 2, 4 and 6 rounds

WATERCOLORS
Brown Madder

Burnt Sienna

Cobalt Blue

French Ultramarine Blue

Permanent Rose

1 Paint the Boat

Draw the boat lightly. Paint the hull's bottom and interior with a dark mix of French Ultramarine Blue and Brown Madder. Paint the wood trim with light Burnt Sienna, adding French Ultramarine Blue for the shadow areas. Paint the hull shadow with a mix of French Ultramarine Blue and Alizarin Crimson.

Paint the water with a gradated wet-into-wet wash of Cobalt Blue, French Ultramarine Blue and Permanent Rose, starting the wash with a light value and adding more of the palette mixture as you work down. Let dry. Paint the reflection with French Ultramarine Blue and Brown Madder.

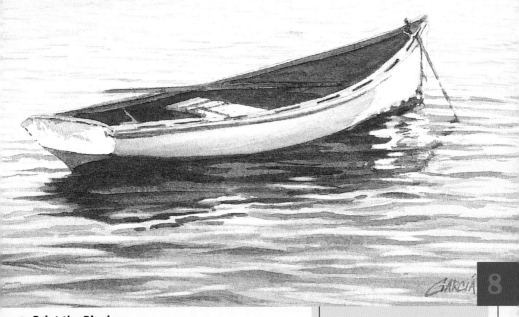

2 Paint the Ripples

Think of each ripple as having a top and sides. Paint the top as the highlight and the sides in shadow. As the ripples move closer they appear larger and darker. Use a ¾-inch (19mm) flat to lift highlights from some of the larger waves. As the ripples recede, they lose value and detail. In the background, paint the ripples as dashes of value on the wash. Add the anchor chain and its reflection last. The chain's reflection does not show in the highlights of the ripples.

RIPPLES IN THE WATER
Watercolor on 140-lb. (300gsm) cold-pressed paper
5" × 9" (13cm × 25cm)

Broken Reflections

Paint these broken reflections in the same manner as you painted the water ripples. You will paint the water with a gradated wash from light to dark to create depth in the painting.

Materials

BRUSHES
¾-inch (19mm) and
 1-inch (25mm) flats
Nos. 4 and 6 rounds

WATERCOLORS
Alizarin Crimson
Brown Madder
Cobalt Blue
French Ultramarine Blue
Permanent Rose
Raw Sienna

1 Draw, Then Paint the Coot and Water

Create a light drawing of a coot in rippled water. Paint the coot with a wet-into-wet wash of French Ultramarine Blue, Brown Madder and Raw Sienna. Let dry, then add beak, eye and feather details. Next, saturate the background with clear water. Be careful not to wet the edge of the bird. Paint from light to dark using a gradated wash of Cobalt Blue, French Ultramarine Blue and Permanent Rose. This wash does not have to be perfect. As the wash begins to dry, lift out color using a ¾-inch (19mm) flat, following your light drawing of where the ripples will be.

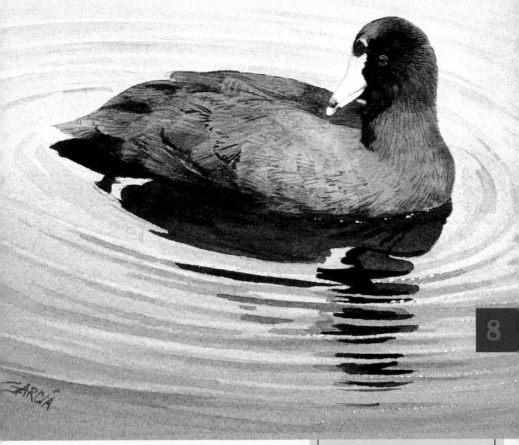

8

2 Paint the Broken Reflections

Let the wash dry completely. Paint the reflection of the coot with a rich wash of French Ultramarine Blue and Alizarin Crimson. The larger ripples intersect and break up the reflection. Smaller ripples distort the shape. Think of the ripples as small hills and valleys, with the hills being highlights and the valleys being in shadow. Make the reflections follow the elliptical shapes of the ripple. Use a ¾-inch (19mm) flat to lift out color along the top of the ripples. With the point of a palette knife, scrape out a few spots of white paper to show a little sparkle.

BROKEN REFLECTIONS
Watercolor on 140-lb. (300gsm)
cold-pressed paper
5½" × 7" (14cm × 18cm)

Ocean Waves

I always enjoy painting an ocean scene with water crashing onto rocks. What an opportunity for textures and spontaneity! Painting waves is not as difficult as you might think.

Materials

BRUSHES
¾-inch (19mm) and
 1-inch (25mm) flats

No. 4 round

WATERCOLORS
Alizarin Crimson

Brown Madder

French Ultramarine Blue

Sap Green

Viridian

1 Draw, Then Paint the Rocks and Add Texture

Do a loose drawing of the rocks and white water. Paint the rocks with a ¾-inch (19mm) flat and Sap Green, Brown Madder and French Ultramarine Blue. Before they dry, use a palette knife to scrape out the highlighted sides. (These staining colors work well with the palette knife technique.) Add the shadow on the large splash using Alizarin Crimson, French Ultramarine Blue and Viridian. Next, dry-brush the middle ground around the rocks.

8

2 Paint Water and Add Final Details

Continue to create texture by dry-brushing into the foam and whitewater area. Mix a large, dark puddle of French Ultramarine, Alizarin Crimson and Viridian. Load it onto a ¾-inch (19mm) flat and dry-brush it around the white water. This dark value will make the white seem brighter. Let dry. Use the edge (not the tip) of a single-edged razor or utility knife blade to scrape away paint. This technique catches the high points of the paper and removes the paint from them. Try to leave a very loose, broken texture. Use the tip to scratch a few lines to show highlights or the sparkle of water on rocks.

OCEAN WAVES
Watercolor on 140-lb (300gsm)
cold-pressed paper
5" × 7" (13cm × 18cm)

Rushing Water

Rushing water is an opportunity to experiment with creative and spontaneous techniques. The white of the paper represents the flow and splash of the water.

Materials

BRUSHES
¾-inch (19mm) and
 1-inch (25mm) flats
No. 3 round

WATERCOLORS
Cobalt Blue
Brown Madder
French Ultramarine Blue
Raw Sienna
Viridian

1 Draw, Then Paint Rocks and Background
Loosely sketch the landscape and the direction of the water flow. Paint the rocks with Brown Madder and French Ultramarine Blue. Use a palette knife to lift highlights from the damp rocks. Quickly paint the background of rocks and trees. With a mixture of Viridian, Cobalt Blue and Raw Sienna, dry-brush texture into the water. Let your strokes follow the direction of the water.

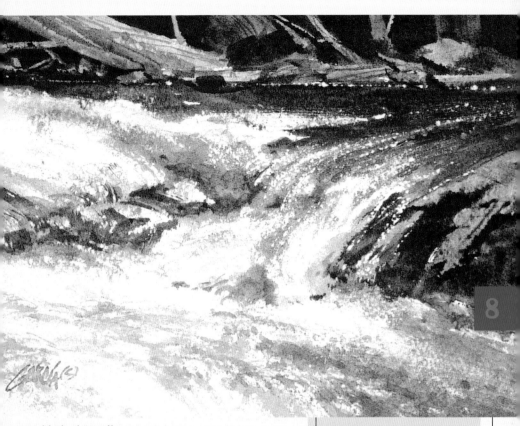

8

2 Add Final Details

Dry-brush the foreground water and add more value around the rocks in the water. Let dry completely. With the flat edge of a utility knife blade or single-edged razor blade, soften the edges of the water by scraping paint away. Use sandpaper to scrape directional flow lines in the water. Be careful not to overdo these textures. With the tip of the blade, scrape highlights into the water's edge in the background and on the wet rocks.

RUSHING WATER
Watercolor on 140-lb. (300gsm)
cold-pressed paper
5" × 7" (13cm × 18cm)

271

MAN-MADE OBJECTS

Painting man-made subjects is in some regards exactly the same as painting natural subjects. In both cases, you must be aware of cast shadows, perspective, values and so on.

Yet man-made subjects also present special painting challenges. Man-made objects are often shapes that cannot be found in nature, such as machinery or buildings. Man-made objects tend to have repetitive features—think of brick walls, picket fences, telephone poles or the numerous windows in a high-rise building. Man-made subjects often have textures such as rust, peeling paint or reflections that you can't find in nature. Stop, look and try to visualize how you would paint these textures. Would you use a sponge, resist, dry brush, sandpaper or all of these?

I like to combine man-made objects with natural subjects such as wildlife. An old tin roof or fence can be a great subject for a painting, especially when it is teamed with an interesting natural setting.

Keep your mind open to all objects as possible painting subjects. Man-made still-life subjects can range from the very complex, such as cut crystal and dinnerware, to simple objects like a book of matches. Look for interesting shapes or situations that man-made objects create. A lone park bench or an old metal chair can cast interesting shadows. When you see something you want to paint, capture it with a quick sketch or a photo.

FOLLOW THE MASTERS

Monet never seemed to tire of painting haystacks—a natural material, yet a man-made subject—or cityscapes.

Old Wood

This old wooden post is a man-made object. The techniques in this demonstration could be used for old trees, old wood, rocks or rust—anything with a rough, textured surface.

Materials

BRUSHES
¾-inch (19mm) and
1-inch (25mm) flats

Nos. 4 and 6 rounds

WATERCOLORS
Alizarin Crimson

Brown Madder

Burnt Sienna

Cobalt Blue

French Ultramarine Blue

New Gamboge

Olive Green

Raw Sienna

Sap Green

Winsor Green

8

1 Draw, Mask Out the Wire and Paint the Wood
Loosely draw the fence post and the barbed wire. Cover the wire with liquid masking agent to keep the wood color from getting on it. Paint the post with a wet-into-wet wash of Raw Sienna, Burnt Sienna, Brown Madder and Cobalt Blue. The Cobalt Blue creates a subtle gray in areas. Let this wash dry completely.

2 Add Texture

Use an old 1-inch (25mm) flat to dry-brush vertical strokes over the post. This adds value and color as well as texture to this area. Add some long, thin texture lines with a new no. 6 round that has a good pointed tip. Paint the large holes and the shadow area of the post.

ADDING MORE TEXTURE

If, after the painting dries, you want to add more texture, try splattering. Lay paper along both sides of the post to protect the background. With a ½-inch (25mm) flat, lightly splatter paint to create the appearance of small various-sized holes in the old wood.

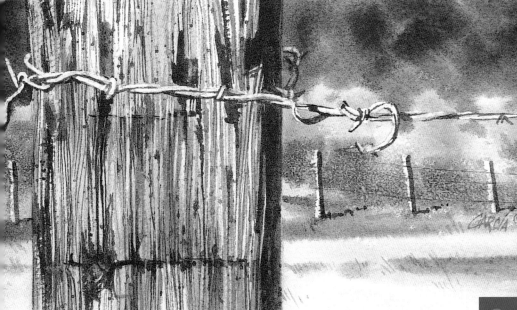

3 **Paint the Background**
Cover the background with water right up to the edge of the post. Paint the foreground with a very thin wash of Burnt Sienna, New Gamboge and Cobalt Blue. Paint the middle ground a stronger value of Olive Green, Sap Green and Cobalt Blue. Sprinkle salt over this area to create an organic texture. Paint the background a rich, strong mixture of French Ultramarine Blue, Alizarin Crimson and Winsor Green. Allow this color to mix with and soften the edge of the middle ground. Add a couple of brushstrokes of background color across the foreground to indicate shadows. Use a palette knife to scrape in the fence posts. Finally, remove the masking agent from the wire. Lay a thin wash of Cobalt Blue over most of the wire, adding shadows and lifting out color where necessary.

OLD WOOD
Watercolor on 140-lb. (300gsm)
cold-pressed paper
4½" × 8" (12cm × 20cm)

8

Old Wooden Fence

Old wooden fences offer a variety of textures to paint in one subject. The textures include peeling paint, rust, dried and cracking wood, and the overall texture of repetitive shapes.

Materials

BRUSHES
¾-inch (19mm) and
 1-inch (25mm) flats
Nos. 3 and 4 rounds

WATERCOLORS
Alizarin Crimson

Brown Madder

Burnt Sienna

Cobalt Blue

French Ultramarine Blue

Olive Green

Raw Sienna

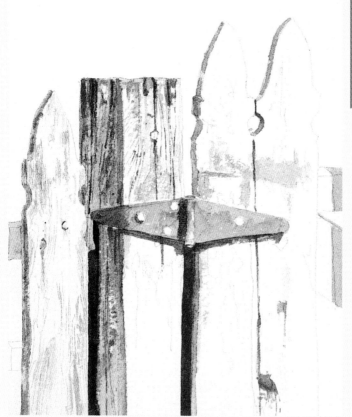

1 Draw, Then Dry-Brush and Add Shadows
Sketch the composition. Paint a transparent dry-brushed texture using a thin gray mix of Cobalt Blue, Brown Madder and a touch of Raw Sienna. Dry-brush on a little Burnt Sienna for rust stains on the wood. Paint the shadows on the post and pickets to give shape and dimension to the fence, and glaze a light value of Burnt Sienna over the rusty hinge on the fence.

276

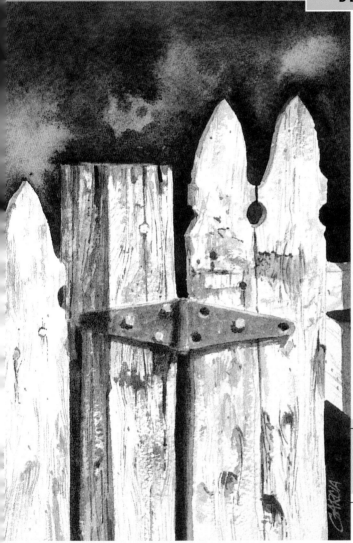

8

OLD WOODEN FENCE
Watercolor on 140-lb. (300gsm)
cold-pressed paper
7" × 5" (18cm × 13cm)

2 Add the Background and Final Textures
Pay close attention to the wood texture on the fence. Paint
the holes, cracks and marks using a dark value of French Ultramarine
Blue and Alizarin Crimson. Paint the wood grain with a no. 3 round
and a light value of French Ultramarine and Brown Madder so the
grain isn't too pronounced. When you are satisfied with the texture
on the fence, wet the background with water to start a wet-into-
wet wash. Paint the background with a rich, dark mixture of French
Ultramarine Blue, Alizarin Crimson and Olive Green. Add final tex-
turing on the fence by darkening some of the cracks and splattering
the wood with the same light-value color used on the wood grain.
Lift color from the empty bolt holes on the hinge to create
a little depth.

277

Brick Texture

This painting is of an old brick wall with morning glories growing on it. I passed it on a back street of Sienna, Italy. I used my camera to isolate a few flowers for a painting. This is a good example of using natural and man-made objects together.

Materials

BRUSHES
¾-inch (19mm) and
 1-inch (25mm) flats
Nos. 2 and 4 rounds

WATERCOLORS
Brown Madder

Burnt Sienna

Cobalt Blue

French Ultramarine Blue

Mauve

Sap Green

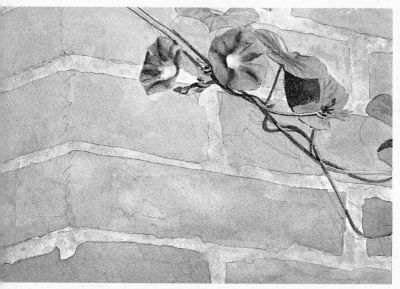

1 Draw, Then Paint the Flowers, Vine and Bricks
Loosely draw the bricks, the flowers and the cast shadows. Paint the flowers with a small wet-into-wet wash of Mauve with a little Alizarin Crimson using a no. 4 round. Paint the shadows with a dark-value mix of Mauve and French Ultramarine Blue. Paint the vine and leaves with a flat wash of Sap Green and Cobalt Blue. Use a slightly darker value of this color for the shadows on the leaves and vine. Paint the bricks with a light-value wash of Burnt Sienna, Brown Madder and Cobalt Blue. Try to avoid the mortared areas. You don't want too much dry-brush texture—if the textures or values are overdone, they will compete with the flowers and leaves.

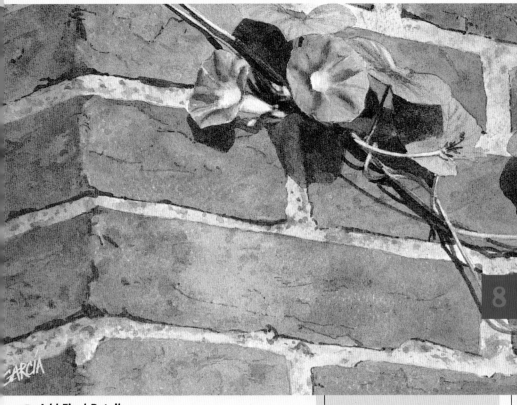

8

GARCIA

2 Add Final Details

Glaze a mixture of Burnt Sienna and Cobalt Blue on the bricks over the previous glaze. Keep it uneven in value. Let dry. Paint the shadows on the wall, making the area on the left darker to indicate the turning of the corner. Also paint the shadows under the flowers with a rich mixture of Cobalt Blue and Alizarin Crimson. Paint a very light, broken wash of Cobalt Blue and Burnt Sienna over the mortar. Add a dark value along the lower edge of the brick. With a very light value of "palette mud," splatter over the brick area, being careful to avoid the flowers and leaves. Lift color out of the vines to distinguish them from the shadows.

OLD OR NEW BRICK TEXTURE
Watercolor on 140-lb. (300gsm)
cold-pressed paper
5" × 7½" (13cm × 19cm)

Window Glass

Glass windows can show reflections or can be dirty, cracked and ready to be replaced. This window was in an old barn. Frosted, cracked and covered with spider webs, the window had seen better days. With a subject like this, take time and care to build up glazes to show the different elements. The broken area is the same color as the cast shadow, just a darker value.

Materials

BRUSHES
¾-inch (19mm) and
1-inch (25mm) flats
Nos. 3 and 4 rounds

WATERCOLORS
Brown Madder
Cobalt Blue
French Ultramarine Blue
Viridian

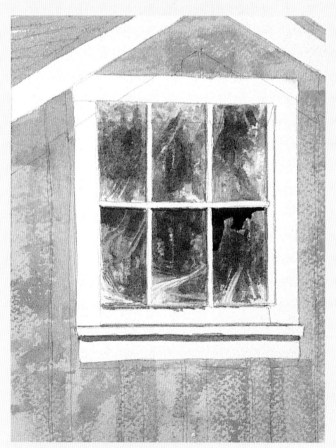

1 Draw, Then Lay In Base Washes
Draw the composition. Dry-brush a mix of French Ultramarine Blue and Viridian in each windowpane with an old no. 3 round. Paint the wall a light-value, loose wash of Brown Madder and just a little Cobalt Blue. Paint the roof with Viridian and use the white of the paper for the trim.

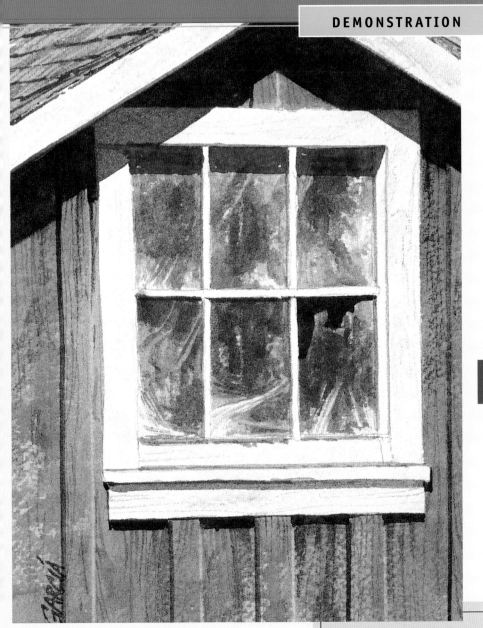

2 Darken the Value on the Siding
Use the same mixture of Brown Madder and Cobalt Blue to dry-brush texture and value on the siding. Deepen the value on the roof. Glaze shadows over all the textures, being careful to follow the contour of the siding. Add a very light-value, dry-brushed texture of Cobalt Blue and Brown Madder over the white trim. This adds a little detail and helps the trim not look empty.

WINDOW
Watercolor on 140-lb. (300gsm) cold-pressed paper
6" × 4½" (15cm × 11cm)

Book of Matches

Even simple objects such as a tube of paint, a piece of fruit or a book of matches can be good subjects to paint. As with any subject, start with a sketch with accurate perspective and plan where the flat washes and cast shadows will be. In this study I decided not to use a background value.

Materials

BRUSHES
¾-inch (19mm) and
1-inch (25mm) flats
Nos. 2, 3 and 4 rounds

WATERCOLORS
Alizarin Crimson
Burnt Sienna
Cobalt Blue
French Ultramarine Blue
New Gamboge
Sepia
Winsor Red

1 Draw, Then Lay In the Base Values
Do a quick, accurate sketch of the matchbook and its shadow. Paint the interior using a tan color mixed from Cobalt Blue, Burnt Sienna and Winsor Red. Add Sepia to the mix, then paint the matches. Use New Gamboge for the yellow. Because this object is made of cardboard, let your washes have some texture rather than making them perfectly smooth and flat.

2 Add the Shadows

This painting depends on the strong shadows to add depth and interest to the subject. Use a wash of French Ultramarine Blue and Alizarin Crimson for the shadow color. Glaze this color over the shadow area, making sure it follows the contour of the matches. Because there is less light shining into the back of the open cover, that is the darkest shadow area; make it a little darker in value. Lift a little color from the fold line and along the edge of the matchsticks. Glaze a shadow over the yellow, using quick, long strokes so the yellow doesn't lift. Finally, paint the black lines, add a few dark marks to the torn matches, and put shadow underneath the outside edges of the matchbook.

BOOK OF MATCHES
Watercolor on 140-lb. (300gsm) cold-pressed paper
4½" × 6" (11cm × 15cm)

Old Red Chair

This is another man-made object that makes a wonderful subject to paint or sketch. Every day I walk by this old chair that sits in our garden. The strong cast shadow first caught my attention.

Materials

BRUSHES
¾-inch (19mm) and
1-inch (25mm) flats

Nos. 2, 3 and 4 rounds

WATERCOLORS
Alizarin Crimson

French Ultramarine Blue

Permanent Red

Winsor Green

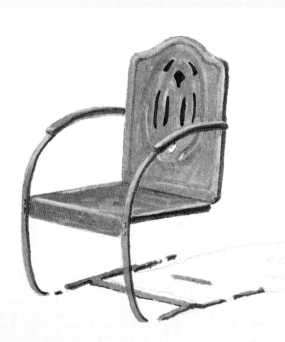

1 Paint the Base Wash
Paint a medium-value wash of Permanent Red over the entire chair. Paint the dark holes in the back of the chair and the shadows. Lift out highlights from places that catch more light.

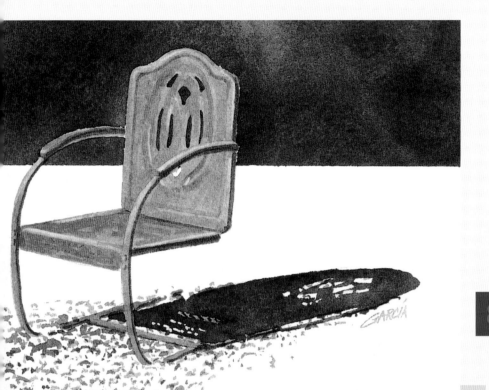

8

2 Paint the Ground, Background and Cast Shadow

A complex garden background would distract from the subject of the painting, so you'll paint only the ground, cast shadows and a simplified background. Paint the background rectangle by first placing masking tape over the painting of the chair. Use a sharp art knife to cut around the exterior of the chair and remove the unwanted tape. Also place masking tape around the perimeter of the picture area. Make sure all the tape is burnished down so paint doesn't run under the edges. Apply a wet-into-wet background wash of French Ultramarine Blue, Alizarin Crimson and Winsor Green using a 1-inch (25mm) flat. Paint the shadows on the ground using the same colors, but with a loose, freehand approach. When the background dries, carefully remove the masking tape, leaving a crisp, clean edge.

THE OLD RED CHAIR
Watercolor on 140-lb. (300gsm)
cold-pressed paper
5" × 6½" (13cm × 17cm)

PEOPLE

People come short and tall, wide or thin, singly or in groups. The more you know and understand your subject, the better you can translate what you see into a painting or drawing. To start sketching people, break down the body into boxes, tubes and planes.

Skin Color

After you have a sketch of your subject, start adding color. Skin color does not come in a tube and there is not a magi-

cal formula for it. Look for the color variations created by light and shadow.

Hair

When you paint hair, try not to add too much detail. Start with large light- and dark-value patterns, then look for highlights and try to use as many soft edges as possible. After you get the basic planes down, use a few well-placed brushstrokes to indicate detail.

Practice Drawing People From Different Angles
Create quick studies and try to follow the basic proportions of the head.

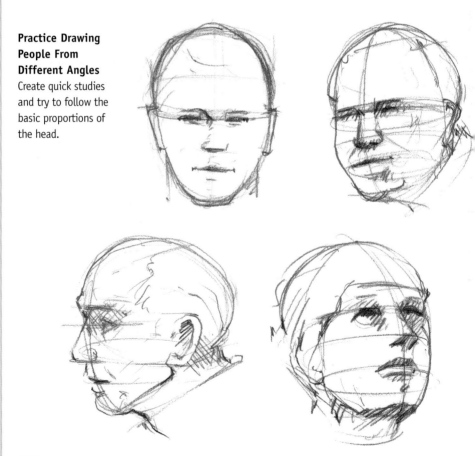

HEAD PROPORTIONS

Proportions are a starting point when you're learning how to draw people. Use basic proportions to see how facial elements relate to one another. Remember that a child's facial and body proportions are different from those of an adult. Study the adult example shown here, then try creating a similar diagram showing the proportions of a child's face.

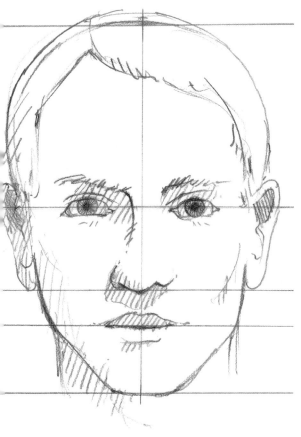

Establishing Facial Proportions

1 | Establish the height of the head by drawing two horizontal lines. Also draw a vertical line to indicate the center axis of the head.

2 | Establish the eyes halfway down the head on a horizontal line. The eyes are approximately one eye width apart. The eyebrow, a bony projection that protects the eye, sits above the eyeball and is covered by small, delicate hairs. The top of the ear is on the same level as the eyebrow.

3 | The bottom of the nose will fall about half way between the eyebrows and chin. The bottom of the ears will line up with the bottom of the nose.

4 | Divide the area from the bottom of the nose to the chin into thirds. The mouth is approximately one-third of the way down from the bottom of the nose.

8

SKIN COLOR

When painting skin, try to limit your paint colors to three or four. Glaze on colors with multiple layers or use a wet-into-wet wash. Glazing colors gives a luminous tone, while premixing or painting wet-into-wet gives a more sub-dued color range.

ADD WARMTH

Warm up facial areas like cheeks, nose, eyebrows or chins. The blood is closer to the surface and makes these areas warmer. Shadows in these areas are cool colors but on the warm side of the color wheel.

Fair Skin (Children)
Burnt Sienna, Winsor Red, Cobalt Blue
Apply very thin; after the wash dries, layer more color on if needed.

Native American, Hispanic
Burnt Sienna, Brown Madder, Cobalt Blue
This combination is rich and dark. Adjust the ratio to fit the skin color and value.

Dark Complexions
Burnt Sienna, Burnt Umber and French Ultramarine Blue
Add a little more Burnt Sienna (or substitute Winsor Red) to warm up the mixture.

Fair Skin, Highlighted Fair Skin, and Asian
Raw Sienna, Burnt Sienna and Cobalt Blue
Start this wash with a very light application of color.

288

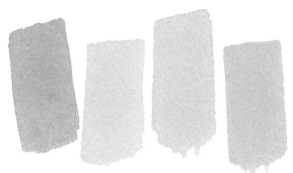

Burnt Sienna, Winsor Red, Cobalt Blue

Experiment With Color Ratios

In these mixtures I have changed the ratio of pigments to achieve a few of the countless possible variations. I have kept the values of the mixtures the same and not changed the intensity. Experiment by adding or taking away water from the mixture.

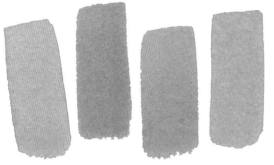

Burnt Sienna, Brown Madder, Cobalt Blue

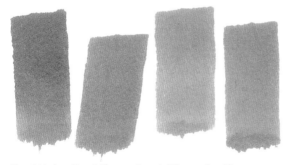

Burnt Umber, Burnt Sienna, French Ultramarine Blue

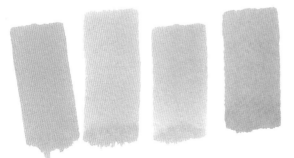

Raw Sienna, Burnt Sienna, Cobalt Blue

Face

When you paint portraits, the ultimate goal is to capture the personality of the person. Before you paint, decide how to approach the painting. Having a plan helps you decide the techniques you will use: loose and spontaneous or more controlled and detailed. You also need to decide how much color and value to use. Once you have a plan, start painting the basic shapes, going from light to dark and loose to tight, and add detail only as needed.

1 Sketch the Head
Sketch a basic human head. You will be painting over this drawing, so it must be dark enough to be visible through washes. Use an HB pencil.

2 Add the Basic Colors
Lay in a warm underpainting using a mixture of Winsor Red, Permanent Rose and Raw Sienna with a ¾-inch (19mm) flat. Use more of the Winsor Red in the wash when you are painting areas where the blood is closer to the surface of the skin: the forehead, cheeks, nose and chin. Use very little color on the high forehead, the ridge of the nose and the upper chin; these areas are highlights.

3 Add the Middle Values

Mix a shadow color of French Ultramarine Blue and Alizarin Crimson. Use a no. 6 round and a ½-inch (12mm) flat to quickly add this color to the shadowed side of the face, the eye sockets, the area between the nose and upper mouth, and the throat. Do not try to create detail with this wash. Let dry. Using a less diluted version of the same shadow color, darken the eye socket, the ridge of the nose, below the lower lip, under the chin and along the hairline.

4 Add the Final Details

Paint the eyelids, lashes, eyebrows and teeth with a no. 3 round. The eyebrows are a quick indication of hair in a darker value—use the mixture of French Ultramarine Blue and Alizarin Crimson for this detail. Add a few brushstrokes to the lower forehead, the nostrils, the nose and the lower chin with a no. 6 round and a mixture of Winsor Red and Cobalt Blue.

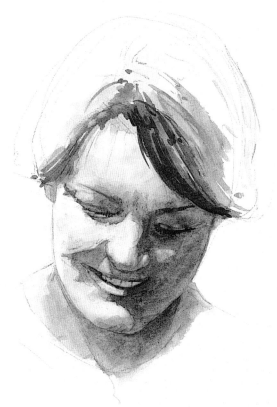

WOMAN'S FACE
Watercolor on 140-lb. (300gsm) cold-pressed paper
6" × 4½" (15cm × 11cm)

Profile

This profile portrait is an African-American woman with short, dark hair. Her skin tone is a medium value, similar to a Hispanic, Middle Eastern or Latin American skin color. She also has a small ponytail that catches a slight highlight along its outside edge.

1 Draw, Then Add Basic Tone
Draw the head lightly with a 2H or H pencil so you don't score the paper. Paint the face with a no. 8 round and a mixture of Brown Madder, Burnt Sienna and Cobalt Blue. Continuing with the same brush, paint the hair with a light wash of Cobalt Blue and Brown Madder. Let dry. Apply a less diluted mix of the same hair colors to darker shadow areas. The shadow areas make the front and side of the head stand out.

2 Build the Values
Use nos. 4 and 6 rounds to paint the face and hair. Each layer of color is less diluted than the previous one. Paint the hair with Cobalt Blue and Brown Madder follow the short curly hair direction. Paint the shadows on the face with Burnt Sienna, Brown Madder and Cobalt Blue. Alternate between the dark areas of the face and hair to keep the two in balance. This way you can establish the lightest lights and darkest darks as you continue working.

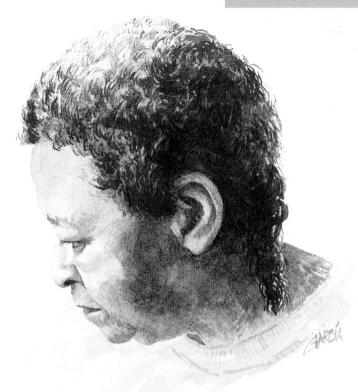

8

3 Add Final Details
Keep building value on the hair and face. Add French Ultramarine Blue to the hair color of Cobalt Blue and Brown Madder, then use this and a no. 4 round to darken the hair. Darken the skin by adding thin washes of Winsor Red, French Ultramarine Blue and Brown Madder. The Winsor Red is much stronger in areas like the ears, chin and cheek. The dark shadows on the cheek and neck have much more of the French Ultramarine Blue. Allow some skin tone to show through near the edge of the hair to soften the edge.

AFRICAN-AMERICAN WOMAN
Watercolor on 140-lb.
(300gsm) cold-pressed paper
6" × 4½" (15cm × 11cm)

Straight Hair

When you are painting straight hair, make sure your sketch is dark enough that you can see the shape and direction of the hair through the first wash of color.

Materials

BRUSHES
Nos. 6 and 8 rounds

WATERCOLORS
Alizarin Crimson

Cobalt Blue

French Ultramarine Blue

1 Sketch the Hair

Indicate the head shape and direction of the hair with an H pencil. Add lines or a crosshatch pattern to show shadows and darker values. It's important to know where these areas are, so make these lines dark enough to see through the first wash of color.

2 Add the First Wash

Mix a large puddle of French Ultramarine Blue, Cobalt Blue and Alizarin Crimson on your palette. Use scrap watercolor paper to test the mixture until you get the color you want. Paint this first wash with diluted color and nos. 6 and 8 rounds. Be careful not to paint areas of highlight. Follow the direction of the hair as you apply the color.

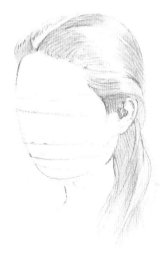

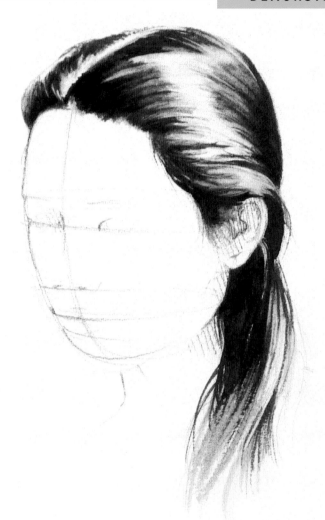

3 Add Final Details
Continue to darken the values in the hair, especially in the shadows. Let dry. Use an old no. 6 round to soften or lift color. Since this is dark hair, try to create contrast between the highlights and the dark values. Don't overpaint or add too much detail.

STRAIGHT HAIR
Watercolor on 140-lb. (300gsm)
cold-pressed paper
5½" × 4" (14cm × 10cm)

Wavy Hair

Paint wavy hair using a wet-into-wet technique to create soft highlights and shadows.

Materials

BRUSHES
Nos. 4 and 6 rounds

WATERCOLORS
Burnt Sienna
Burnt Umber
French Ultramarine Blue
Raw Sienna
Sepia

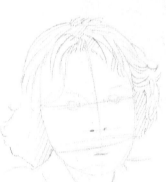

1 Create a Sketch
Sketch a basic head with wavy hair. Don't worry about making it too detailed.

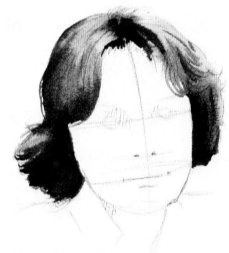

2 Add Dark Values
Saturate the hair with water. Mix Burnt Sienna and Raw Sienna and apply this color in the direction of the hair with a no. 6 round. As this area softens, start adding dark values: a mixture of Burnt Sienna, Sepia and Burnt Umber. When this is almost dry, mix French Ultramarine Blue, Sepia and Burnt Umber and paint the shadows using a no. 4 or no. 6 round.

8

3 Add Final Details

Using a mixture of Burnt Sienna, Sepia and Burnt Umber and a no. 4 round, add a few lines to show the direction the hair falls from the top of the head. Use an old no. 4 round to soften and lift secondary highlights from the hair.

WAVY HAIR
Watercolor on 140-lb. (300gsm) cold-pressed paper
5½" × 4" (14cm × 10cm)

White Hair

When you start the drawing for this project, remember that the lines need to be dark enough to see through the paint as you add the initial wash of color on the face and hair.

Materials

BRUSHES
Nos. 4 and 6 rounds

WATERCOLORS
Brown Madder

Burnt Sienna

Cobalt Blue

Winsor Red

1 Create a Sketch
Draw a portrait of an older man with an H pencil. His hair is white with a receding hairline.

2 Add the First Wash
The subject is fair-skinned, so create a warm, fresh tone from Burnt Sienna, Winsor Red and Cobalt Blue. Paint the hair with a gray mix of Cobalt Blue and Brown Madder, using a no. 4 round and allowing the brush to follow the direction of the pencil lines. Blend the flesh tone into the hair using a no. 6 round and clear water. Paint some hair over the flesh tone so you can see some of the flesh color in the hair; this reinforces the idea that the hair is thinning.

3 **Add the Final Details**
Develop the waves in the hair using a Cobalt Blue–Brown Madder mixture and a no. 4 round. Lift color and soften areas of the hair with a worn no. 4 round. As you lift the color, follow the hair flow to accent the wave in the hair.

WHITE HAIR
Watercolor on 140-lb.
(300gsm) cold-pressed paper
4" × 4" (10cm × 10cm)

8

INDEX

THE BEST IN FINE ART INSTRUCTION IS FROM NORTH LIGHT BOOKS!

The Drawing Bible

Answers to most every common, real-life situation the artist who chooses to draw will encounter can be found in this compact, easy-to-use guide that is organized topically and has an enclosed spiral binding. This book covers all standard drawing materials (black-and-white and color) and covers topics such as mixing media and exploring a variety of surfaces and styles. The many step-by-step demos provide plenty of clear visual instruction.
ISBN 1-58180-620-5, concealed spiral binding, 304 pages, #33191

Creative Watercolor Workshop

Overcome creative block and break out of your norm. This book offers creative exercises for every skill level and comfort level, as well as demonstrations, painting critiques, weak/strong comparisons and examples. In no time, you will have a variety of tools for jumpstarting your creativity and painting with confidence.
ISBN 1-58180-532-2, concealed spiral binding, 128 pages, #32886

The Watercolorist's Answer Book

This is the authoritative guide to watercolor featuring the combined expertise of eight successful professional artists. With 425 tips, techniques and solutions selected from North Light's best watercolor instruction books and 20 step-by-step demonstrations, this book will help every watercolorist, beginning or advanced.
ISBN 1-58180-633-7, paperback, 192 pages, #33208

These books and other fine North Light titles are available at your local fine art retailer or bookstore or from online suppliers.